KEYS TO
Drawing with Imagination

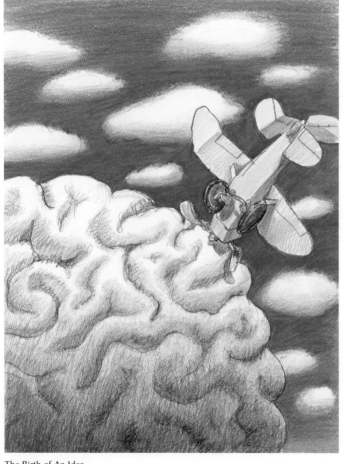

The Birth of An Idea
Colored pencil

strategies and exercises for gaining confidence and enhancing your creativity

BERT DODSON

NORTH LIGHT BOOKS
CINCINNATI, OHIO
www.artistsnetwork.com

ABOUT THE AUTHOR

Bert Dodson is a painter, teacher, author and illustrator. He is the author of the best-selling North Light book, *Keys to Drawing*. He has also co-authored *The Way Life Works* with Mahlon Hoagland and worked as an animation designer for the PBS television series *Intimate Strangers*. He has illustrated over 70 children's books. He has studied and taught creativity for over twenty years.

Photo by John Douglas, Flying Squirrel

Keys to Drawing With Imagination: Strategies and Exercises for Gaining Confidence and Enhancing Your Creativity.
Copyright © 2007 by Bert Dodson. Manufactured in China. All rights reserved. No part of this book may be reproduced in any form or by any electronic or mechanical means including information storage and retrieval systems without permission in writing from the publisher, except by a reviewer who may quote brief passages in a review. Published by North Light Books, an imprint of F+W Publications, Inc., 4700 East Galbraith Road, Cincinnati, Ohio, 45236. (800) 289-0963. First Edition.

Other fine North Light Books are available from your local bookstore, art supply store or direct from the publisher.

11 10 09 08 5 4 3

DISTRIBUTED IN CANADA BY FRASER DIRECT
100 Armstrong Avenue
Georgetown, ON, Canada L7G 5S4
Tel: (905) 877-4411

DISTRIBUTED IN THE U.K. AND EUROPE BY DAVID & CHARLES
Brunel House, Newton Abbot, Devon, TQ12 4PU, England
Tel: (+44) 1626 323200, Fax: (+44) 1626 323319
Email: postmaster@davidandcharles.co.uk

DISTRIBUTED IN AUSTRALIA BY CAPRICORN LINK
P.O. Box 704, S. Windsor NSW, 2756 Australia
Tel: (02) 4577-3555

Edited by Amy Jeynes and Erin Nevius
Designed by Guy Kelly
Production coordinated by Matt Wagner

Library of Congress Cataloging-in-Publication Data

Dodson, Bert.
 Keys to drawing with imagination : strategies and exercises for gaining confidence and enhancing your creativity / Bert Dodson.
 p. cm
 ISBN-13: 978-1-58180-757-8 (alk. paper)
 ISBN-10: 1-58180-757-0 (alk. paper)
 1. Drawing—Technique. 2. Creative ability. I. Title

NC730.D562 2006
741.2—dc22 2006046724

METRIC CONVERSION CHART

To convert	to	multiply by
Inches	Centimeters	2.54
Centimeters	Inches	0.4
Feet	Centimeters	30.5
Centimeters	Feet	0.03
Yards	Meters	0.9
Meters	Yards	1.1

acknowledgments

I wish to thank the following artists who have generously contributed their work to this book:

Robert Baxter
Frank Bettendorf
Guy Billout
Ted Chaffee
Alan E. Cober (courtesy Ellen Cober)
John G. Crane
Steve Cosentino
Dave Creek
R. Crumb
George Dugan
Steven Guarnaccia
Don Helms
Stephen Huneck
Aya Itagaki
John Joline
Maya Lin
Zelma Loseke
Michael Mitchell
Victor Moscoso
Alex Pinkerson
Stephen Plume
Omar Ruiz
Paul Rump
J.R. Smith
Reinhart Sonnenberg
Trina Schart Hyman
Gidon Staff
Lynn Sweat
Joey Tate
Joan Waltermire
Ricker Winsor

I am particularly grateful to Amy Jeynes, managing editor at North Light Books, for seeing this book through to completion; Peter Mallary for additional and valuable editing; Judith Church and Scott Dodson for offering key suggestions; my agent, Jill Kneerim, for getting this project off the ground; and my key organizer, Suzi Claflin, for keeping it there. In addition, the following people have given important technical and moral support:

Phillip Bowman
Bill Germer
Ira Ginsberg
Mahlon Hoagland
David Kelly
Don Lambert
DeWitt Mallary
Brian McGuiness
Ben Moore
Phyllis Nemhauser
Emilie Perry
Ed Reinhardt
Mason Singer
John Stephens
David Webster

Finally, I'm indebted to the following writers and thinkers who, through their work, have contributed to my understanding of the subject of creativity:

Gregory Bateson
Deepak Chopra
Werner Erhard
Robert Fritz
Arthur Koestler
J. Krishnamurti
Douglas Hofstadter
Peter Loundon
Steven Pinker
Twyla Tharp
David Whyte

For **Michael Mitchell**,
who showed me what was possible with drawing

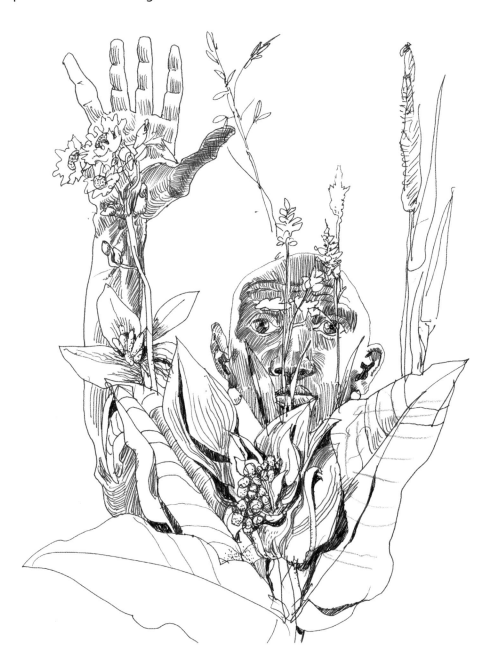

contents

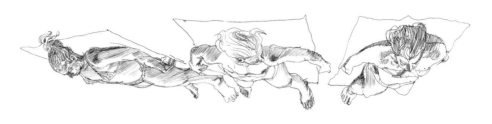

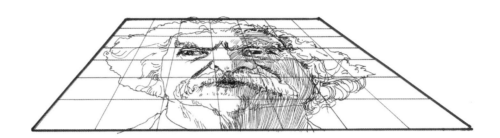

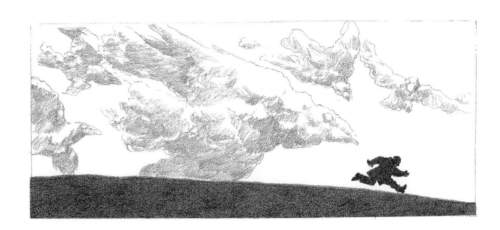

introduction

Asked to describe the creative process, the painter Jasper Johns replied, "It's simple: You just take something and do something to it, and then do something else to it. Keep doing this, and pretty soon you've got something."

Johns' comment succinctly summarizes everything I have learned about creativity in 60+ years of drawing. Having said that, we will use the rest of this book to explore what it means to "take something and do something to it." In the process, I hope to deepen your experience of imagining and creating.

Keys to Drawing With Imagination takes a broad look at what it means to draw from your imagination. This might mean drawing the fantasy images in your head. It could also mean distorting, abstracting or simply doodling. Imaginative drawing may include making strange combinations, making connections between seemingly unrelated things or simply drawing from memory. It certainly involves making creative choices about the things you choose to draw.

We tend to think of imagination and creativity as qualities that people *have*. But in reality these qualities show up only in action—as something you *do*. Simply put, imagining is what you do in your head; creating is what you do on paper. Are there rules for creating? Probably not, if a rule is something that you must do. But let's distinguish between rules and principles. I believe that there are useful principles that can help you create. Jasper Johns has already given us a first principle: **Creativity occurs in action**.

You don't need to be exceptionally clever to draw creatively. Certainly theories about creativity don't help much. You don't even need to have particularly good ideas. Often, ideas don't occur to you until after you've started drawing. So you should not wait around for great ideas. Just begin with simple ideas. Bigger things will emerge out of them. We can make this our second

principle: **Creativity begins with simple ideas.**

The one indispensable quality essential for creating is engagement with the work. When you are engaged—lost in the work—you shift out of the future and into the present. This is where creativity thrives. Out of this comes our third principle: **Creativity lives in the present.**

A common experience for both artists and students is to be disappointed in the gap between what we imagine and how it actually appears on paper. Our skills rarely seem up to the products of our minds. This is simply the way it is—and it is true for almost everyone. There are two things you can do about it. First, draw a lot—a whole lot. All mastery comes through practice. (My previous book, *Keys to Drawing*, may also be helpful. It focuses on developing basic drawing skills.) This gives us our fourth principle: **Creativity increases with practice.**

The other thing that you can do is confine your judgments to the practical and specific: to such things as shading, proportions, pattern and so on. General self-criticism isn't helpful. Avoid subtly self-disparaging statements such as:

"You're either creative or you're not."

"Some people just have it. Others don't."

"I don't have any ideas."

"I have lots of ideas, but I don't draw well enough to express them."

This leads us to yet another principle: **Creativity increases as judgment and criticism decrease.**

Even as I encourage you to exercise freedom in drawing, I will also emphasize that the imagination needs a certain amount of specificity. If I say to you, "Imagine something," you might have to struggle. But if I tell you about a land where dogs are in charge—the police force, the Supreme Court, the astronauts, all dogs—you will immediately get a more specific picture.

I actually never liked those grade-school art assign-

ments in which I was told, "Draw anything you want." I was overwhelmed by the possibilities. My mind came up blank. There was nothing to push against—no problem to solve. The experience left me with an early and intuitive appreciation for the value of constraints. In fact, it is both beautiful and ironic that constraints can actually give you more freedom. They activate your imagination. Mature artists have learned to set their own constraints. You will as well, but understand that this stage usually comes later in an artist's development. Principle: **Creativity likes constraints and specifics.**

Creativity is a lot like happiness. It shows up when you're thinking of something else. Here is what I mean. Imagine that you are sitting in a room with your sketchbook in hand. You have an urgent desire to create. Your pencil is poised. Your energy is focused. You are determined. But nothing happens. Why? Because *wanting* to be creative is all about you. It is a goal, not an action. Goals are about the future. Actions are about the present. Try picturing yourself differently. You have a definite project in mind. For instance, you might try combining two of your previous sketches into a single drawing. Now you have a specific task. While the rules may be simple, the possibilities are vast. The project is no longer about you, but about solving a problem. Your creativity comes alive in the present instead of being stalled in the future. Principle: **Creativity emerges in experimentation, manipulation and exploration.**

So the projects in this book are set up as problems. They have built-in constraints of one sort or another. They are also intended to be open-ended enough to allow you to work them out in your own way. If, while working on one of these projects, your drawing spins off in a new direction—one entirely your own—then so much the better. Principle: **Creativity is about having a plan and a willingness to depart from it.**

Most of this book is about strategies, with names like adding on, spinning off, reversing, progressively changing, and repeating—with variation. These strategies are based on the use of your own work as source material for further, more imaginative drawings. In other words, making a drawing is often only the first stage of an extended creative process. (This involves some "setting up " instructions provided on pages 8 and 9.)

After I was well into the writing of this book, I realized that several of the transforming operations which I promote (such as mirror imaging, distorting and multiplying) can be done mechanically by computers. Even though this is the case, I urge you to take the more laborious—and more creative—path of drawing by hand. This not only develops skill, it produces warmer and more personal results. I'm a strong believer in a quality that I call "wobble," the less-than-perfect execution of things crafted by hand.

A subject as vast as this one demands a little humility from the author. The ideas in *Keys to Drawing With Imagination* are not necessarily new in the world, but some are new to me. Like any teacher, I propose to share what I've learned from others and from my own experience with drawing. I believe that the principles and projects in this book will help you take your own work in new and original creative directions. The examples by me and my colleagues are meant solely to enliven the text. They are not intended to show you "the way to do it." In the end, the way to do it is your own unique way.

Keys to Drawing With Imagination is designed to be progressive, meaning it starts simply and gets more complex as it goes along. The earlier projects are mostly specific and controlled. The later ones leave more room for you to make your own choices. The chapters and projects are designed to be taken in sequence, but I believe in chance and serendipity, so I invite you to follow any sequence that best suits you.

generating and transforming your ideas

To create effectively, I have found it useful to separate the original impulse—what I call generating—from later manipulations that I call transforming. Here is how it works. First, I make an original sketch or doodle. Then I experiment with different ideas which transform the original—often copied or otherwise redrawn—into something novel or surprising. I believe that to separate the process of generating and transforming into two distinct steps has great value, and I have structured many of the exercises in this book that way. Simply put, generating is like sketching, while transforming is just as it sounds—you take the sketch to the next level, moving to a more defined and specific place.

Moving from generation to transformation often requires redrawing all or part of your original sketch. There are several practical ways to do this. You can simply copy the original by

hand. You can tape the original to a sunlit window with a blank sheet on top of it, and then trace. You can photocopy the original, and then work on the copy. Finally, you can buy or construct a light box for tracing originals.

To get the most out of your work in this book I recommend the last of these options. A light box can become an indispensable tool. It is for many artists. Or it may just become a useful learning device, like training wheels for the fledgling bicyclist. Either way, the things you will discover by using it are well worth the effort it takes to build one.

A light box is simply a sheet of glass or thick plastic, supported by a frame, with a light underneath the glass. They are available in art stores, but making one yourself is much cheaper. Here is a homemade design that works perfectly well. Even I, a carpentry-challenged person, found this easy to put together.

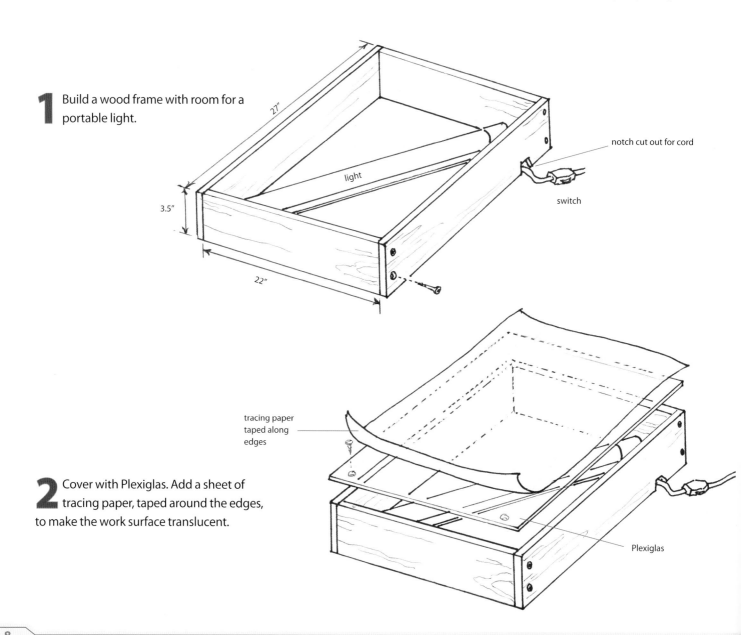

1 Build a wood frame with room for a portable light.

27"

light

notch cut out for cord

switch

3.5"

22"

2 Cover with Plexiglas. Add a sheet of tracing paper, taped around the edges, to make the work surface translucent.

tracing paper taped along edges

Plexiglas

Here are just a few of the ways in which a light box can be helpful.

RETRACING YOUR WORK TO MAKE ALTERNATE VERSIONS

COMBINING IMAGES FROM MORE THAN ONE DRAWING

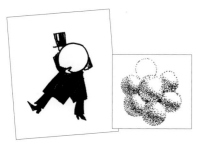
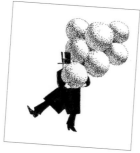

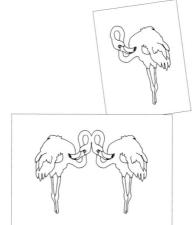
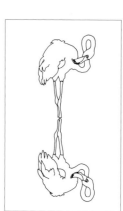

FLOPPING AND MIRROR IMAGING

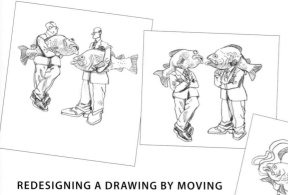

REDESIGNING A DRAWING BY MOVING AND ADJUSTING THE ELEMENTS

EXPERIMENTING WHILE PRESERVING THE ORIGINAL

Generating and transforming—the point where drawing and imagination first come face-to-face—are at the heart of this book. This conjunction encourages the use of your own drawings as source material for new and more imaginative drawings. The sketches you make in your sketchbooks become something more than ends in themselves. They become springboards for new possibilities. You may not see this right away. Often this happens months later, when you browse through your sketchbook. The most insignificant little doodle suddenly becomes the template for a series of imaginative transformations. It happens.

Doodling and Noodling

Generating and Transforming / Doodling / Noodling / Drawing With Letterforms / Inventing Icons / Mixing and Matching

Most of us doodle. While on the phone or in a meeting, we make squiggles or geometric shapes or sketchy images. The fact that we can do this while carrying on a conversation shows that doodles don't require much thinking. We move our pencils naturally and spontaneously, and we also don't worry a whole lot how our doodles look. This frame of mind—spontaneous, non-judgmental, relaxed—is what runners and tennis players call "being in the zone." This is *the ground state for creativity*. It is home for the creator.

In this chapter I introduce a two-step process that will help you unpack your natural creativity. I call it doodling and noodling or, more accurately, "doodling *and then* noodling."

Think of the doodle as the first stage—the generating stage. To doodle is to get something on paper, no matter how rough, incomplete or simple.

The second stage, which I call "noodling," is the transforming stage in which you tinker with your doodle. "Noodling" is an old illustrator's expression. If an illustrator was particularly good at precise and detailed work, he or she would be called a "noodler," as in "He can noodle like a madman," or "Don't noodle it to death." Noodling includes such operations as shading, silhouetting, reversing, repeating and many others. These operations refine, develop or radically change your original doodle.

By separating these two functions you discover that each involves different attitudes and different mechanics. You can actually feel a shift as you move from doodling to noodling. Doodling is pure play—often aimless and free. Noodling operations are more often rule-based, involving a set of discreet steps. The steps may be simple, but the results are often complex and surprising.

PRINCIPLES OF DOODLING

1. Suspend judgment. Doodling isn't art. It's just doodling.
2. Vary your doodles. If you're like most people, you tend to doodle the same thing over and over. Now it's time to expand your repertoire.
3. Practice. Every new skill is first learned consciously. Then, over time, the operations are passed to the subconscious as they become automatic. That's when you're actually doodling.
4. Doodle on old envelopes and scrap paper rather than "nice" paper. You'll feel freer and more willing to experiment.
5. Save your doodles in a large envelope. Now and then, go through them and pick out the most interesting or unusual ones. Put these in a second envelope. These may be source material for later work.

the two-step "doodling and noodling" process

THE TWO-STEP DOODLING AND NOODLING PROCESS

Swiss artist Paul Klee sometimes began a drawing by moving his pencil in a free, semi-random manner that he called "taking a line on a walk." Let's start with a simple example based on that idea.

1 DOODLING
You begin by letting your pencil go in any direction it wants—but taking care to end up where you started, so that the line encloses a shape. A doodle produced in this spontaneous way might look something like this.

2 NOODLING
Next, you "decorate" your original doodling in a deliberate and controlled manner. A doodle can be transformed in any number of ways by various noodling operations, such as the examples shown here and on the next page.

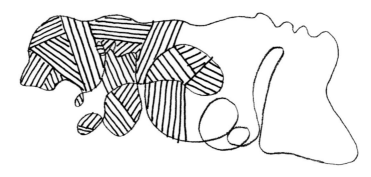

PATCHES
Straight, parallel, evenly spaced lines laid down at different angles

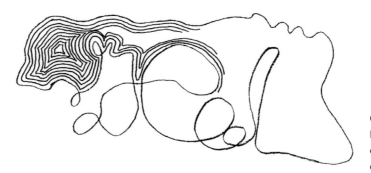

CONCENTRIC
Lines are parallel to the outer edge of the doodle, creating progressively smaller concentric shapes.

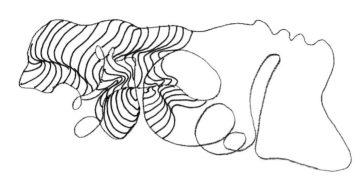

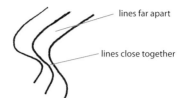

lines far apart

lines close together

UNDULATING
Semi-parallel lines are drawn widely spaced initially, in graceful curves; then they grow closer together as they turn sharply, creating a 3-D effect.

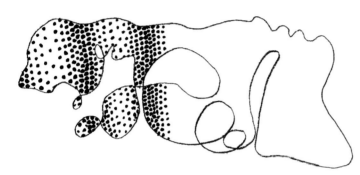

DOTS
Dots with variable spacing are laid out in rows or other patterns.

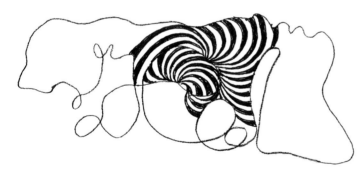

PINWHEEL
Stripes radiate from a point on the edge of each shape; alternate stripes are filled in.

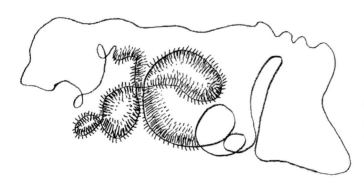

CACTUS
A prickly series of parallel short strokes and dashes grows along every line, both inside and out.

THE DIFFERENCE BETWEEN DOODLING AND NOODLING

The doodling stage is different from the noodling stage. Doodling is typically free, loose, spontaneous, vigorous and fragmentary. The noodling stage is often controlled, patient, mechanical, repetitive and complete. But these neat categories have a way of spilling into each other.

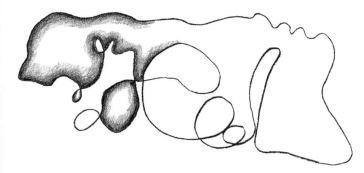

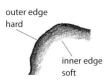

outer edge
hard

inner edge
soft

SHADED EDGE
The shape is shaded smoothly from dark to light with a soft black pencil.

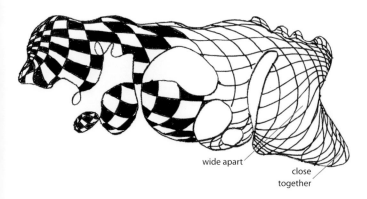

wide apart

close
together

STRETCHED CHECKERBOARD
Semiparallel lines (vertical and horizontal) curve in rows; alternate squares are filled in with black.

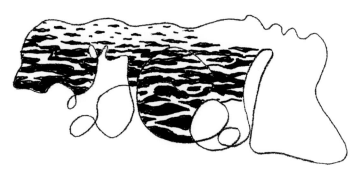

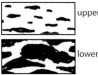

upper areas

lower areas

WATER
Irregular shapes, pointed at the ends, become smaller toward the top to create a sense of depth.

exercise 1

Take a Line on a Walk

Do six of these "line on a walk" doodles, making sure that your pencil winds up at the starting place. Then decorate each doodle with a different "noodling" operation. You can try your versions of the examples shown here, or you can invent your own algorithms —completely different from those shown here.

noodling to transform a doodle

NOODLING TO TRANSFORM A DOODLE

The word *transformation* implies a significant change, a caterpillar-into-a-butterfly kind of change. This is the sort of change to aspire to when noodling. The key here is recognizing the two-step process: You begin with a doodle (the original marks, squiggles, lines or motif), then come back and add the algorithms, procedures and happy accidents of noodling to transform the doodle into a more developed drawing.

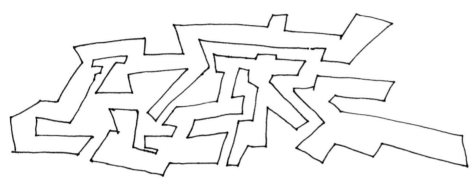

THE DOODLE
Let's call this original doodle—which is all straight lines and angular shapes—*Maze.*

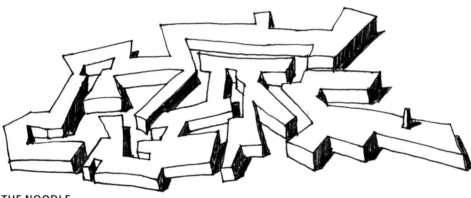

THE NOODLE
Give the shapes some thickness and fill in all the planes on one side to indicate shading. Also add some cast shadows. Now we have *Maze in the Shade.*

Doodling and noodling are separate functions—doodles are spontaneous and largely mindless, while noodles are deliberate and planned. When you begin doodling, it's not necessary to know how you're going to noodle it. In fact, it's better if you don't know.

CREATING THREE DIMENSIONS

Here's a sample nooding procedure that transforms two dimensions into three.

Start with a geometric shape.

Draw vertical lines at each corner . . .

Connect the vertical lines . . .

Fill in all the planes on one side . . .

. . . and add cast shadows.

ANOTHER DOODLE

Here's another example that I got from an artist friend. It's just a repeated spiral. I call it *Loopy*.

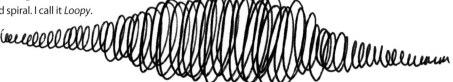

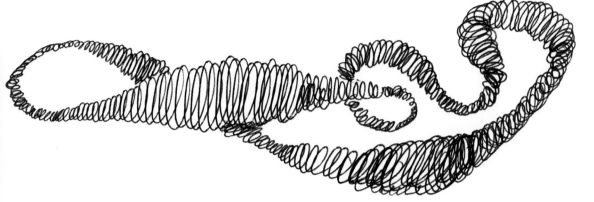

ANOTHER NOODLE

Let's noodle my friend's doodle by adding a few twists and turns to give us *Loopy, Twisted*. This drawing also incorporates a new noodle technique, *overlapping*. Overlapping makes some shapes appear to go behind others, which conveys a sense of depth.

TAKING THE NOODLE FURTHER

Noodling can lead to further noodling. The squiggly lines look a bit like the springs that support Jack-in-the-box faces, so I added these clown heads. Because the result looks a little sinister, I call this noodle *Loopy, Twisted and Weird*.

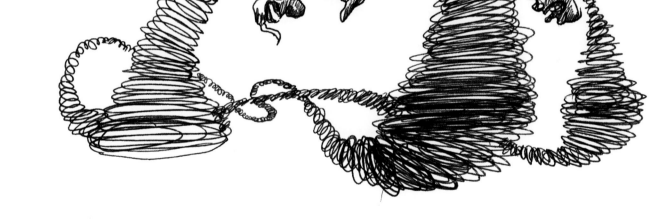

OVERLAPPING FOR DEPTH

When one shape goes behind another, or a shape circles around behind itself, it clearly places the shape in space.

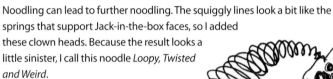

Shapes without overlapping tend to appear flat. Shapes with overlapping appear three-dimensional.

doodling ideas: geometrics and waves

DOODLING IDEAS: GEOMETRICS AND WAVES

Even though we've characterized doodles as "mindless," a doodle is often drawn in a sequence of simple steps. Sometimes these steps are so simple they're performed unconsciously. The doodles on this page require a bit of hand control, but after you've done one a few times, you'll be able to do it in your sleep. It's at this point that you're ready to move on to something different, some new variation.

There is a creative sequence here: (1) learn a new doodle, (2) practice it until it's easy, and (3) introduce your own variations. You'll notice that the doodles on these and subsequent pages are grouped in categories: geometrics, waves, tangles, shape clusters, building blocks, etc. Try the ones that appeal to you and even some that don't. Inspiration is often found in the untried and the unfamiliar, and sometimes in the uncomfortable.

Center lines are longer.

Outer lines are short and closer together.

SEEING THE PATTERN

This doodle, *Starburst*, is executed in a series of triangular patches radiating outward from the center. Each patch is made of straight lines, long in the center and gradually shorter and closer together at the ends. Like many algorithms, it's actually easier to do than it is to describe.

Geometrics

CONTINUOUS LINE
Without lifting your pencil, make a zigzagging line that attempts to maintain an even spacing between lines.

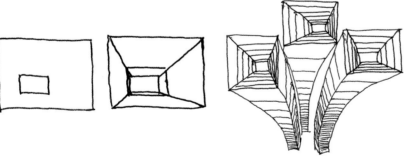

DUCTWORK
Make parallel lines that grow progessively closer together to suggest depth.

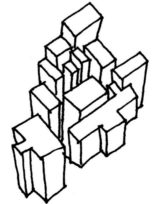

CITYSCAPE
Draw a cluster of closely packed rectangular shapes, then apply the three-dimensional thickness algorithm (see page 14).

Making Complexity Easy

The beauty of algorithms lies in the way they produce complex results by very simple means.

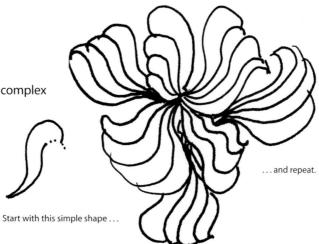

Start with this simple shape . . .

. . . and repeat.

CREATING THE ILLUSION OF COMPLEXITY

This doodle, *Floral*, looks as if it were all planned ahead of time, when in fact it was done by repeating a simple curve in clusters.

Waves

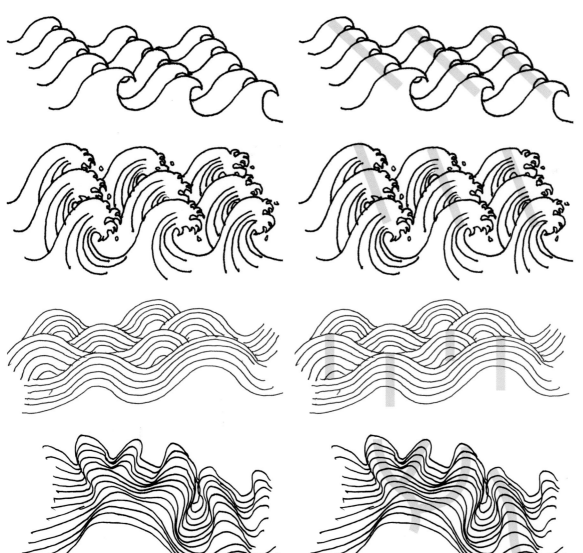

CURLING WAVES

Starting with the first row, strive for evenness and consistency—but not perfection. Note how the rows line up.

FOAMY WAVES

Try this variation on the doodle above, giving each wave this stylized treatment.

RHYTHMIC WAVES

Here make the rows irregular, and the troughs and crests staggered.

ROOTS

Semi-parallel lines widen across the top and converge along the sides. With practice, you can make the sections branch into smaller forms that grow in new directions.

doodling ideas: tangles and shape clusters

DOODLING IDEAS: TANGLES AND SHAPE CLUSTERS

Strings, ropes, spaghetti, worms and meandering roads all belong to a class of doodles I call "tangles." The algorithm for producing them involves drawing a small section, stopping, drawing an overlapping section, stopping, etc. The sections should twist and loop in various ways, but the real key is stopping often.

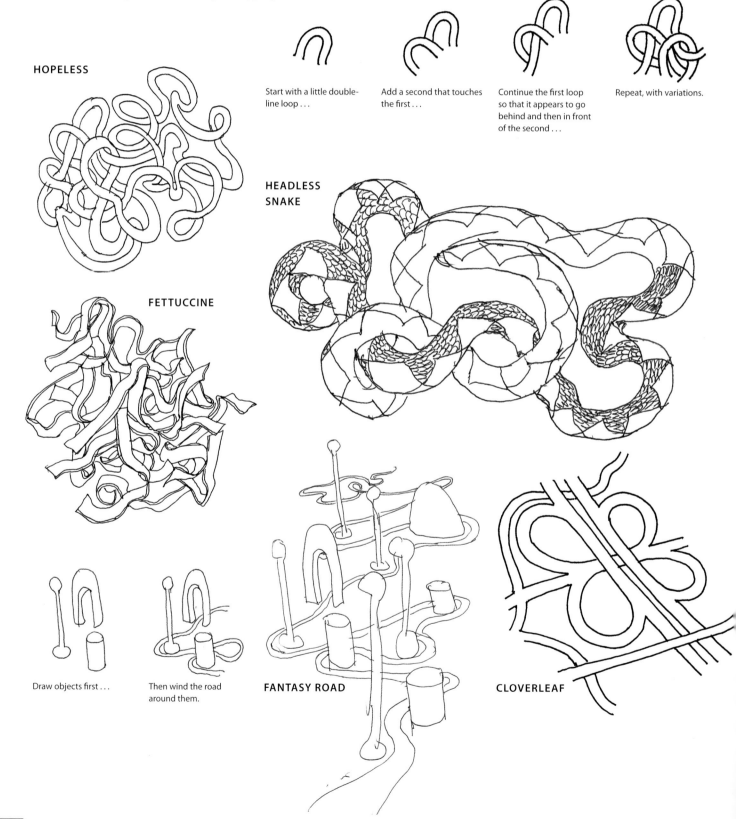

HOPELESS

Start with a little double-line loop . . .

Add a second that touches the first . . .

Continue the first loop so that it appears to go behind and then in front of the second . . .

Repeat, with variations.

HEADLESS SNAKE

FETTUCCINE

Draw objects first . . .

Then wind the road around them.

FANTASY ROAD

CLOVERLEAF

Shape Clusters

The idea behind "shape clusters" is keeping an even spacing between the shapes you draw. Begin with any kind of shape. Draw the next one as close as you can to the first, and so on. You should end up with a more or less uniform area between the shapes. Each shape you add is influenced by the shapes already there; this can mean you have to invent a shape to get a tight fit.

The fit you achieve is not exact, like pieces in a jigsaw puzzle, but more like chocolates in a box with dividers. Doodles like these help your sense of design—they make you aware of the overall pattern.

FLORAL

FLORAL, SHOWING UNIFORM BACKGROUND SPACING (IN GRAY)

MACHINERY AND STUFF

LIMBER PEOPLE

exercise ②

Doodling Algorithms

Pick one of these categories—geometrics, waves, tangles or shape clusters—and do a series of six to ten doodles using that algorithm. Make each one different from the others (if only slightly).

Now look at your doodles. Pick the one that seems the most different from the rest. What makes it different? Do a new doodle that emphasizes and exaggerates this difference.

19

doodling ideas: building blocks

DOODLING IDEAS: BUILDING BLOCKS

Building shapes out of strokes is both a very simple idea and a good one. It can be as easy as dot dot dot dot—and with a little directed luck, an image emerges. It's best to do these without much planning and just let the image appear.

 The type of nib you use will affect the look of your shapes. Markers make dots that are crude and funky. As the strokes (or dots) get smaller, the results get more subtle. Stippling can yield incredibly soft effects if you use a very fine nib. When you try this technique, practice gradation—change the strokes seamlessly from densely packed to widely dispersed.

Use a repeated stroke or shape and build it into an image.

MARKER DOTS
These two doodles were made with the nib of a thick, felt-tip marker.

STUBBLE
This was done with short dashes, like whiskers.

STIPPLE
These were built up with repeated pen marks. Spacing is close for the darks and wider apart for lighter areas.

Building With Recognizable Shapes

The building blocks on this page aren't just blocks; they're shapes in their own right: bricks, stones and strips. Fantastic, impossible-but-nearly-believable structures can emerge from this kind of doodle.

When you begin one of these, you may have a vague vision of your complete structure, but you don't need to sketch it all out ahead of time. Just keep adding bricks until you have something. This helps you appreciate a fundamental paradox about creativity: You don't always know what you're doing until you've done it. This is why we place so much emphasis on process.

Building Blocks

1. Make a page or two of building block doodles using each of these techniques: marker dots, stubble and stipple. Try at least some versions without a fixed plan. Just start making dots and see where they lead.

2. Do six to ten imaginary and improbable structures made of bricks, stones or curvy blocks. Again, let at least some of these just happen. Start at the bottom and build as if you were laying actual stones or bricks—but imaginatively.

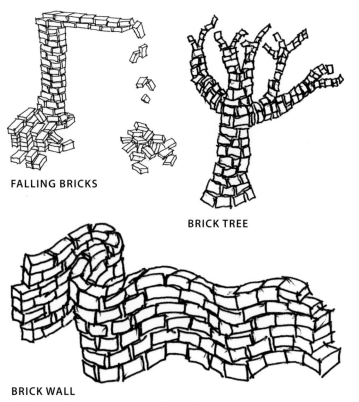

FALLING BRICKS

BRICK TREE

BRICK WALL
Bricks in straight rows are easy, but bricks flowing around curved surfaces take practice.

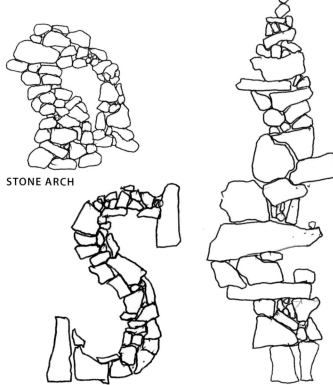

STONE ARCH

STONE "S"
A certain precariousness makes these structures more interesting.

STONE COLUMN

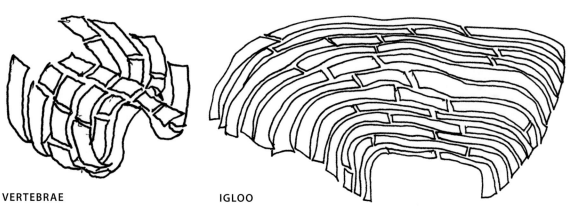

VERTEBRAE

IGLOO

These building blocks of different sizes that bend and curve create an organic, naturalistic feeling.

noodling ideas: silhouetting

NOODLING IDEAS: SILHOUETTING

Generally speaking, when you doodle, you're making a map. When you noodle, you're enriching and embellishing that map. The creative power of this combination will become apparent as you work with it.

Silhouetting is the most obvious example of this map-making. It's also the easiest algorithm: Simply fill in the shapes that you draw. The shapes can represent things, like ducks, spoons or keys, or they can be abstract shapes. I like to mix the two. I also like to gather them close together in shape clusters as if they were slightly separated puzzle pieces.

There are lots of ways of filling in your shapes, each with its own charm and character. Felt-tip markers or india ink will give you strong, solid blacks. Ballpoint or rollerball pen shows the patient buildup of strokes and the little white spaces between them.

Draw a shape.

Fill it in.

SILHOUETTE CLUSTER
The idea here is to keep a uniform distance between the shapes.

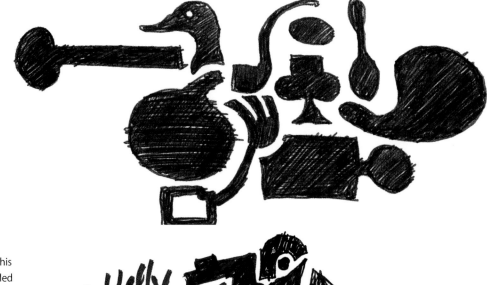

JIGSAW GATOR
Here's a variation on the shape-clustering idea. This started as some filled-in geometric shapes doodled around some phone messages. At some point it started to look a bit like an alligator, so I added the tail, feet and snout.

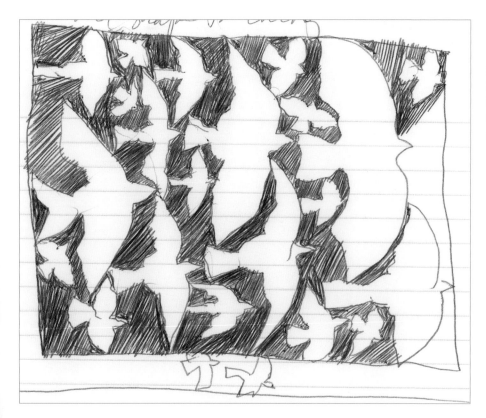

MIGRATION
Reversing the black/white pattern can also be interesting. This bird doodle was drawn with all shapes touching. When I filled in the background, the birds became slightly separated.

B-BALL

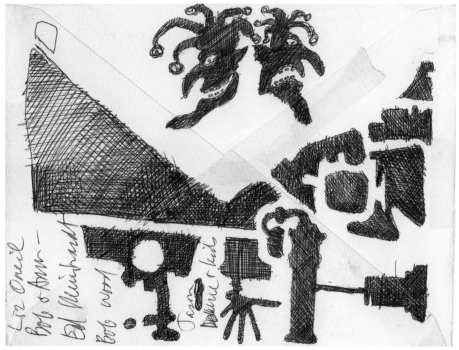

**JESTERS AND STRANGE OBJECTS
ON THE BACK OF AN ENVELOPE**
In this doodle, I used a ballpoint pen and coarse crosshatch to give a hint of gray tones. I also like the ragged edge where the strokes go past the line.

exercise 4

Silhouetting

1. Do a few shape-cluster doodles, then fill in the shapes with solid black.
2. Do a shape-cluster doodle. Make all of the shapes touch in at least one place. Put a border around the doodle and fill in all the background shapes with solid black.

noodling ideas: shading

NOODLING IDEAS: SHADING

Nothing imparts a sense of three-dimensionality to a drawing like light and shadow. And after some practice, it's very easy to do. Simply imagine a light source, and logic will tell you where to put the shadows.

An object will have a light side and a shadow side. It will also cast a shadow where the light is blocked. The cast shadow is usually darker than the shadow side. The lower the light source, the longer the cast shadow. It helps to place objects—particularly cubes, cylinders and spheres—under a strong light and observe how the light and shadow falls.

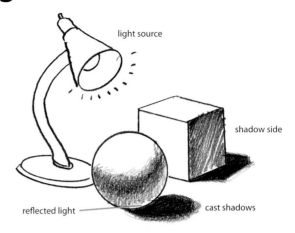

light source

shadow side

reflected light

cast shadows

3-D CLOVERLEAF WITH SHADING

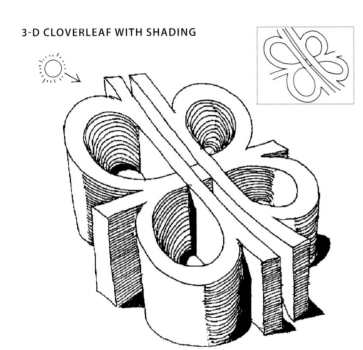

ROCK COLUMN AT NOON
Top lighting (light from directly above) leaves a thin ridge of light along the upper edge of each stone. Because the stones are rounded, the shadow edges are somewhat soft.

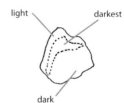

light

darkest

dark

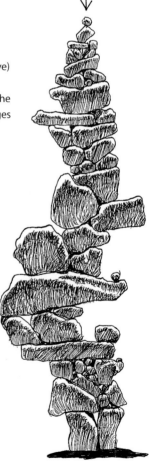

SUNLIT GRAPES
Compare these two drawings of grapes. Notice the definite light and shadow pattern on the drawing with the clear light source, and see the way the shadow curves on the spherical surfaces. It has much more depth and realism than the other drawing.

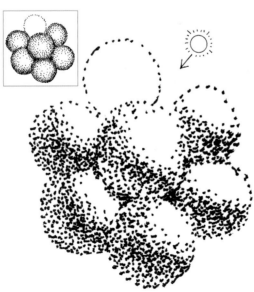

Creating Three Dimensions

These rules, once understood, allow you to draw convincing three-dimensional objects with ease. Each of the examples below is accompanied by a little sun and arrow to make the direction of the light clear. You might try in your own drawings to pencil in a similar directional arrow. Once you've established this, you'll know just where to put the shadows.

When filling in the shadow side, make the greatest contrast between dark and light just where the form turns. Also notice how the shadow edge is soft on rounded objects and sharp on objects with an edge.

Shading

Copy or trace the six doodles you made for Exercise 3 on page 21. Add light and shade to them, as well as cast shadows. Be sure to imagine the direction of your light source or indicate it with an arrow.

Make your cast shadows blacker than your form shadows. On rounded forms, soften the shadow edge (where light meets dark).

SOFTLY SHADED TANGLE

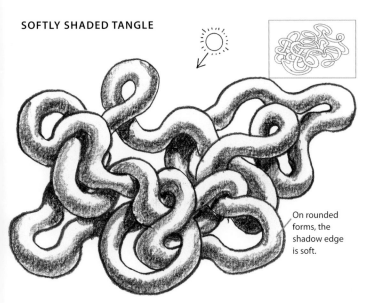

On rounded forms, the shadow edge is soft.

ARCH, EARLY MORNING

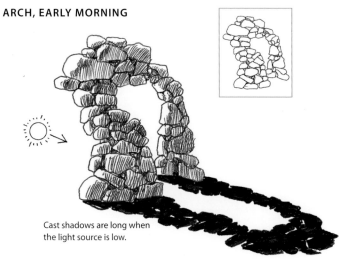

Cast shadows are long when the light source is low.

"ET," SHADED

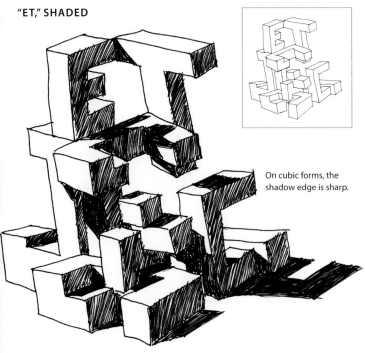

On cubic forms, the shadow edge is sharp.

SHADY GATOR

Sometimes you can give the cast shadow a personality of its own.

noodling ideas: multiplying

NOODLING IDEAS: MULTIPLYING

A surprising range of creative possibilities opens up when you make multiple copies of an image. I don't mean simply repeating the exact same image over and over, but repetition with variation. Repetition gives an overall pattern, while variation provides individualistic detail. The natural tension between these two opposites will frequently produce satisfying results.

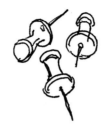

Draw the same object from different angles, in different positions or in different sizes.

PUSHPINS

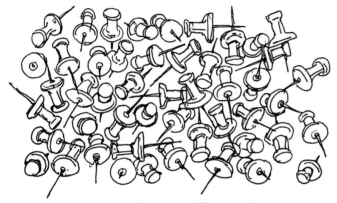

In this example, I drew the pin from many different angles.

SHADED PUSHPINS

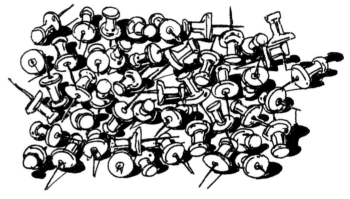

In this more dramatic version, I added some strong black shadows.

SUSPICION

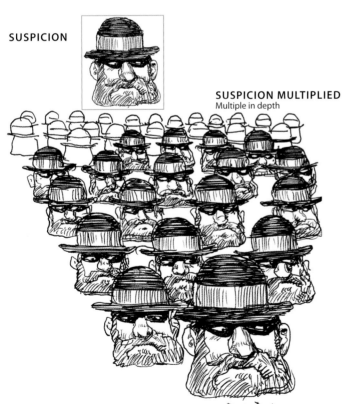

SUSPICION MULTIPLIED
Multiple in depth

This image started as a simple character. Because I like doing objects receding in space, I began adding rows, each progressively smaller. Diminishing the size of an object as it gets farther back in space creates the illusion of depth.

TOOTHBRUSH AND TOOTHPASTE

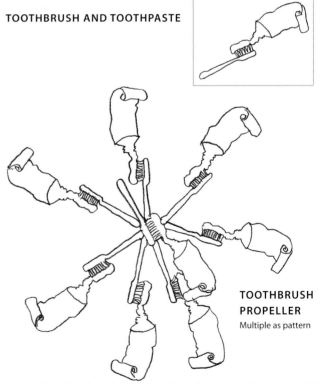

TOOTHBRUSH PROPELLER
Multiple as pattern

I slipped this doodle under another sheet of paper, and then retraced it multiple times in a pinwheel design. Placing the object in a symmetrical arrangement invites the viewer to see the doodle as an overall pattern.

reversing, inverting and mirror imaging

REVERSING, INVERTING AND MIRROR IMAGING

This algorithm is about opposites. If something is white, make it black. If it's right side up, make it upside down—or backward. I know artists who look upside down at their subjects or hold a mirror up to their work to get a fresh view. Creativity begins when we can look at something familiar in an entirely new way.

All of the examples here required retracing the doodle on a light table—in some cases, multiple times. The drawing *Ductwork Multiplied* involved tracing the original five times, including flopped and upside down.

Multiplying

1. Trace multiple copies of a previous doodle, arranging them into a radial or otherwise symmetrical pattern.
2. Do a mirror-image drawing, placing one image right side up and the other, its duplicate, upside down. The two images should touch in the middle.

TREE AND REFLECTION

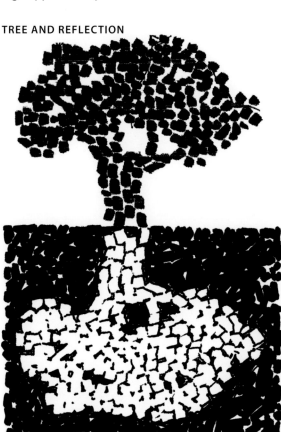

1 START WITH A CHARACTER

Draw a little character.

2 TRACE, FLIP AND TRACE AGAIN

Trace it on a light table, then flip it over and retrace it facing the other way.

3 REPEAT AND FILL IN THE BACKGROUND

Turn the pair upside down and trace it again, then place them inside a circle and fill in the background.

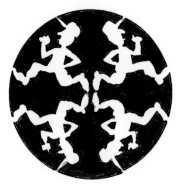

As well as looking completely different from each other, these black-and-white trees were drawn in very different ways. The black tree was traced in bold marker strokes, while the upside-down tree was traced with a fine-tipped marker. I then carefully filled in each of the little black shapes between the leaves.

DUCTWORK MULTIPLIED

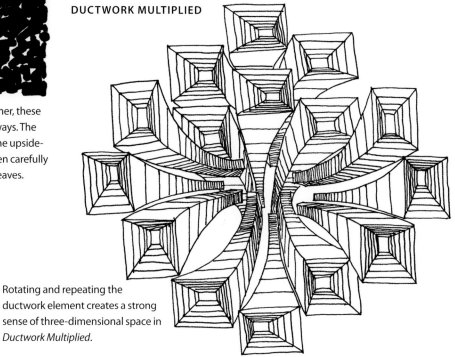

Rotating and repeating the ductwork element creates a strong sense of three-dimensional space in *Ductwork Multiplied*.

inventing iconic characters

INVENTING ICONIC CHARACTERS

Doodlers often invent little characters to inhabit their work. I call these characters "iconic" because they're usually simple, stylized and easy to draw. For those of you who feel inhibited about drawing figures from imagination, doodling is the perfect place to challenge that fear. After all, the idea is not accuracy, but simplicity and expressive charm.

Adding a character to a doodled landscape immediately suggests a story of some sort. Repeating one over and over allows you to doodle crowd scenes, parades and dances. Once you're able to represent a figure with a few lines, you can branch out—change the action, viewpoint, anything you'd like your characters to do.

A CREATIVE SEQUENCE FOR CHARACTERS

1. Develop a shorthand way of doodling a figure.
2. Practice drawing that figure in action until you can do it easily.
3. Move on to another way of representing the figure.

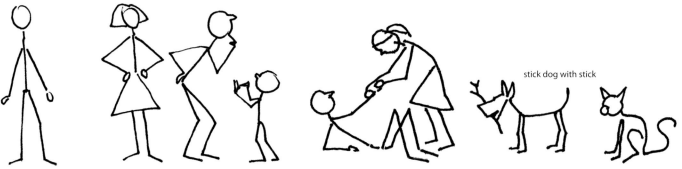

stick dog with stick

THE MUCH-MALIGNED STICK FIGURE
If you're new to drawing and have never drawn a figure in your life, you can always start with stick figures. However, even with simple figures like these, strive for action and variety.

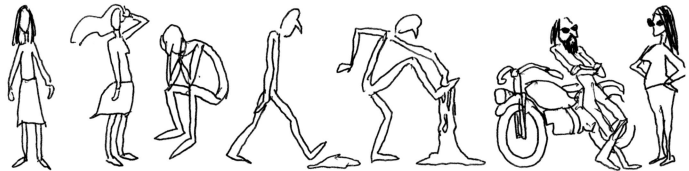

THE MODIFIED STICK FIGURE
Giving the body a little dimension allows more flexibility. These "rubber band people" have a more naturalistic look than stick figures do.

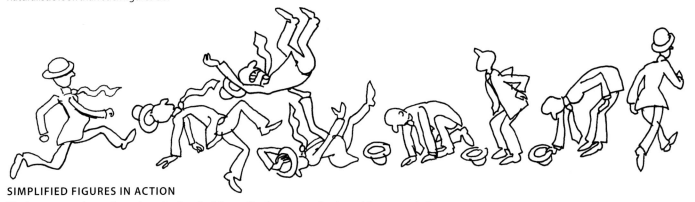

SIMPLIFIED FIGURES IN ACTION
The best way to show a figure in action is to feel that action in your own body, and then execute it with exaggeration.

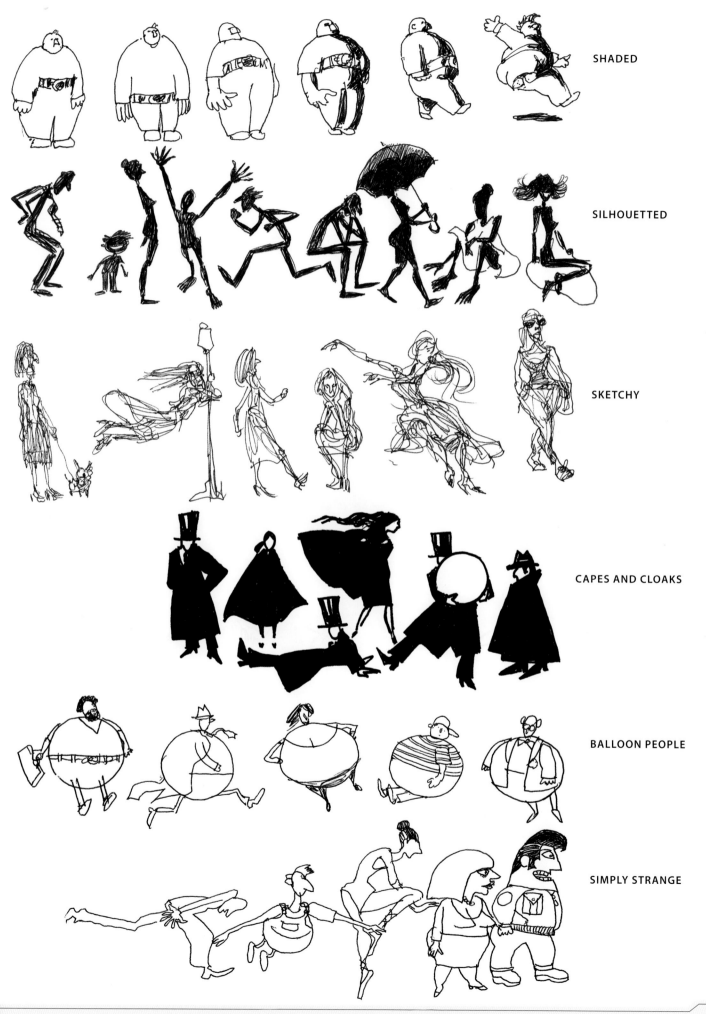

SHADED

SILHOUETTED

SKETCHY

CAPES AND CLOAKS

BALLOON PEOPLE

SIMPLY STRANGE

letterforms

LETTERFORMS

Many of us regularly write notes and phone numbers on whatever envelopes or scraps of paper happen to be around. Once they've served their purpose, I enjoy decorating these letters and numbers, often beyond recognition. There are almost countless ways of playing with the letters and shapes of old notes.

LOOPY LETTERS
Try drawing connecting lines between some letters so that they enclose spaces. Then fill in all of the enclosed shapes.

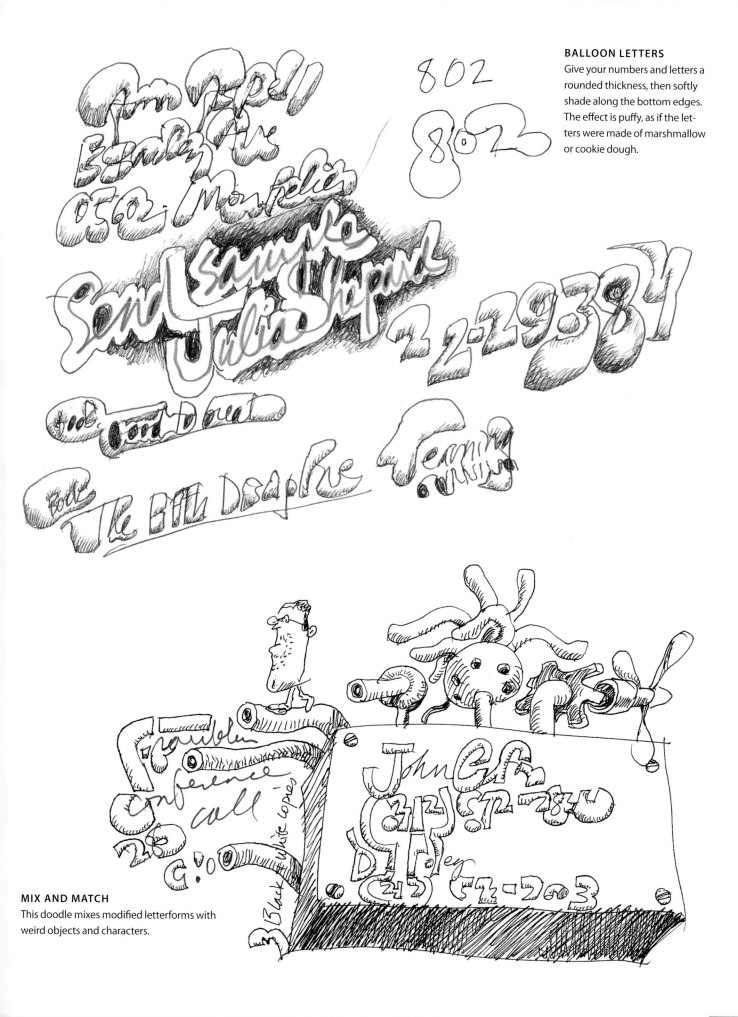

BALLOON LETTERS
Give your numbers and letters a rounded thickness, then softly shade along the bottom edges. The effect is puffy, as if the letters were made of marshmallow or cookie dough.

MIX AND MATCH
This doodle mixes modified letterforms with weird objects and characters.

noodling ideas: mixing and matching

NOODLING IDEAS: MIXING AND MATCHING

Creating is, in part, about finding relationships between seemingly unrelated things. It's about putting things together that don't seem to belong with each other—at least not until you do it. The more unexpected and improbable the pairing, the bigger the creative leap.

We will discuss this idea at length in later chapters, but for now, let's begin by simply taking an iconic character and combining it with another doodle. For example, we might first trace the character on the light table, and then trace another doodle around it as a background. That was the method I used with *Flowerdancer*.

Sometimes you'll want to integrate the two images in a more intricate way. Notice how in *Lost at Sea* the waves are both behind and in front of the floating people. To do this sort of thing you need to align both original doodles on your light table with a fresh sheet of paper on top. Even then it may take several tries to get it the way you want it.

In the course of combining images, you may see a need to alter them. In *Stone Arch and Archie* I was simply going to place the man's face partly behind the arch. As I drew, it occurred to me to make the face out of stone as well.

FLOWERDANCER

STONE ARCH AND ARCHIE

MOLECULE MAN

LOST AT SEA

LACOÖN

TRANSITION

PRISONERS OF LOVE

SOCIAL CLIMBERS

exercise 7

Combining

Pick any two of your doodles and trace or redraw to combine them. The new image may be a simple figure-on-background like *Flower-dancer* on page 32, or a more complicated intertwined image, like most of these other examples. You could also devise an altogether different way to put your doodles together.

add-on doodles

ADD-ON DOODLES

For two or three years I used this sheet of heavy brown paper to protect my taboret. As it accumulated ink spills, coffee stains and telephone numbers, I also used it as a doodling pad. Layers of marker, pencil, colored pencil and ballpoint pen lines built up over time. Occasionally I would rotate the paper to find room for a new doodle. After about a year of this I began to get artsy, touching up some doodles and obscuring others. I started using white paint to highlight some of the images. (Some images, like the flying crow on the far left, were simply attempts to cover up india ink spills.)

I call work like this "add-on doodling." Parts are done at different times, some on top of each other. There's no planning, no central theme. The work becomes a kind of tapestry. Its variety derives from the simple fact that it's much easier to think of one image a day for a hundred days than to think of a hundred images in one day.

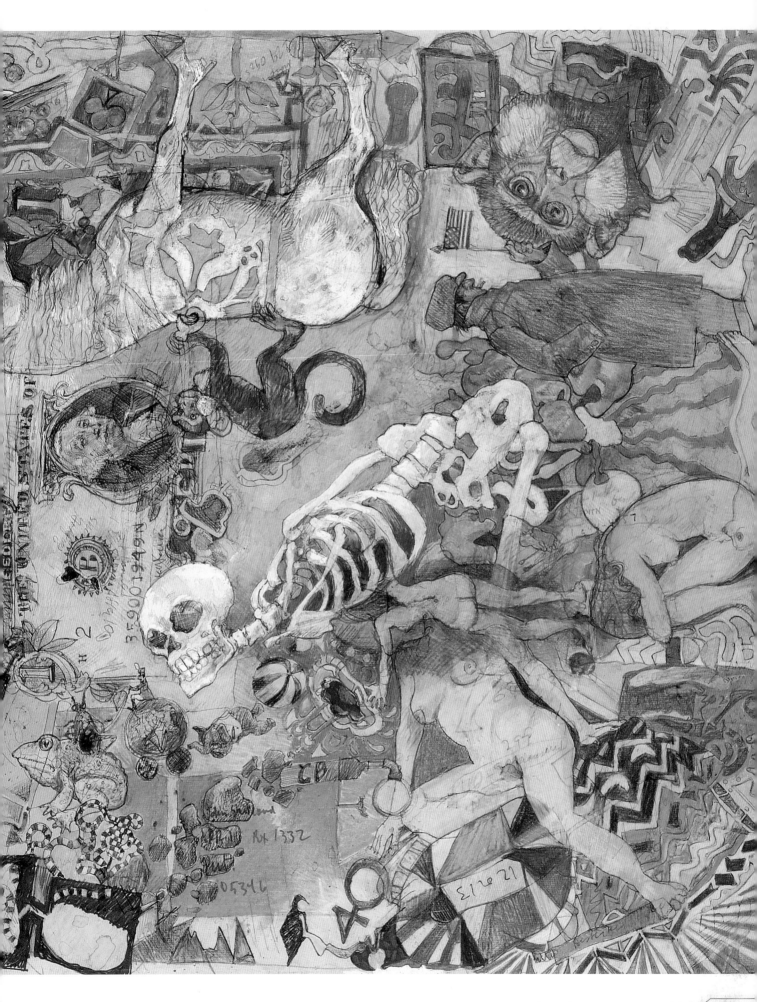

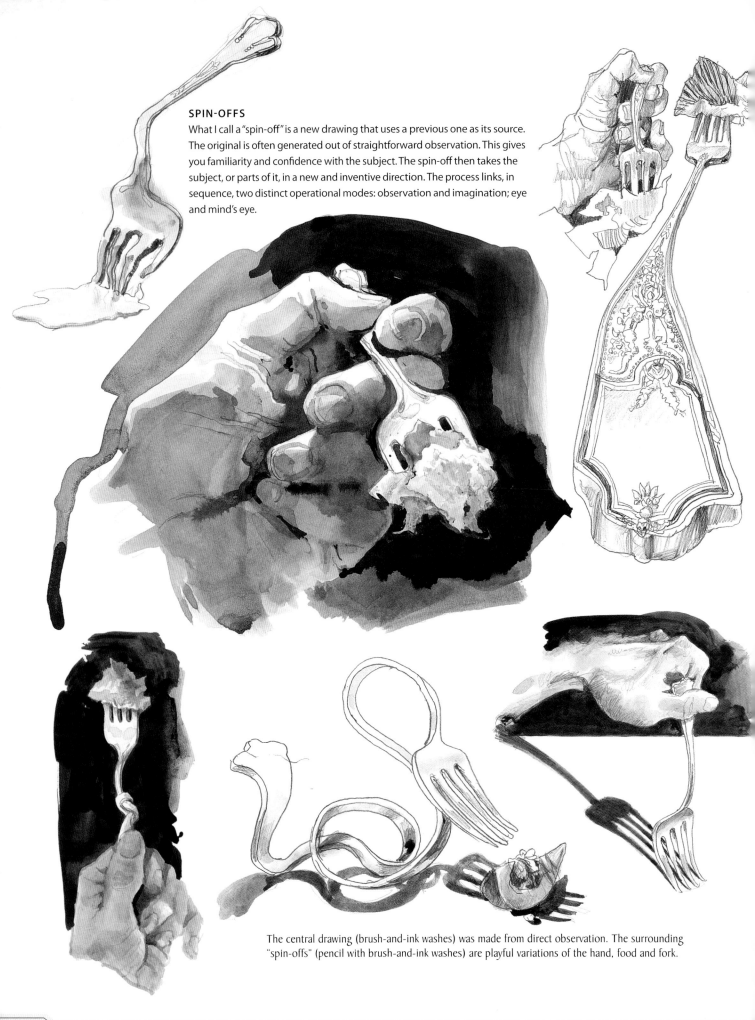

SPIN-OFFS

What I call a "spin-off" is a new drawing that uses a previous one as its source. The original is often generated out of straightforward observation. This gives you familiarity and confidence with the subject. The spin-off then takes the subject, or parts of it, in a new and inventive direction. The process links, in sequence, two distinct operational modes: observation and imagination; eye and mind's eye.

The central drawing (brush-and-ink washes) was made from direct observation. The surrounding "spin-offs" (pencil with brush-and-ink washes) are playful variations of the hand, food and fork.

Drawing a
New Reality

2

Imagination is tightly linked to observation—a familiarity with how something *actually* looks makes it possible to imagine how it *could* look. While it is the goal of this book to help you with drawing the world as seen through imagination, there is no better way to develop the imaginative muscles than drawing from direct observation. Every time you draw from life, you strengthen the connection between your eye and your hand. These connections can be powerfully adapted to drawing the images you see in the mind's eye.

How do you make drawings that are memorable, compelling, unusual, intense, from a reality that often seems to have none of these qualities? Our habits of seeing are necessarily lazy. As a practical matter, we simply haven't time to notice every strange play of light, every unusual juxtaposition or distorted reflection that crosses our visual field. Almost daily, clouds resembling rhinos and tubas pass overhead, but we are simply too busy to notice. These visual oddities get pushed to the periphery while our attention is directed to practical necessities: the traffic that surrounds us, the stair step in front of us, the food on our fork, the information on our computer screen. In this common habit of viewing the world, we don't really see—we use our eyes to confirm our expectations. We might call this *utilitarian seeing*, and we owe an ancient debt of gratitude for it—it was vital to the survival of our species and keeps us from wandering into traffic today. But it's not so good for making art.

When we get out our sketchbooks, it's time to set aside this way of looking at things. As artists, we want look at objects, even familiar objects, as if we had never seen them before. Everything is new. See the object before you not as confirmation of what you already know, but with innocent curiosity. That forkful of food coming toward your mouth has a shape. What is that shape? When you hold it in position and draw it, all of its textures, shadows and reflections come into being. The food, the fork, the hand—these everyday items have a new vividness, a new intensity. From here it's a short step to a fanciful sketch of the fork melting and the food floating off.

HYPER-LITERAL SEEING

Innocent seeing requires that we be hyper-literal about shapes. Everything has a shape, but we must never assume in advance that we already know what it is. Each shape is unique in a particular light and from a particular angle. When we look at things as shapes, every shape is new.

it starts with shape

IT STARTS WITH SHAPE

Shape (along with line) is a common language used by both the eye and the hand. Beauty, interest, vivaciousness and the like can all be observed by the eye, but they do not automatically translate into something the hand can do. Shape is different. To see a shape is to be able to draw it, so the surest way to success-fully draw the things you see is to learn to break them down into shapes—the overall silhouette shape, the major subordinate shapes and the detailed enrichment shapes.

For most people, even beginners, the overall shape of an object or person is pretty easy to see. But the major subordinate shapes, particularly of complex subjects, is sometimes difficult to discern.

OBSERVING AND DRAWING A PAPER BAG

Drawing a commonplace object, such as a paper bag, requires that you look at it as if you've never seen one before. This is best done by looking at the shapes and then drawing them as if they were territories on a map.

The photos below illustrate how this works.

1. Look at the overall shape.
2. Draw it lightly.
3. Next, notice the major shadow shape.
4. Draw the major shadow shape as a definite shape, even though some of its edges may be indistinct.
5. Observe the darkest shapes.
6. Again, draw these as definite shapes.

You can see this better when you squint at your subject. Squinting simplifies and unifies, merging all the insignificant details into a single shape. Seeing the major shapes in this way preserves the pattern of your drawing—even as you add all the little bends and creases that make the texture convincing.

1 Overall silhouette

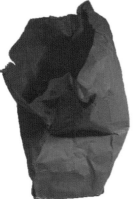

2 Drawing of overall shape

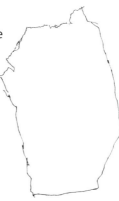

3 Major subor-dinate shape (shadow area)

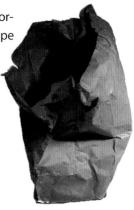

4 Drawing of major subor-dinate shape

5 Other subor-dinate shapes (darkest darks)

6 Drawing of other subor-dinate shapes

Hard and Soft Edges

A hard edge is crisp and sharp, while a soft edge gradually fades out. Clearly distinguishing between these two will give your shapes an authentic realism. Notice how many of the crumpled shapes in this bag have hard edges on one side and soft on the other.

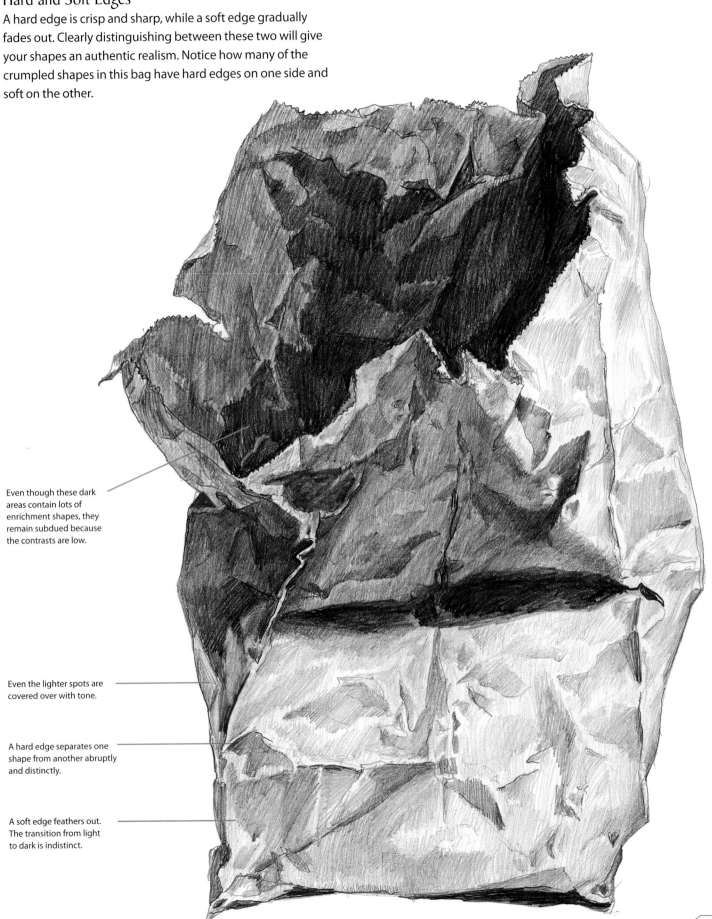

Even though these dark areas contain lots of enrichment shapes, they remain subdued because the contrasts are low.

Even the lighter spots are covered over with tone.

A hard edge separates one shape from another abruptly and distinctly.

A soft edge feathers out. The transition from light to dark is indistinct.

add-on drawings

ADD-ON DRAWINGS

A drawing is different from a snapshot: Because it takes place over time, your drawing is really a time-lapse image of your subject. Add-on drawings allow the artist to build a drawing in separate stages over an extended period of time.

Sometimes you have only a narrow window of time in which to draw, so you create a fragment—an incomplete drawing that you leave for another day. When you go back to it, it might be months later. You might be in a new location, perhaps even looking at an entirely different subject. You simply add new elements to the white spaces of your earlier fragment. In this way you build the drawing in stages, adding on parts at different times.

Add-on drawings generate countless ideas. They open possibilities for imaginative work because of the time separation between the drawing stages. Your state of mind when you return to a drawing can be quite different than it was when you started it. This mix of mind-states can lead to interesting new combinations of images. It enhances fresh seeing, along with radical shifts in intentionality.

Drawing a Crowd

1 START WITH ONE
Draw one person.

2 QUICKLY ADD MORE
Add people as they move in and out of your scene. (Sketch quickly.)

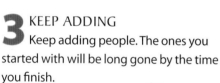

3 KEEP ADDING
Keep adding people. The ones you started with will be long gone by the time you finish.

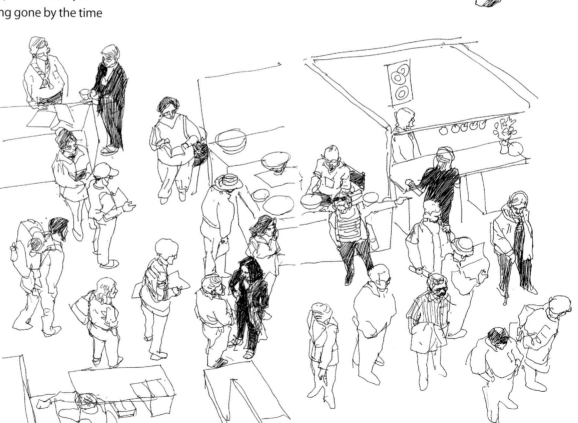

Drawing Plumbing

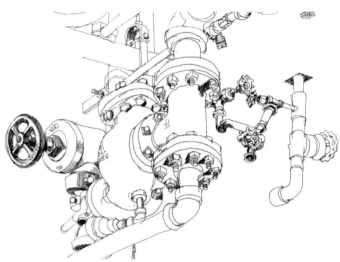

A year after the first drawing, I added more pipes and valves, this time from a building in Vermont.

I like to draw pipes and plumbing fixtures. It's good training for drawing ellipses and parallel lines in perspective. And it's a natural subject for adding on, since so much actual plumbing is done that way. I drew this in a building in Seattle.

Some time later, I completed this drawing with additions from yet another building.

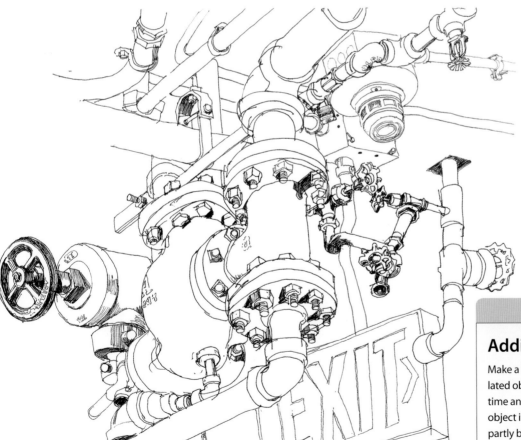

exercise 8

Adding On

Make a line drawing of three or more unrelated objects, each drawn at a different time and in a different place. Place the first object in the foreground and the others partly behind (i.e., overlapped by) the first. Don't worry about keeping the objects in scale, but draw them accurately. Work in the medium of your choice and allow at least ten minutes per object.

crumpled, dented, crushed

CRUMPLED, DENTED, CRUSHED

Georges Clemenceau, the President of France during World War I, was once standing motionless on a hill overlooking the great city of Istanbul. After a long silence, one of his aides asked, "What are you thinking, Mr. President?" He replied solemnly, "I was thinking what beautiful ruins this place would make."

Indeed, there is something aesthetically pleasing about the partially destroyed—especially for a draftsman. Junkyards, weathered barns, broken dolls and ripped billboards all suggest the ravages of time and hard use. Things become more abstract (and often more interesting) as they deteriorate, offering the artist rich opportunities for line, tone and texture and a great opportunty for mastering shapes.

Crumpled paper, put under a strong light, reveals dozens of small planes and edges. You can capture these in a drawing by carefully observing the shapes: first the overall shape of the paper, then the shapes of the creases and facets. Squint often to distinguish the strong from the subtle.

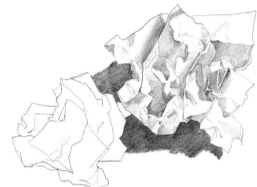

MAPPING YOUR SUBJECT
Mapping the major shapes of your subject is a key first step in drawing complex damaged objects. This makes filling in the unusual planes and shadows a manageable problem.

DENTED METAL
Drawing shiny, reflective objects like these crushed cans requires a patient rendering of shapes, as well as a clear distinction between hard and soft edges.

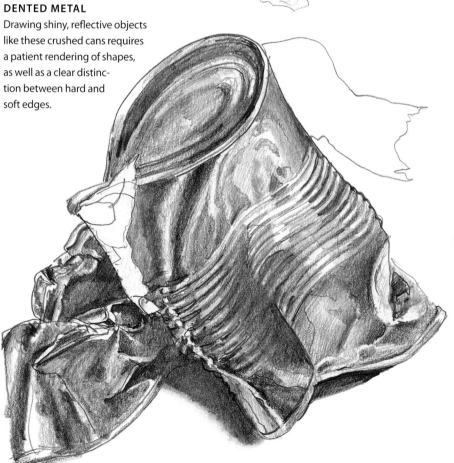

DRAWING A SPIN-OFF
After making a few crushed-metal drawings, you get a feel for the kinds of shapes and edges involved. This familiarity allows you to invent your own forms, as I did in this drawing.

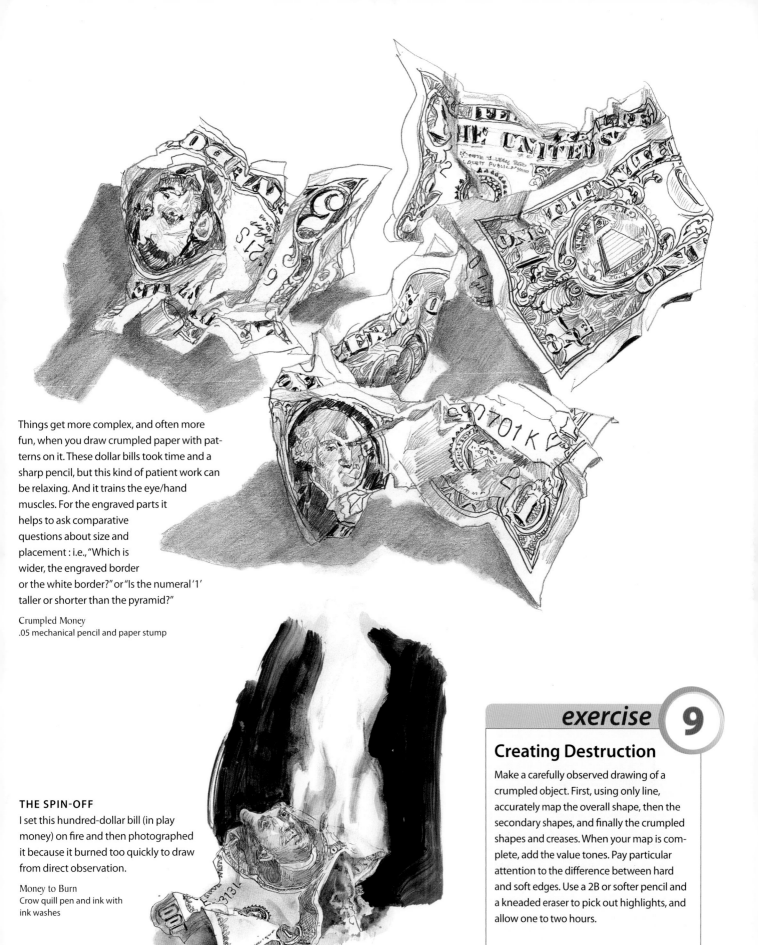

Things get more complex, and often more fun, when you draw crumpled paper with patterns on it. These dollar bills took time and a sharp pencil, but this kind of patient work can be relaxing. And it trains the eye/hand muscles. For the engraved parts it helps to ask comparative questions about size and placement : i.e., "Which is wider, the engraved border or the white border?" or "Is the numeral '1' taller or shorter than the pyramid?"

Crumpled Money
.05 mechanical pencil and paper stump

THE SPIN-OFF
I set this hundred-dollar bill (in play money) on fire and then photographed it because it burned too quickly to draw from direct observation.

Money to Burn
Crow quill pen and ink with ink washes

exercise ⑨

Creating Destruction

Make a carefully observed drawing of a crumpled object. First, using only line, accurately map the overall shape, then the secondary shapes, and finally the crumpled shapes and creases. When your map is complete, add the value tones. Pay particular attention to the difference between hard and soft edges. Use a 2B or softer pencil and a kneaded eraser to pick out highlights, and allow one to two hours.

melted and deformed

MELTED AND DEFORMED

Over the years I have collected many photographs of people in crowds—marches, demonstrations and riots, as well as artists' depictions of historical battles. It's so interesting to see how the mood of a crowd shows up in its overall shape; how the individual parts, angular, jagged, energetic and clashing, can combine to create a whole with similar characteristics.

I bought a bag of plastic American Civil War soldiers and melted and fused them together to form a single writhing mass. I used an old saucepan and pair of tongs to partially melt and then fuse the hot pieces together. I then tried drawing this tangled glob under different lighting conditions.

Projects like this highlight the value of mapping. It shifts your attention to the abstract pattern rather than the individual faces, arms and weapons.

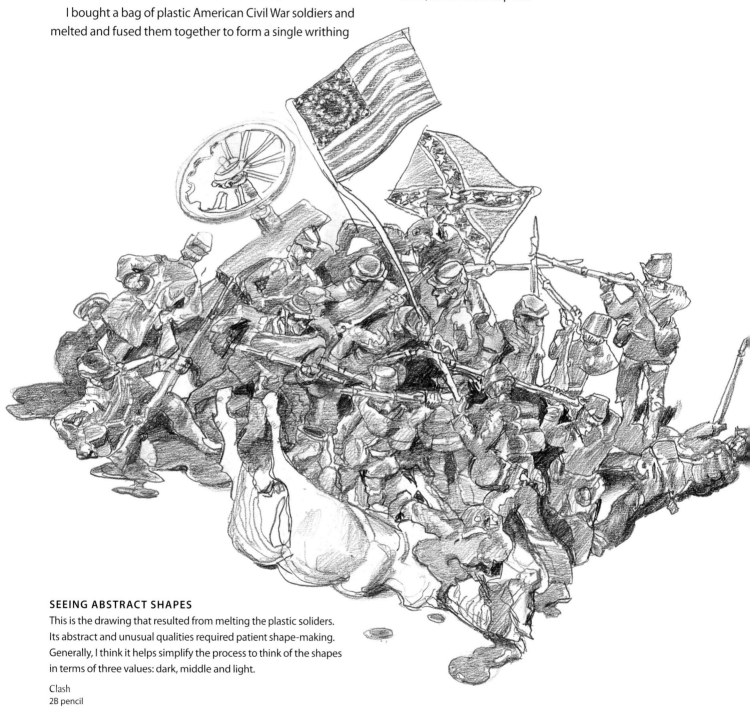

SEEING ABSTRACT SHAPES
This is the drawing that resulted from melting the plastic soliders. Its abstract and unusual qualities required patient shape-making. Generally, I think it helps simplify the process to think of the shapes in terms of three values: dark, middle and light.

Clash
2B pencil

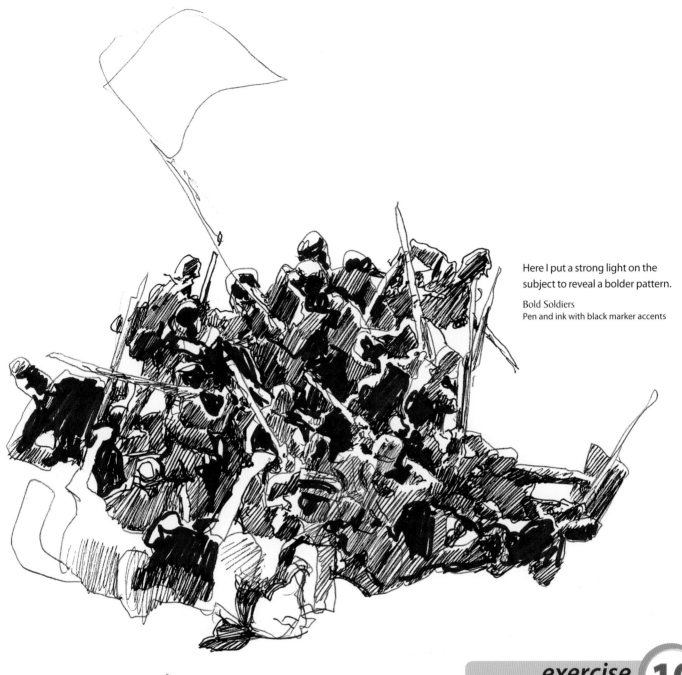

Here I put a strong light on the subject to reveal a bolder pattern.

Bold Soldiers
Pen and ink with black marker accents

The melted rifles add
an almost comic touch.

Straight Shooters
Ballpoint pen

exercise 10

Drawing
Melted Plastic

Heat and soften several plastic objects (such as soldiers, toy cars or plastic utensils) and fuse them together. Make a tonal drawing of the aggregate, paying particular attention to the overall shape of the mass. Notice the small, trapped shapes (negative spaces) and draw them accurately. Put a direct light on your subject to create strong light and shadow shapes. Use a 2B pencil and allow one to two hours.

macro drawing

MACRO DRAWING

Enlarging an object transforms it. It reveals a level of structure and detail that is otherwise invisible to us. Macro drawing involves carefully rendering something as you look at it through a magnifying glass. This requires good lighting and careful, patient work. I've also found that the mechanics of holding the glass and drawing sometimes requires a fair amount of erasing, which is why I usually use a smooth-finish plate paper for this type of drawing. Such paper takes erasure well and allows for more fine detail. Take your time with a drawing like this—even if it means completing it over several sessions.

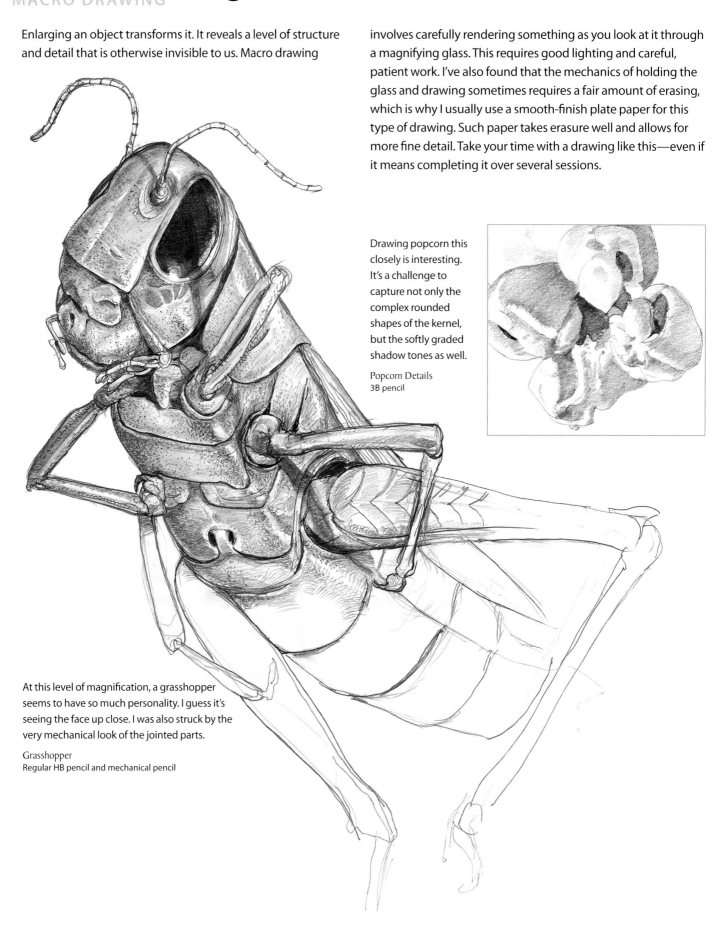

Drawing popcorn this closely is interesting. It's a challenge to capture not only the complex rounded shapes of the kernel, but the softly graded shadow tones as well.

Popcorn Details
3B pencil

At this level of magnification, a grasshopper seems to have so much personality. I guess it's seeing the face up close. I was also struck by the very mechanical look of the jointed parts.

Grasshopper
Regular HB pencil and mechanical pencil

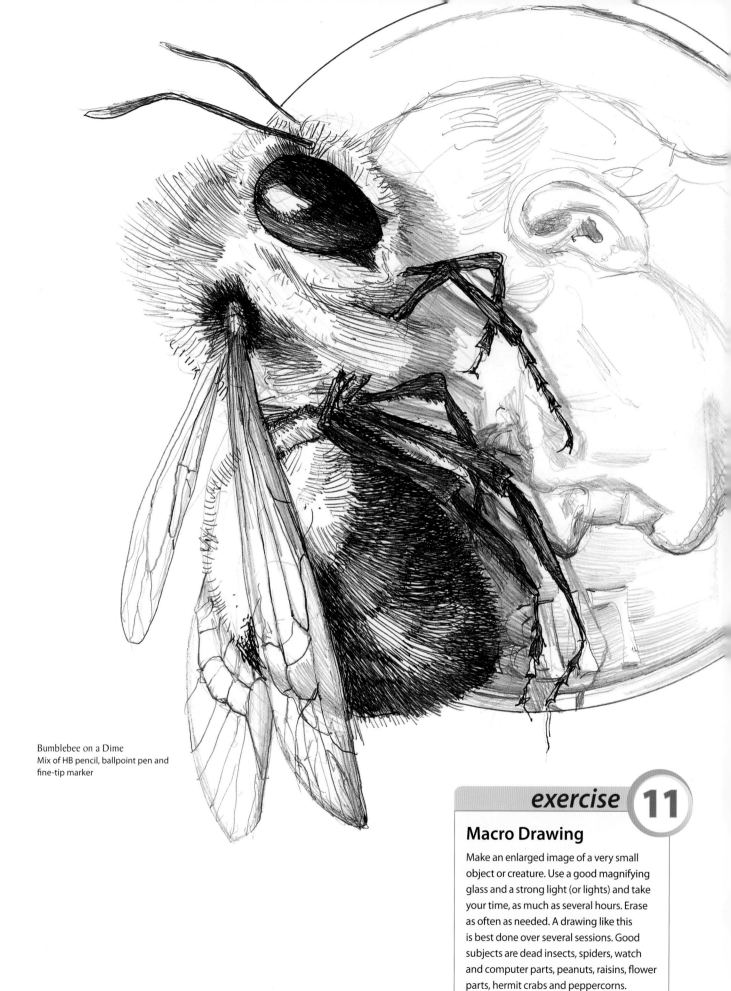

Bumblebee on a Dime
Mix of HB pencil, ballpoint pen and
fine-tip marker

Macro Drawing

Make an enlarged image of a very small
object or creature. Use a good magnifying
glass and a strong light (or lights) and take
your time, as much as several hours. Erase
as often as needed. A drawing like this
is best done over several sessions. Good
subjects are dead insects, spiders, watch
and computer parts, peanuts, raisins, flower
parts, hermit crabs and peppercorns.

distorted reflections

DISTORTED REFLECTIONS

All drawing is distorted. The eye/mind/hand process invariably and unconsciously emphasizes some things at the expense of others. Rather than correct such distortions, we, as imaginative artists, should find ways of emphasizing them.

Here's a good way to start: Draw your own reflection in a fun-house mirror. If you can't get a fun-house mirror, a sheet of flexible, mirrored Mylar (available at many art stores) will do. The drawings on these pages were made by bending Mylar in various ways. You'll need to tape or clamp the Mylar so that the desired bend is held in place.

What's interesting about this exercise is that no matter how extreme the distortion, your image is still recognizable. The parts are garbled, sometimes wildly, but the relationships between them are held constant. If you draw the strange reflection accurately, it still looks like you. (It's equally interesting that sometimes you can look in a regular mirror and hardly recognize yourself. Well, at least I do that.)

A project like this one can make you comfortable with distortion. Once you've done a few of these, you can elongate, compress or otherwise torture any image you see without the help of Mylar or mirrors.

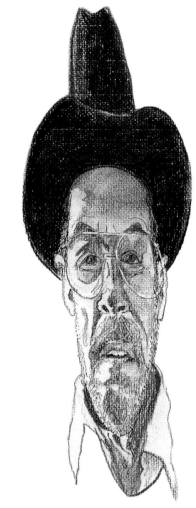

SLIM

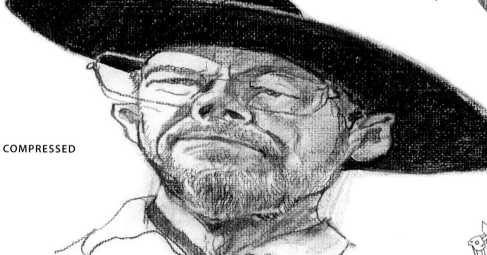

COMPRESSED

OLD HAT

This series of distorted self-portraits was done by looking into a sheet of mirrored Mylar. To do this, pin or tape the Mylar so that it bends in various ways—and hold very still as you draw. Most of these were done in vine and compressed charcoal with the help of a kneaded eraser.

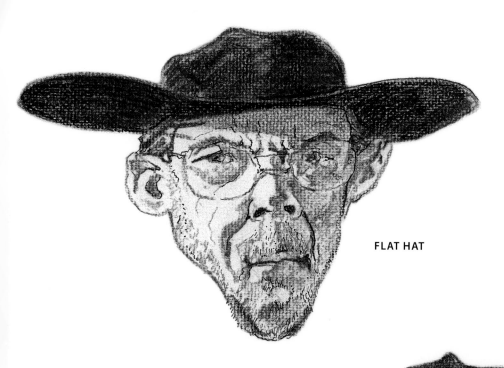

FLAT HAT

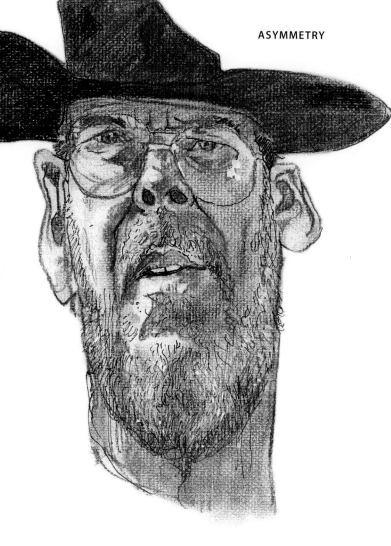

ASYMMETRY

MOSAIC COWBOY

The drawing below was done from reflections in a mosaic mirror. It's easy to lose your place and forget which square you're working on in a complex image like this. I put a little dot on the mirror square that reflected the tip of my nose. I also kept one eye closed most of the time.

mirror imaging

MIRROR IMAGING

There is something satisfying in symmetry. When you hold a slightly tilted mirror alongside an object or a person, you see the object and its reflection as a single merged shape—a shape composed of identical halves. Your mind shifts to a pattern sensing mode. With an ease that borders on magical, symmetry transforms a random fragment into an ordered design.

1 SKETCH
Sketch a subject.

2 COPY AND FLOP
Copy and flop the subject vertically by tracing it on a light table.

3 COPY AND FLOP AGAIN
Copy and repeat the pair, this time horizontally. Notice how at each stage the image becomes more of an abstract design.

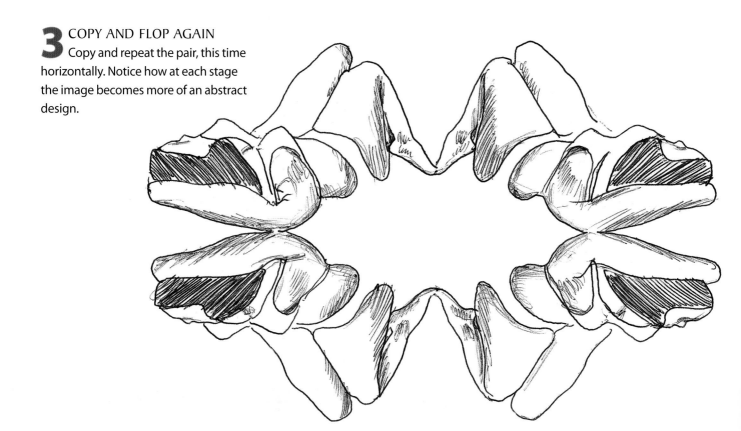

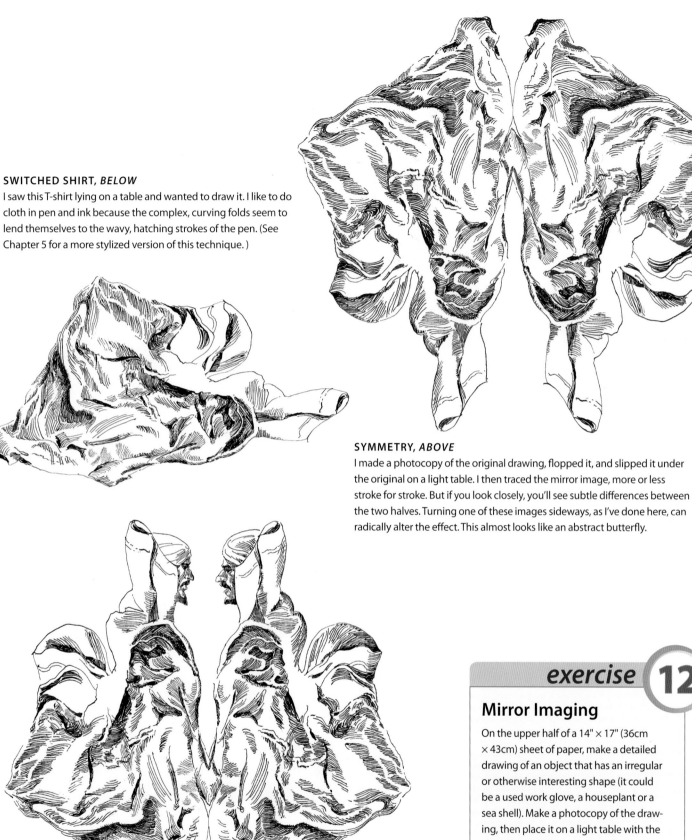

SWITCHED SHIRT, *BELOW*
I saw this T-shirt lying on a table and wanted to draw it. I like to do cloth in pen and ink because the complex, curving folds seem to lend themselves to the wavy, hatching strokes of the pen. (See Chapter 5 for a more stylized version of this technique.)

SYMMETRY, *ABOVE*
I made a photocopy of the original drawing, flopped it, and slipped it under the original on a light table. I then traced the mirror image, more or less stroke for stroke. But if you look closely, you'll see subtle differences between the two halves. Turning one of these images sideways, as I've done here, can radically alter the effect. This almost looks like an abstract butterfly.

SPIN-OFF
Turned upside down, the image looked a little like two nomads in conversation, so I added these faces.

exercise 12

Mirror Imaging

On the upper half of a 14" × 17" (36cm × 43cm) sheet of paper, make a detailed drawing of an object that has an irregular or otherwise interesting shape (it could be a used work glove, a houseplant or a sea shell). Make a photocopy of the drawing, then place it on a light table with the photocopy underneath. The photocopy should be flopped and inverted so it looks like a mirror image of the original. It should also be aligned so that the two images are touching. Trace the photocopied image onto the original so that they make a single, symmetrical shape. Use a 2B pencil and allow one hour.

obscuring

OBSCURING

In most pictures—just as in real life—the eye quickly settles on the center of interest and relegates everything else to the background. So what happens when you deliberately thwart this convention by placing elements in front of the center of interest to obscure or obstruct it? Challenging convention is often a starting place for imaginative work.

It just so happens that if you choose interesting foreground elements and draw them accurately, you will often create a tantalizing frame for your subject. The effect will be one of peering through the foreground. This often makes the subject intriguing, appealing.

You can also obscure your subject with a dramatic light-and-shadow pattern. Dim light often conveys mystery. Strong cast shadows reveal the forms that they fall on. The shadow side of an object often merges with the dark of the background.

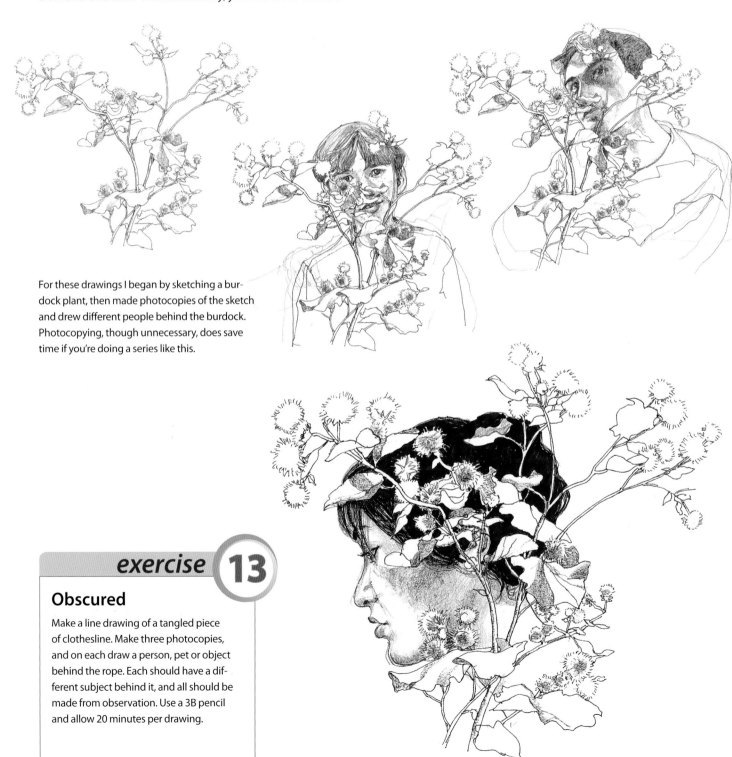

For these drawings I began by sketching a burdock plant, then made photocopies of the sketch and drew different people behind the burdock. Photocopying, though unnecessary, does save time if you're doing a series like this.

exercise 13

Obscured

Make a line drawing of a tangled piece of clothesline. Make three photocopies, and on each draw a person, pet or object behind the rope. Each should have a different subject behind it, and all should be made from observation. Use a 3B pencil and allow 20 minutes per drawing.

obscuring with dramatic light and shadow

OBSCURING WITH DRAMATIC LIGHT AND SHADOW

1 Take some photographs of your subject under a strong light.

2 Create a simple map by tracing the photo on a light table.

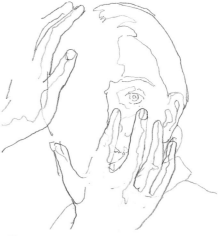

3 Add a second element in front of the face—in this case, a pair of hands.

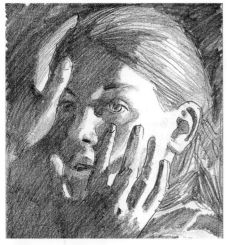

4 Fill in and darken the tones. Try several variations.

5 Posterize: keep details to a minimum . . .

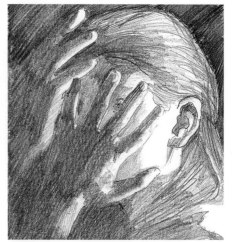

6 . . . but capture the difference between hard and soft edges.

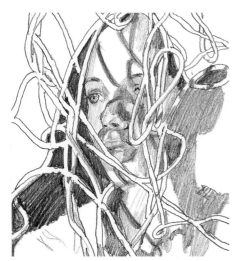

7 Here's a different effect, using a tangled piece of clothesline rope . . .

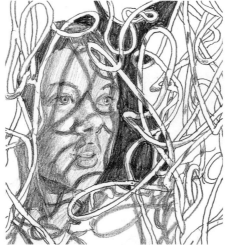

8 . . . positioned so as to cast strong shadows on the face.

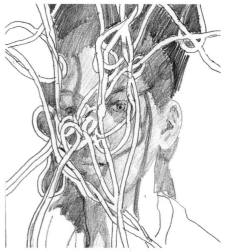

9 With only selected background shapes filled in, the drawing appears more abstract.

sketching the unusual

SKETCHING THE UNUSUAL

Any subject that catches your eye is a good subject for your sketchbook—but it may be time to get bolder in your range of choices. We are trying to build neuron bridges between the eye and the mind's eye—perhaps more accurately, between the visual centers of the brain and the visual imagination, which happen to share much of the same equipment. For this work, a good subject is one that jolts you out of your habitual way of seeing. These are subjects that in some way appear compelling, vivid or strange.

Sketching your dental X-rays, a tray of plastic utensils, or a dead fly under a magnifying glass could trigger a shift in your seeing habits. Like the images in your dreams, the "new reality" you draw should include the odd, the illogical, the ambiguous and the absurd.

ARRESTING PATTERN
I liked the shape produced by the black of this young woman's hair meeting the black of her shawl.

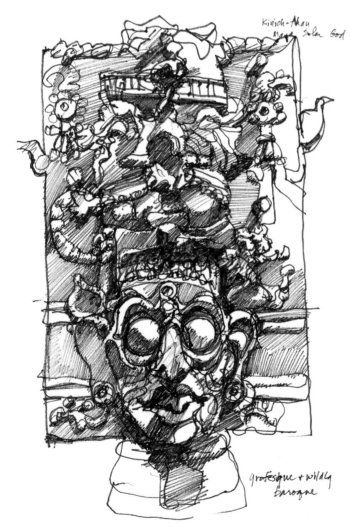

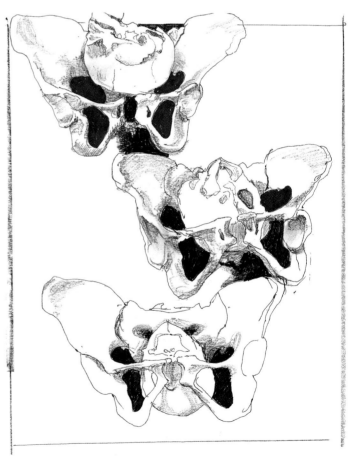

COMPELLING STRANGENESS
Early Mexican art often combines the grotesque with a wild, Baroque quality. Copying work from other cultures can be liberating—you can feel their boldness and difference. This Mayan solar god was sketched from a sculpture in Mexico's National Archeological Museum.

IMPROBABLE SOURCES
This was drawn from a photograph in a medical textbook depicting how a baby's head passes through the birth canal. I liked the abstract qualities and the odd archeological feeling.

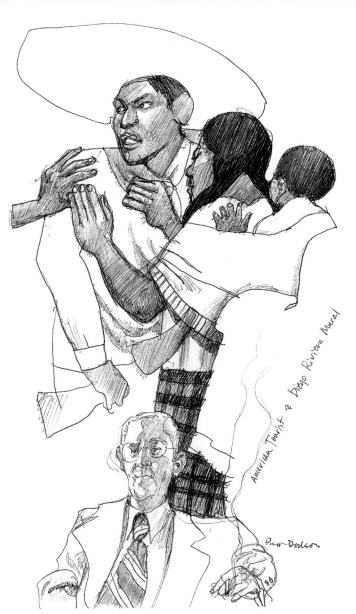

American Tourist on Diego Rivera Mural

IMAGINARY STORIES

In Mexico City, I drew this American businessman sitting with his cigarette beneath a Diego Rivera mural. I was struck by the contrast between the iconic mural and the laconic smoker. I kept wondering, "Who is this guy? Is he a ruthless capitalist, in town to exploit indigenous workers like the noble but distressed peasant family in the mural? Or is he just a gentle retiree from Ohio?" I never found out.

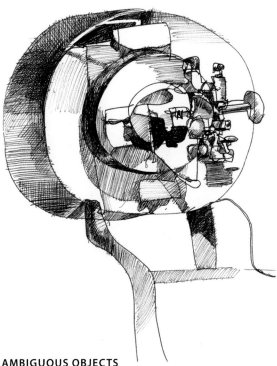

AMBIGUOUS OBJECTS

I like drawings that look vaguely familiar but not fully recognizable. I think this was of a Spanish cement mixer, but I don't remember for sure.

ODD SCENES

Once, on a ferry ride, I took out my sketchbook to draw people lounging in the sun. I focused on a father and son sitting in deck chairs. As soon as I had begun, they pulled their T-shirts over their heads and the father turned backwards. This scene would be totally ordinary if it weren't for the goofy T-shirt-over-the-head look. I also loved the kid's shoes!

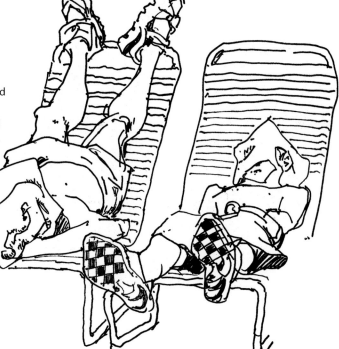

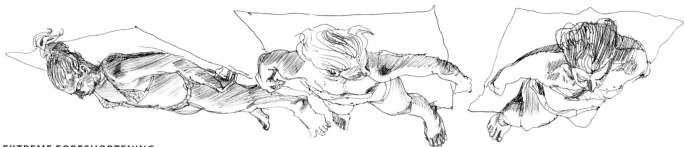

EXTREME FORESHORTENING

End views, especially of people, force you to let go of your ideas about how a person looks and to draw only what your eye tells you. This is an ordinary drawing of three young women on a beach, but I like to view it upside down. It gives the drawing a futuristic, sci-fi look.

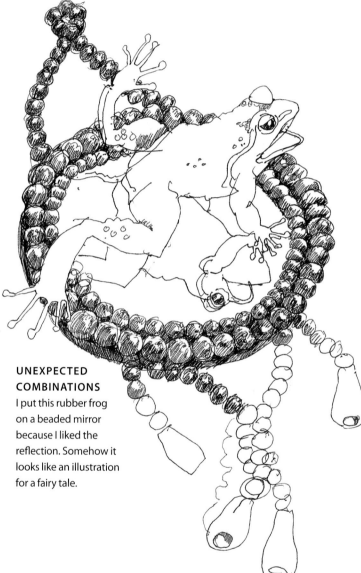

UNEXPECTED COMBINATIONS

I put this rubber frog on a beaded mirror because I liked the reflection. Somehow it looks like an illustration for a fairy tale.

DRAWINGS OF YOUR DRAWINGS

Occasionally, I make little sketches, in a bold pen, of my previous drawings. The crude simplicity of the patterns sometimes gives me new ideas. The two little drawings in the middle are so simple that I no longer remember the originals. But I can make something new out of them.

TIME ON YOUR HANDS AND NOTHING TO DRAW
I did this drawing of my feet while on a long plane trip. It became an almost abstract exercise in drawing shapes and textures.

SO UGLY IT'S BEAUTIFUL
It's interesting how people and objects get more attractive when you begin drawing them. This prehistoric fish in London's Museum of Natural History looked woeful and forlorn. Initially, I felt sorry for him. But as I drew, I came to appreciate his craggy, handsome face.

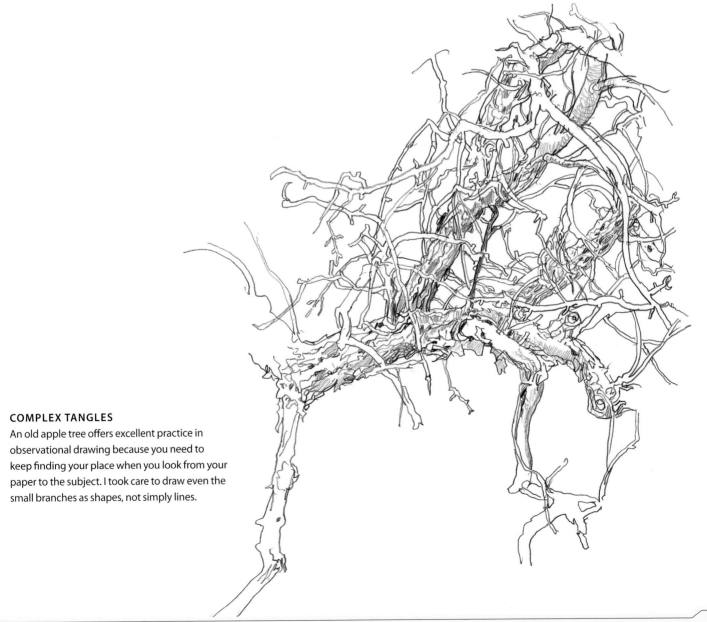

COMPLEX TANGLES
An old apple tree offers excellent practice in observational drawing because you need to keep finding your place when you look from your paper to the subject. I took care to draw even the small branches as shapes, not simply lines.

PROGRESSIVE STRETCHING

For many of us, the best way to alter an image is in stages. We make several drawings of the same subject, each one a little more exaggerated than the previous. By degrees, we get bolder, freer. Each drawing expands our idea of what is possible.

Here I made three drawings inspired by the figure in Jean Antoine Watteau's *Mezzetin*. The proportions in the first one are normal. In the other two I elongated the figure. I've found that distorting in stages allows me to work up nerve. The exaggerated proportions in the middle drawing made the extreme version possible.

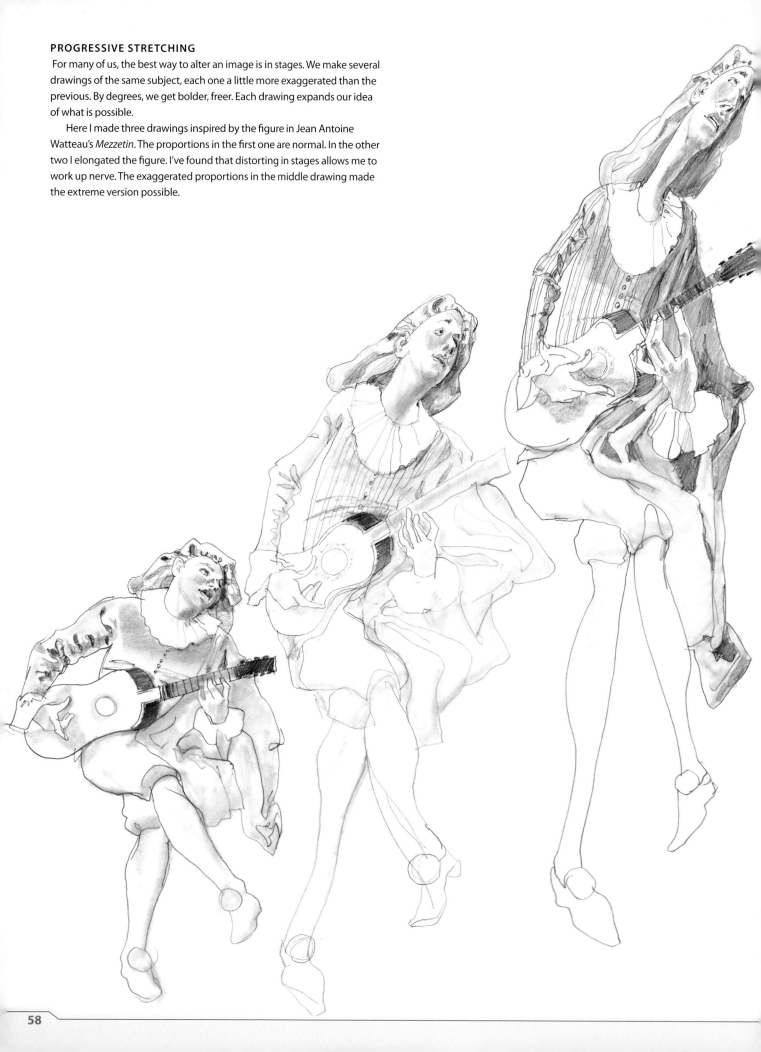

Stretching the Truth

Making the Familiar Strange / Progressively Changing / Exaggerating Proportions / Playing With Scale / Distorting With Grids / Drawing Metaphors / Odd Juxtapositions

Drawing expressively is all about finding ways of intensifying and dramatizing your subjects to inspire a new emotion in your viewer. An accurately drawn object puts the viewer in touch with that object on a literal level—they automatically know exactly what it is and what it's used for. An exaggerated or distorted drawing of the same object tends to touch the viewer on an emotional level, inviting them to see it in a new way. It makes the familiar strange.

Most of us honed our drawing skills by drawing things as they appear. We trained our hand to follow our eye. Happily, these same eye/hand skills, learned through careful observation, come in handy when we draw things as they *might* appear. This point, covered in the last chapter, bears repeating: *Drawing from observation provides a powerful foundation for drawing from imagination.* It's also true that transforming observation into imagination requires something altogether new.

Shift Your Perspective

You need new daring in your drawing—a greater willingness to suspend your inner critic, that voice that's always advising you to play it safe. From this new perspective, rather than seeing objects as having precise dimensions and contours, you see them as raw material—material to be twisted and pulled into an unexpected result. As you draw, think of your subject as clay. This new perspective liberates the imagination and opens up a whole world of possibility.

Making the Familiar Strange

Here's another way to think of it. The reality you observe is like the picture on your TV screen. You like its sharpness and reliability, but sometimes yearn for something more expressive and poetic. Now, suppose that you found fiddling with some control knobs on the back of the set alters the images in interesting and unusual ways. Let's say that you could make the colors more vivid, or the characters more alive. You could make the images wiggly and wavy, blend foreground with background and turn clouds into people and people into trees. In this chapter we'll investigate ways of drawing in a new, more expressive mode, twiddling the knobs of reality to create something unusual, provocative or metaphoric.

PROGRESSIVE CHANGE
Here's another demonstration of how distortion gets easier when you do it in stages. I like to do it in groups of three. Here, the first umpire was drawn from a magazine photograph. The middle stage exaggerated the action and altered the proportions. This emboldened me to make more radical changes in the last drawing.

exaggerating proportions

We recognize differences by comparing and contrasting. If you want to make something look big in your drawing, put it next to something small. If you have only one object, the parts should contrast with each other. Enlarging some parts of your subject while reducing others is a way of intensifying the drawing. It creates an exaggerated emphasis, expressively calling attention to certain aspects of a person or an animal. The results may be amusing or disturbing, but almost always attention-getting.

In the animal drawings on these pages I've simply shrunk or expanded a certain part in relation to the others. Care was taken to represent the parts accurately, though not in proper proportion.

ALL HORN
It's interesting how exaggeration begins to look normal as you draw. By the time I finished this sketch, this outlandish yak seemed quite believable to me.

SMALL HEAD, BIG BODY
Reducing the head size usually makes an animal look bigger—more physical.

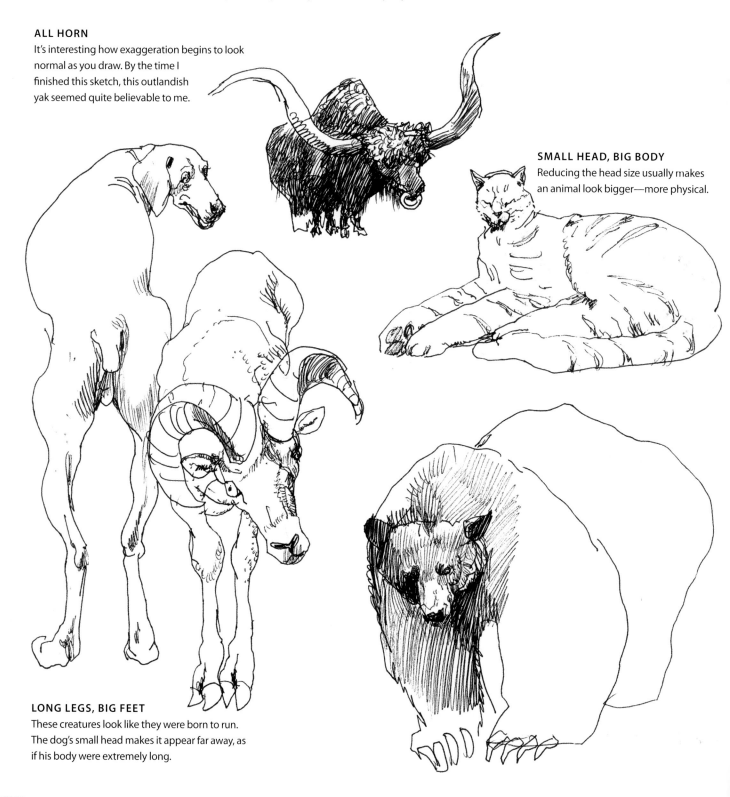

LONG LEGS, BIG FEET
These creatures look like they were born to run. The dog's small head makes it appear far away, as if his body were extremely long.

STRETCHING AND SQUEEZING THE HORSE

The horse represents so many things to us: grace, power, speed, work, companionship, etc. Exaggerating different parts brings out different symbolic aspects.

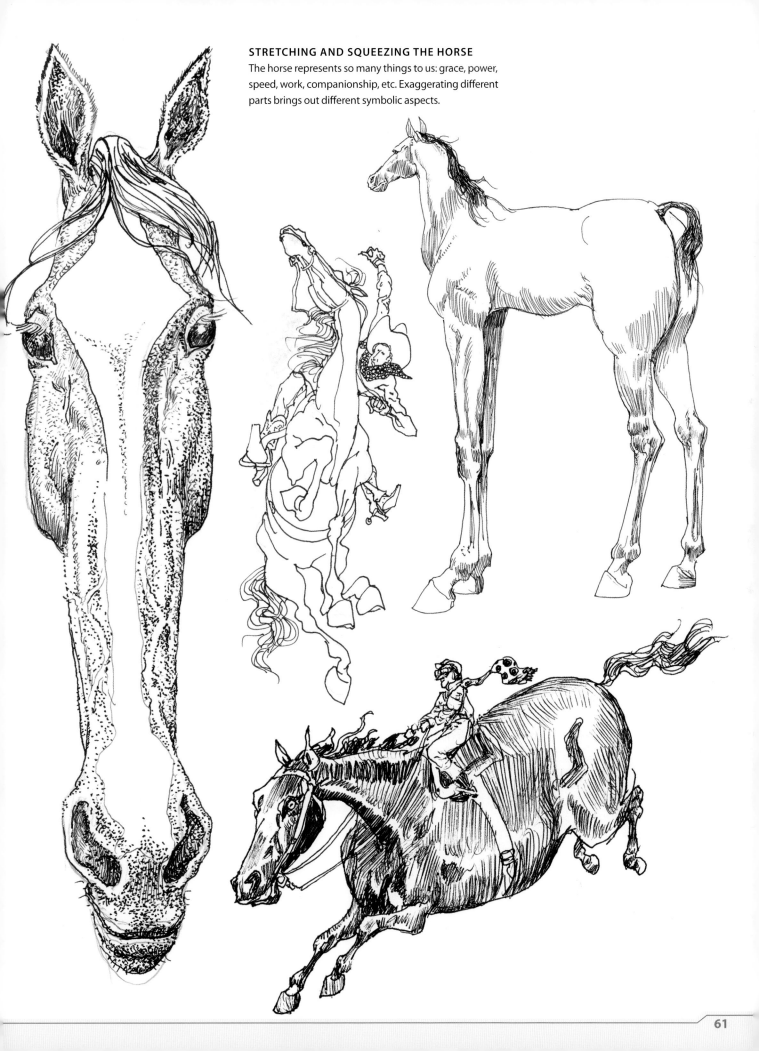

emphasizing differences

EMPHASIZING DIFFERENCES

Difference is information. We are aware of things because they stand out from their background. We are aware of qualities by contrasting and comparing. One way to make the familiar strange is to emphasize differences. That is, put two elements in a drawing and push the differences between them to extremes.

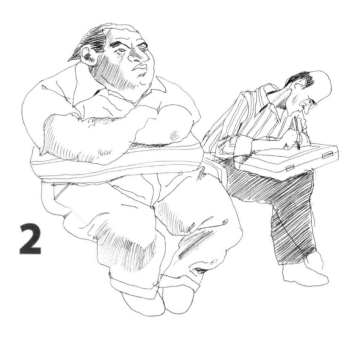

2

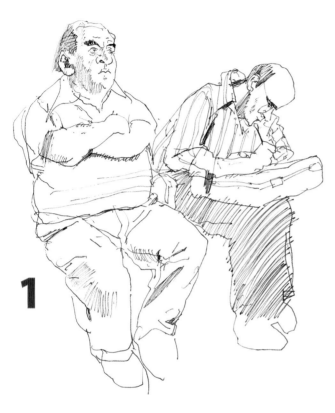

1

EXAGGERATING DIFFERENCES
The first drawing is a sketch I made of two guys waiting in an airport. Something about the difference between their poses and body types caught my eye.

Later, I made a second sketch from the original. I exaggerated the differences between these two figures, making the heavier man much larger and the thinner guy more angular and bookish. For some reason they began to look like monuments to me. I imagined them as a stone sculpture in a park.

So I drew them again, this time in pencil. By using soft shading and eliminating details, I attempted to show them as if they were made of granite. And I added pigeons.

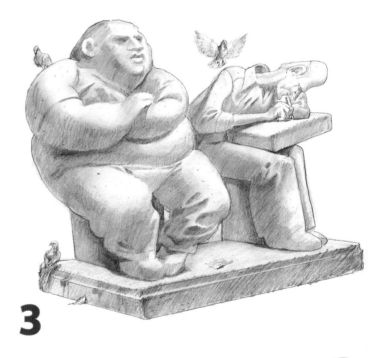

3

exercise 14

Progressive Distortion

Make a series of three drawings (any subject), each more distorted than the last. Draw your original either from life or from a photograph. Then make each of your other two from the previous drawing. Forgo timidity! The last drawing should be greatly exaggerated.

playing with scale

PLAYING WITH SCALE

Sometimes it's fun to make a composite drawing from different sources and to wildly exaggerate size differences. Here I've put the artist Gustave Courbet in the driver's seat of socialite Gaby Deslys' limousine. The drawing is arresting because it almost takes a moment for the viewer to realize that Courbet is a giant.

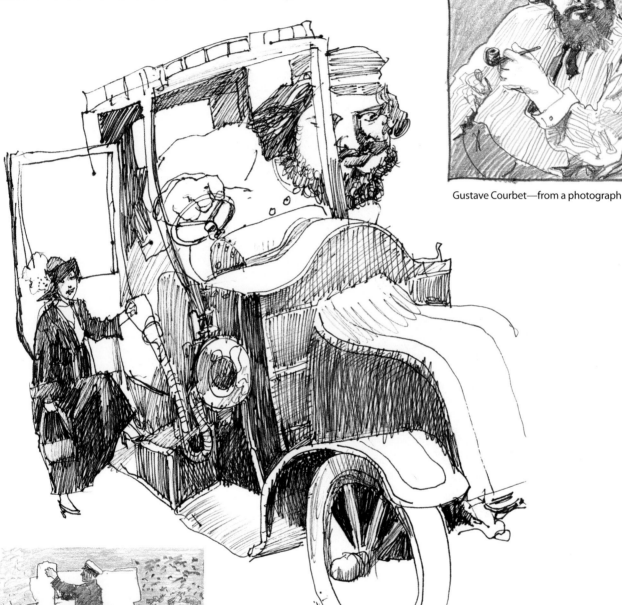

Gustave Courbet—from a photograph

Gaby Deslys and her limousine—from a photograph

exercise (15)

Scale Play

Make a composite drawing by combining elements from two different photographs. Make some of the elements out of scale—distort and exaggerate the size differences between them so that small things appear huge and vice versa. In all other ways, see if you can make the scene convincing and realistic.

forced distortion

FORCED DISTORTION

Many artists—even experienced professionals—find it difficult to deliberately distort their drawings. Paradoxically, good training in observation can inhibit the ability to draw expressively. Here's a two-step process that can help you break out of that constraint. It almost guarantees a more extreme and often striking image. In the first step, drawing blind, map the basic outlines of your subject with a bold, black marker. As you draw, keep your eyes on the subject (or photograph) and not on your

drawing. You may need to cheat a little by glancing at your paper from time to time to keep your place.

When you have completed this contour map, shift to a ballpoint pen and begin carefully filling in shading and details, now freely looking back and forth between subject and paper. The natural distortion that occurs when you draw blindly ensures that no amount of realistic shading will make your drawing look exact.

1 Keeping your eyes on the photo and your paper off to the side, draw the outlines of your subject in bold marker.

2 Move the paper directly in front of you. Add shadows, tones and details with a ballpoint pen.

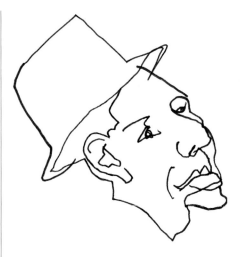

1 In this blind drawing of singer Frank Sinatra, I did the features as well as the overall contours.

1 Draw blind with a felt-tip marker.

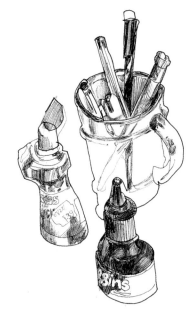

2 Fill in shading and details with a ballpoint pen.

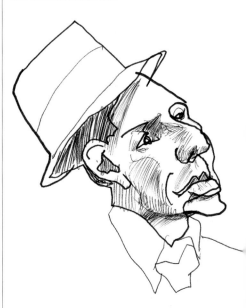

2 Even after filling in, it doesn't look much like Sinatra. But that's OK. I did it my way.

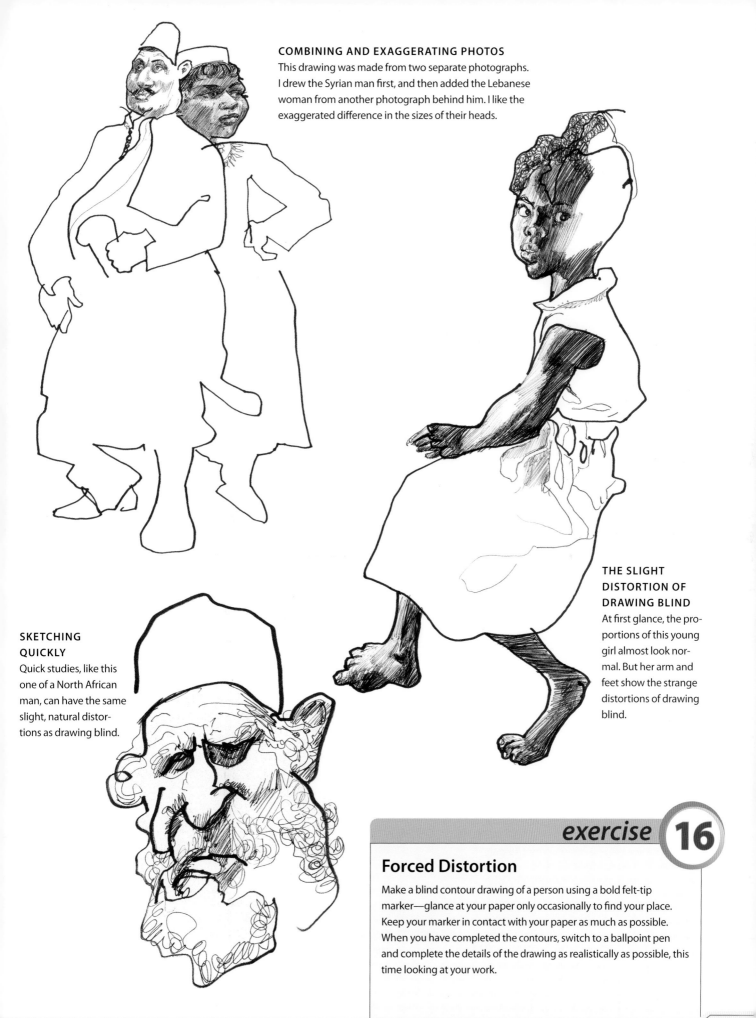

COMBINING AND EXAGGERATING PHOTOS
This drawing was made from two separate photographs. I drew the Syrian man first, and then added the Lebanese woman from another photograph behind him. I like the exaggerated difference in the sizes of their heads.

SKETCHING QUICKLY
Quick studies, like this one of a North African man, can have the same slight, natural distortions as drawing blind.

THE SLIGHT DISTORTION OF DRAWING BLIND
At first glance, the proportions of this young girl almost look normal. But her arm and feet show the strange distortions of drawing blind.

exercise 16

Forced Distortion

Make a blind contour drawing of a person using a bold felt-tip marker—glance at your paper only occasionally to find your place. Keep your marker in contact with your paper as much as possible. When you have completed the contours, switch to a ballpoint pen and complete the details of the drawing as realistically as possible, this time looking at your work.

distortion grids

DISTORTION GRIDS

One interesting way of making the familiar strange is using grids. This method involves dividing a photograph or one of your drawings into even squares. Then you make a second, distorted grid (with the same number of squares) to guide you in creating a new drawing.

Make the second grid on tracing paper, then slip it under a fresh sheet of drawing paper and place it on a light table. Make your distorted drawing simply by following the original, square for square. For some people this kind of work is too mechanistic, but I find it relaxing, and the results are often surprising.

REFERENCE GRID
Reference grids are always rectangular and divided into even squares. Label the horizontal axis 1, 2, 3, etc. and the vertical axis a, b, c, etc.

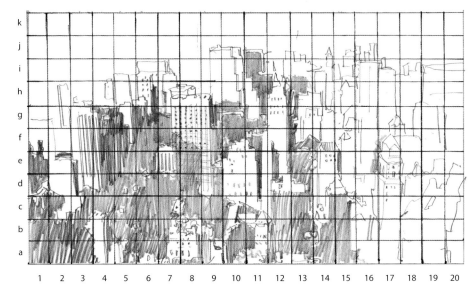

DISTORTED GRID
Grids can be distorted in numerous ways, so long as you have the same number of squares and they're numbered in the same way as your reference grid. Do this grid on tracing paper, then slip it under a fresh sheet of paper and place them on a light table to make your distorted drawing. You can reuse the grid for other drawings.

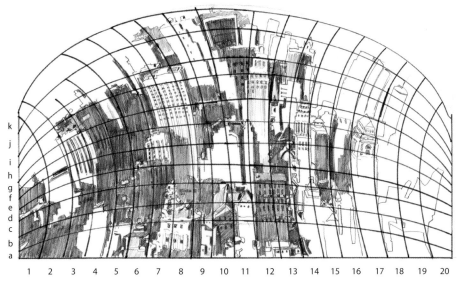

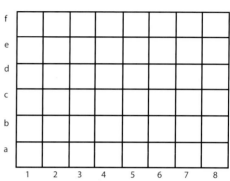

REFERENCE GRID

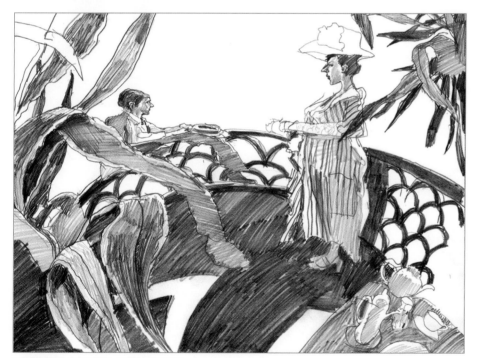

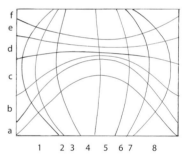

DISTORTED GRID

DRAWING SHAPES, NOT THINGS

These drawings, made from a movie still, illustrate the stretching and bending potential of distorted grids. The image develops in unpredictable, often amusing ways.

This way of working has a side benefit: It offers a vivid demonstration of the power of drawing shapes rather than things. You mostly work out the drawing as a mosaic, one square at a time. You pick a square in the original, find the matching square on the distorted grid and duplicate the lines, shapes and tones of the original. Out of this abstract process the overall image seems to emerge almost magically.

perspective grids

PERSPECTIVE GRIDS

Here's another grid idea that yields interesting results. This method takes a photograph or drawing and puts it into perspective. As before, this requires making two grids. The first is the reference grid—a rectangular grid that divides your photograph into squares. The next step, making a grid in perspective, is a wee bit tricky, so follow the steps on the facing page carefully. Be sure you have the same number of squares labeled in the same way in each grid. It's possible to do these grids without a T-square and triangle, but having these tools sure makes it easier.

The effect of distortion grids and perspective grids is to stretch and bend the image while keeping the relationships constant. These drawings of writer Mark Twain are hugely distorted, yet they're still recognizable.

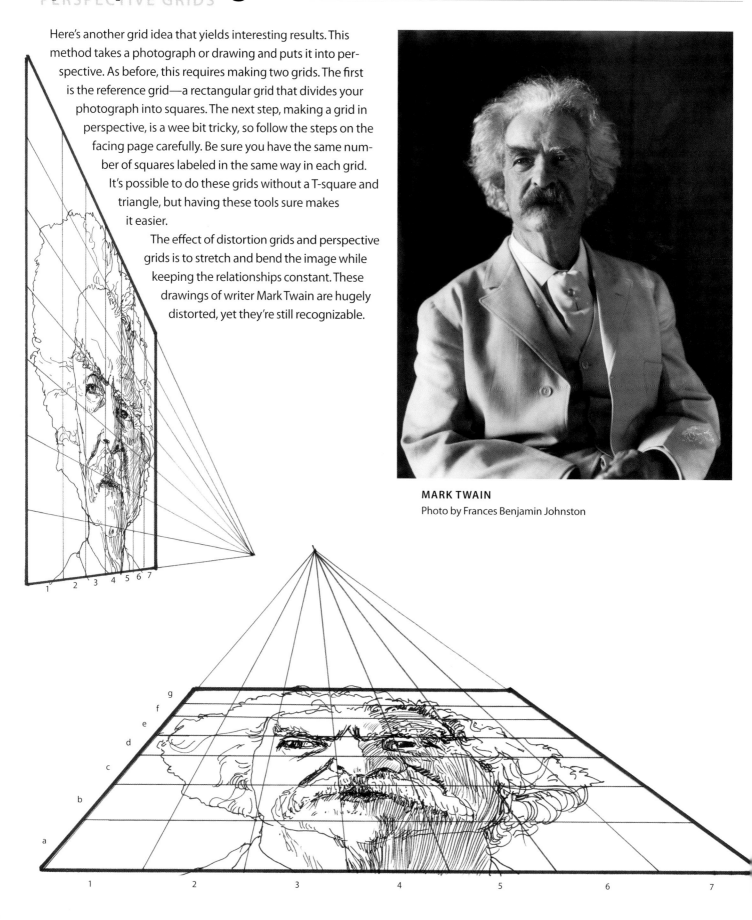

MARK TWAIN
Photo by Frances Benjamin Johnston

making a perspective grid

MAKING A PERSPECTIVE GRID

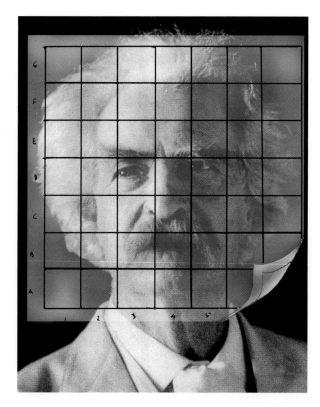

1 The reference grid is always rectangular and composed of even squares. Squares are numbered on one axis, lettered on the other. Do this grid on tracing paper and tape it to the photograph.

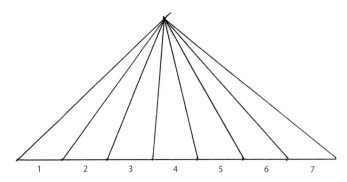

2 Draw a horizontal baseline. Locate a vanishing point somewhere over its center. Mark off equal parts on the baseline, the same number as in your reference grid. Label them 1, 2, 3, etc. Draw lines from these points to your vanishing point.

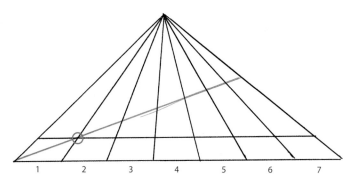

3 Draw a second horizontal line, then a diagonal line (here shown in red) from the bottom left corner through the next point of intersection, shown circled. Notice that your diagonal intersects each of the other converging lines.

exercise 17

Gridwork

Choose a photograph of a face that's at least 8½" × 11" (22cm × 28cm). Make a reference grid of squares on a piece of tracing paper, numbered across the bottom and lettered along the side. Tape it to the photograph. Then make a distortion grid (also on tracing paper) with an equal number of squares, but with curved lines instead of straight. Number and letter these squares just as before. Tape this grid under a fresh sheet of paper and place them on a light table. Copy the photograph square by square.

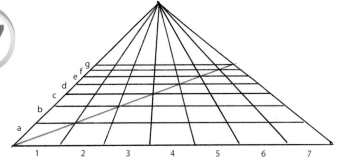

4 Draw additional horizontals through each point of intersection. Notice how these horizontals get closer together as they approach the top of the grid. This grid can be done on tracing paper, and then taped to the back of a fresh sheet of paper and placed on a light table for the final drawing.

metaphoric seeing

METAPHORIC SEEING

Most of us as young children have had the experience of lying in bed at night and staring into the closet, where a barely visible coat or robe begins to look like something sinister, such as a murderer or a monster. The longer you look, the more real it becomes. This is an early and terrifying example of our ability to construct an elaborate reality from just a few visual cues.

We may not have appreciated it at the time, but this is a creative gift endowed to all human beings. Metaphoric seeing is simply looking at something and seeing something else—not just something different, but something strange and vivid that pushes the limits of your imagination. Metaphoric seeing is a skill that can be developed. When you take the time to look not only at, but *into* stains and clouds and gnarled branches, you begin to see things. These are not always distinct and complete, but they often give you a strong start on a drawing that you never would have thought of doing otherwise.

A potted plant? An upside-down pair of bloomers?	An angel? A man throwing a pizza?	A hideous face? A fan?	Two octopuses dueling? A mosquito?	A garden gate? A house plant?	A pelvis? Two ants greeting?

If you can see images in these inkblots, you're seeing metaphorically. What you see, however, might be different from what I see. That's really the point of metaphoric seeing—we bring our own interpretation to reality. Above are some of the interpretations I've gotten from different people. Try your own .

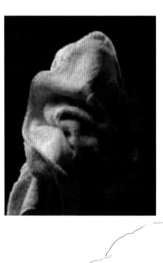

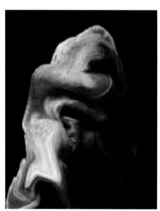

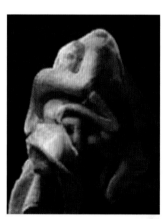

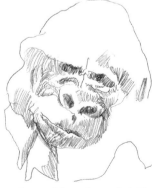

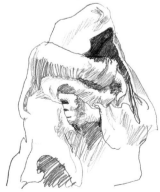

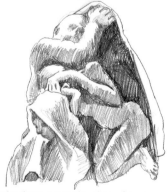

I took this photo of a towel draped on a chair. The folds and shadows suggested the face of a primate to me, so I made this drawing, *Gorilla*.

A little shift in perspective can transform the image you see. I altered the photo slightly to reveal a hooded wraith.

Further visual tinkering reveals a three-figure composition. Interestingly, the three photos look quite similar at first glance.

Making Metaphors

The point of metaphoric seeing is that it presents images you would never think of drawing. It offers not only unusual subjects, but subjects in unique positions, angles and proportions. It takes you beyond the conventional. There is a kind of accidental and random quality to it that's so often essential in creating something new.

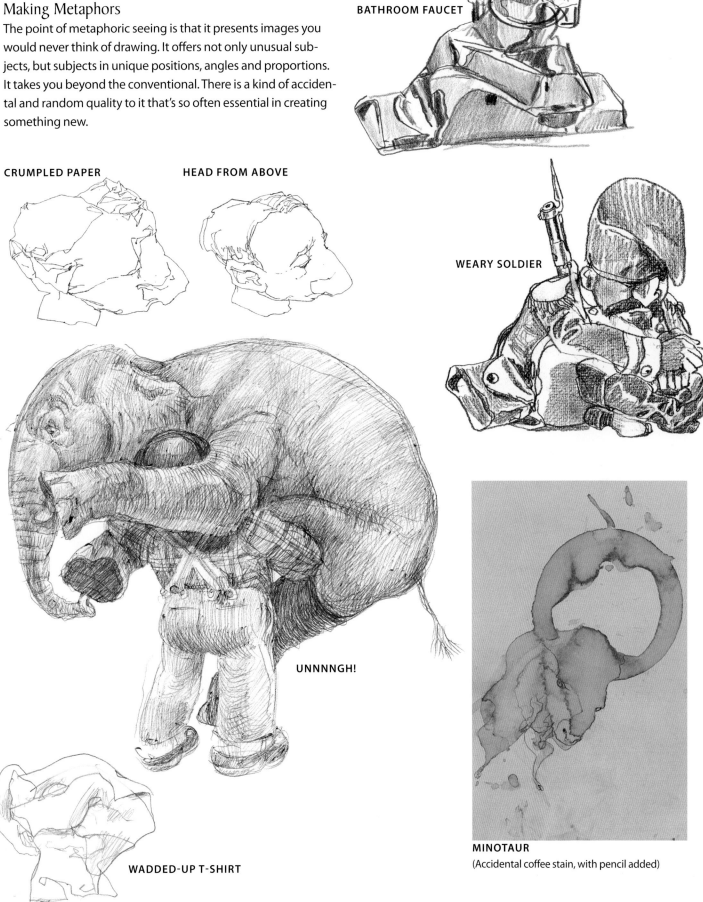

BATHROOM FAUCET

CRUMPLED PAPER

HEAD FROM ABOVE

WEARY SOLDIER

UNNNNGH!

WADDED-UP T-SHIRT

MINOTAUR
(Accidental coffee stain, with pencil added)

inspiration in the clouds

INSPIRATION IN THE CLOUDS

Subtle, ever-changing and complex, clouds offer the richest possibilities for metaphoric seeing. You can find in them not only strange objects, but unusual combinations of strange objects. Because clouds are in continual motion, I find it best to photograph them first and draw from the photographs.

Pick a sunny day when there are lots of billowy cumulus clouds, and shoot lots of pictures that can be sorted through later. Accept right away that a cloud image will not likely be distinct and obvious. The metaphoric eye works by hints and clues; the image needs to be coaxed out.

When making drawings like these, feel free to depart from the photographs. The actual clouds are a starting point—a useful guide, not a precise template. See if you can capture some of the soft, puffy cloud texture while you develop the metaphoric image. Draw as if you had one foot in the metaphor and one foot in the clouds (so to speak).

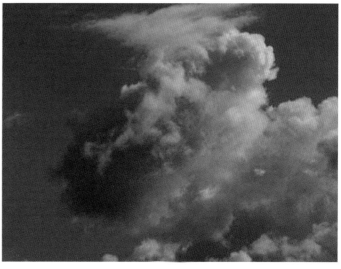

SEARCH FOR THE IMAGE
When I first looked at this cloud formation, I couldn't see anything in it. Now I can't look at the photo without seeing fish.

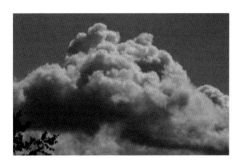

A GUIDE, NOT A TEMPLATE
Initially I thought this looked vaguely like an animal's face—but there was just enough detail in the upper area to suggest two figures.

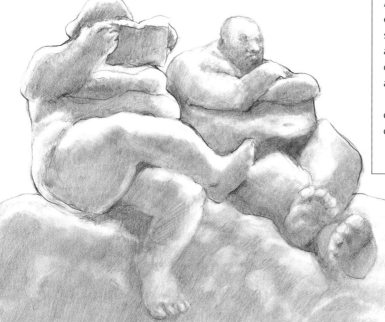

SUN BATHERS
I wanted these two figures to look solid but not realistic, so I copied the light pattern and kept the details to a minimum.

exercise 18

Metaphoric Drawings

Arrange a piece of cloth in various ways under a strong light. With each arrangement, see if you can find a face, figure or animal. If you see one that looks promising, make a sketch of it. After you have made a few sketches, pick one, put it on the light table and make a more complete drawing. Your finished piece should look partly like the cloth and partly like your metaphor.

Take a few photographs of clouds and draw an image you see in one of the formations. Use a soft pencil and a kneaded eraser to pick out light areas, and keep the drawing soft and subtle.

POODLE AND SQUAWKING PARROT

This one seemed obvious from the start—the poodle's face and the open beak of the parrot were so clearly formed in the clouds. Well, to me, anyway.

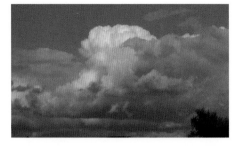

THE SORCERER AND THE OWL

I don't know what they're doing, but it all looks rather sinister.

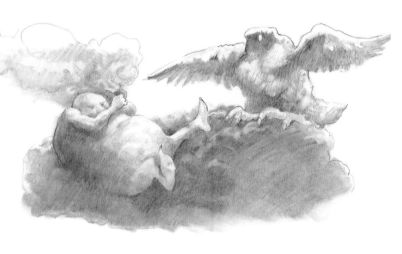

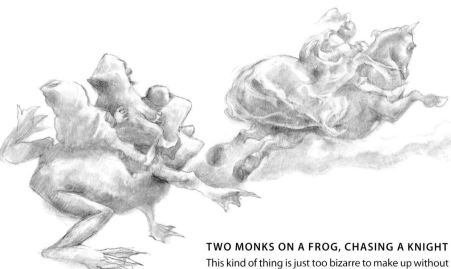

TWO MONKS ON A FROG, CHASING A KNIGHT

This kind of thing is just too bizarre to make up without the help of clouds.

odd juxtapositions

ODD JUXTAPOSITIONS

Imagine walking down a quiet country road and stumbling upon a huge object standing some thirty feet high. As you stare up at it, you realize you're looking at a high-heeled shoe. What would you do? Laugh? Look around suspiciously? Conclude that you're in a dream? Whatever you do, your first reaction is likely to be disorientation. People need to make sense out of what they see, and when they don't, it provokes a queasy, off-kilter feeling that something's not quite right.

Artists—particularly the surrealists—like to evoke this feeling in their audience and play with it. Drawing things out of scale and putting things together that don't belong are two classic ways of doing this. There are endless possibilities for provocatively combining familiar objects. One secret to achieving the right effect is drawing accurately. Render each element to look perfectly normal and conventional, no matter how absurd the whole is.

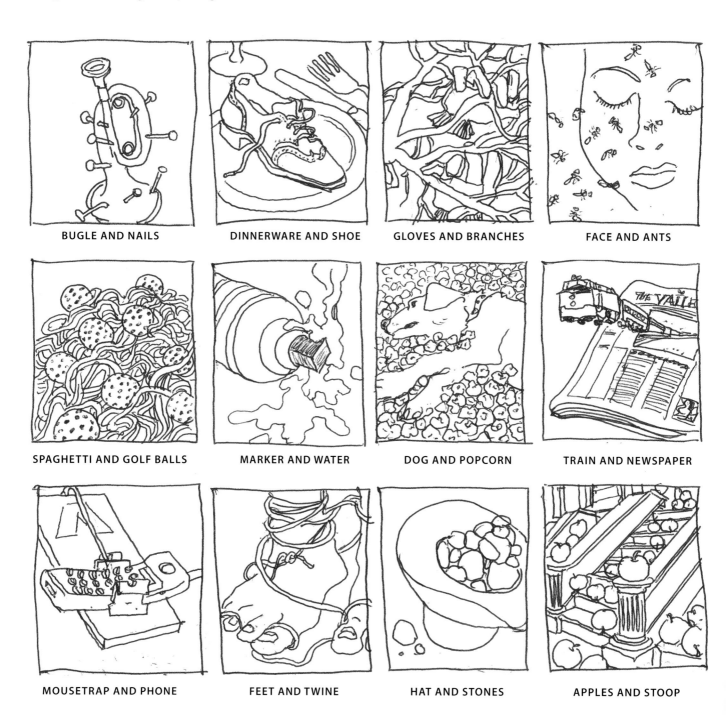

BUGLE AND NAILS

DINNERWARE AND SHOE

GLOVES AND BRANCHES

FACE AND ANTS

SPAGHETTI AND GOLF BALLS

MARKER AND WATER

DOG AND POPCORN

TRAIN AND NEWSPAPER

MOUSETRAP AND PHONE

FEET AND TWINE

HAT AND STONES

APPLES AND STOOP

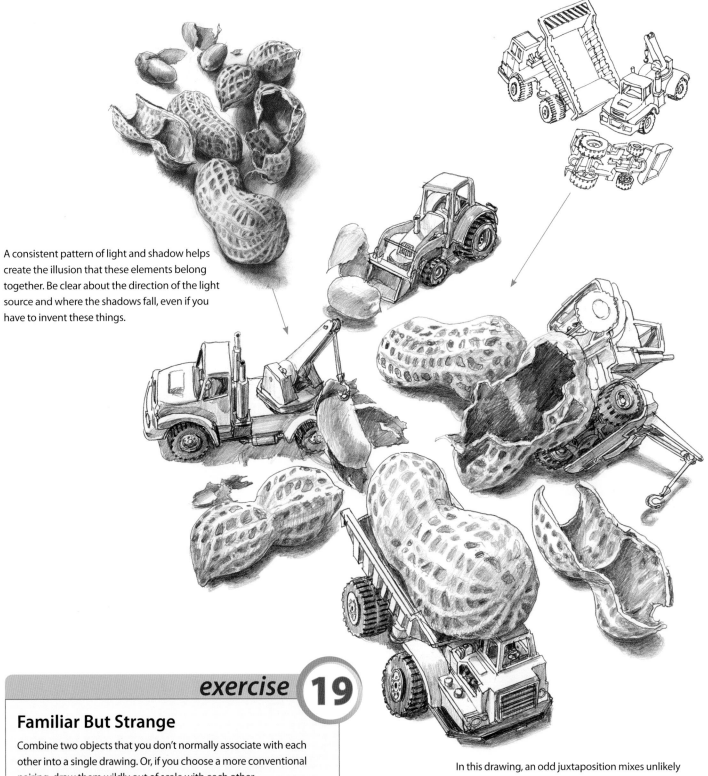

A consistent pattern of light and shadow helps create the illusion that these elements belong together. Be clear about the direction of the light source and where the shadows fall, even if you have to invent these things.

exercise (19)

Familiar But Strange

Combine two objects that you don't normally associate with each other into a single drawing. Or, if you choose a more conventional pairing, draw them wildly out of scale with each other.

Take your time on this drawing. Work from direct observation as much as possible. Make your objects look convincing using a consistent light source, realistic shadows and significant details. Map out your arrangement prior to proceding to the final drawing.

In this drawing, an odd juxtaposition mixes unlikely objects that are often out of scale with each other. Interestingly, when you render this sort of thing in a realistic technique, the scene becomes almost believable. Here I have combined toy trucks with peanuts, first making separate sketches of each. Before making a final drawing, I did a planning sketch so I could see just how things fit together.

MICHAEL MITCHELL
A Master Among Masters

I have never met a more accomplished draftsman than Michael Mitchell. I worked for Michael at the Famous Artist's School in Westport, Connecticut, where he developed much of their home study teaching program. He went on to work in film animation, creating storyboards that were works of art in themselves—considerably more beautiful than the films made from them. Now he teaches drawing to a fortunate few at CalArts in southern California.

Michael speaks in elliptical metaphors, jumping quickly from one to another and leaving as much unexplained as explained—but always with an utter reverence for the art of drawing. Here are some of his comments to his students:

- Drawing from life has much to do with drawing life. It has little to do with copying. It has much to do with crystallizing your thoughts and perceptions of another human being and lifting out of thin air your literally magic translations from three-dimensional reality to the two-dimensional surface. In drawing from life you will be creating a sense of life that, were it not for you, would not exist.

- Our eyes are a two-way processor of sight, sound, thought, meaning and understanding: the conduit connecting the outer world with our inner being. Our vision isn't one-fifth that of an eagle but our insight is a trillion times more. When we draw in the most creative sense, our observational powers move up to those of the eagle. We begin to perceive the extra-dimensional stretch of sight as it incorporates instinct with vision.

Michael's listeners must do a fair amount of interpreting, actively filling in the gaps with their own ideas. This keeps them attentive and involved. And Mitchell's prodigious drawing skill lends enormous credibility to his speaking.

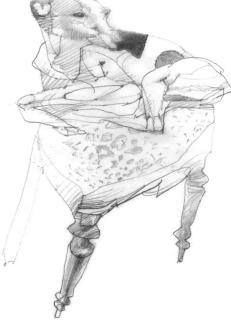

Soft and subtle, this dog/chair drawing looks partly realistic, partly like an animal anatomy lesson. Notice too the radical and dynamic angle of the stool.

Anatomy of a Dog-Chair
HB pencil

I love the way the shapes of this grasshopper merge and blend with the abstract shapes of the foliage.

Bushes at the Bottom
Ballpoint pen

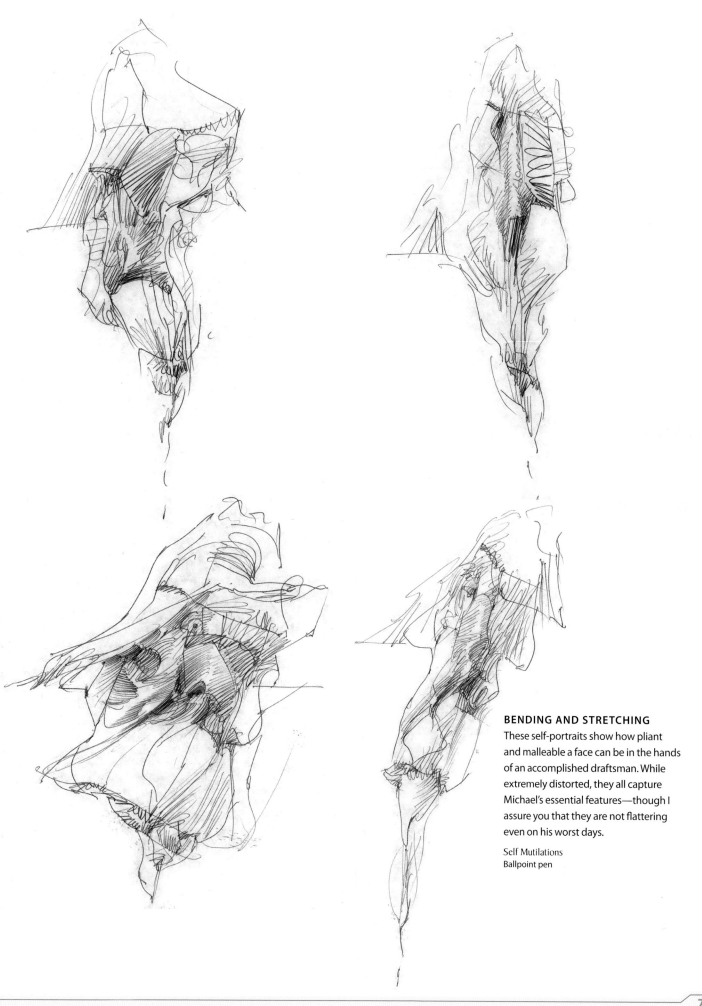

BENDING AND STRETCHING

These self-portraits show how pliant and malleable a face can be in the hands of an accomplished draftsman. While extremely distorted, they all capture Michael's essential features—though I assure you that they are not flattering even on his worst days.

Self Mutilations
Ballpoint pen

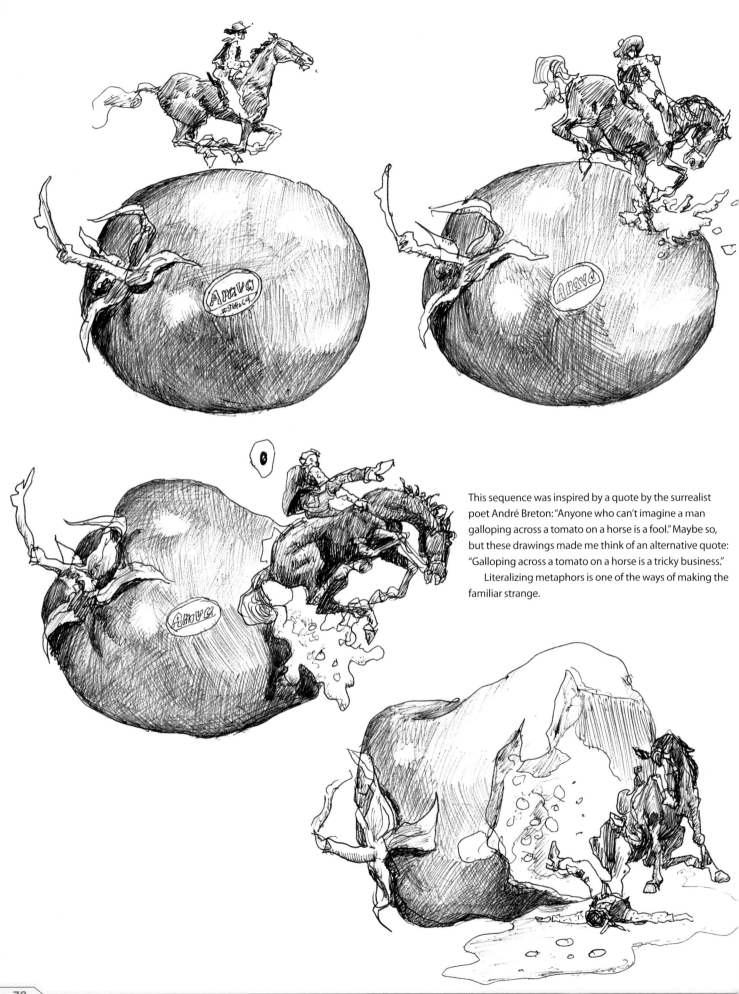

This sequence was inspired by a quote by the surrealist poet André Breton: "Anyone who can't imagine a man galloping across a tomato on a horse is a fool." Maybe so, but these drawings made me think of an alternative quote: "Galloping across a tomato on a horse is a tricky business."

Literalizing metaphors is one of the ways of making the familiar strange.

Visualizing Ideas

Evolving Ideas / Joining Two Bags / Variations On a Theme / Reversing / Associating Ideas / Making Metaphors

Technically, an idea is something that happens in the mind, and a sketch is something that happens on paper. In most drawing, however, these two processes are merged. Ideas inspire sketches, and sketches trigger ideas. You go back and forth.

Unlike the cartoon ideal, ideas are not usually like little bright lightbulbs. More often than not they are fragments—bits and pieces that need to be assembled to create a cohesive whole. Because a mental image often fades quickly, capturing it on paper is key to visualizing. This often means that you start drawing before you know your exact destination. The alternative—thinking long and hard about what you're going to draw—has the effect of erasing each little idea as you wait for the big one. This is not a good creative strategy.

It is true that every once in a while you will get a clear vision of exactly what you want to draw. That's lovely when it happens, but most of the time drawing is about generating and transforming. You take something and do something to it. You get comfortable knowing that things will not end up just as you planned. You can't predict where it will take you. You need both a vision and a willingness to depart from it. That's the nature of creativity.

Words and Pictures

Where does a visual idea originate? Does it start with an image or words? The answer, in my own view, is that it can start either way. Ideas are part words and part image. Words and images together constitute a kind of double description—the same concept available in two different modes and located in two different parts of the brain. Song lyrics like "blue eyes cryin' in the rain" or "she keeps her face in a jar by the door" create an immediate mental image. Your image will be different from mine, but we will each create a distinct personal picture from those lyrics. Appreciating this link between the visual and the verbal enhances creative freedom. Your visual sense takes the lead as you draw, but from time to time words will help.

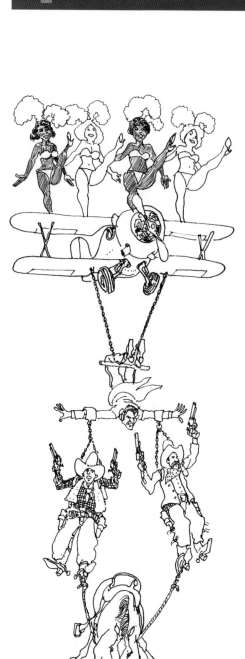

I started this drawing with just the airplane and chorus line. Then I added the guy on the trapeze, then the cowboys, then the horse. I might have gone further, but I ran out of paper.

the evolution of an idea

THE EVOLUTION OF AN IDEA

Creating could be summed up as having a plan accompanied by a willingness to depart from it. Most people think that an artist's vision must be clear and fully formed before he or she begins to draw. Not only is this rarely the case, it is actually based on a misunderstanding about how creativity works. Creativity is an open dialogue between you, the artist, and the particular piece you are executing. The lines you put down on paper often tell you what to do next. Each stage feeds the one that follows.

You start with an idea—some sort of thought or vision about what you're going to do. It can be something quite simple. Once you've drawn a few lines, your image begins to speak back to you. You get new ideas. You may begin to modify your original vision, or you may think of a more vivid way to capture it. In either case, the original concept is only a starting place. You surrender to the process, and therefore you never know exactly what you're going to draw until you draw it.

So what qualifies as an idea? In its broadest meaning, an idea is any thought that gets your pencil moving. Another definition is combining two elements in a novel way. This definition gets to the real power of ideas. Ideas are about creating relationships—about linking things in a fresh way. Your idea can be about anything, but it seems to work best when it's about two things. As the dancer Twyla Tharp puts it, "you don't have a really good idea until you combine two little ideas."

1 I like to start with loose, tangled sketches or little iconic figures. If it's a subject I've drawn a lot, like these monkeys, I make an effort to draw them in some new way—some new angle or position. If I can think of something, I like to add some new element, such as the unicycle.

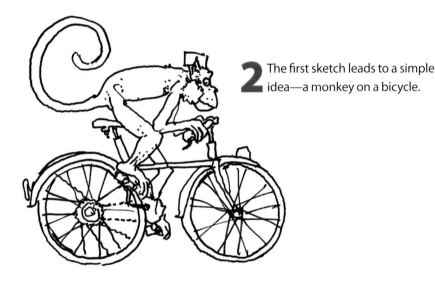

2 The first sketch leads to a simple idea—a monkey on a bicycle.

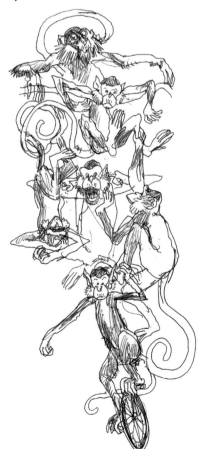

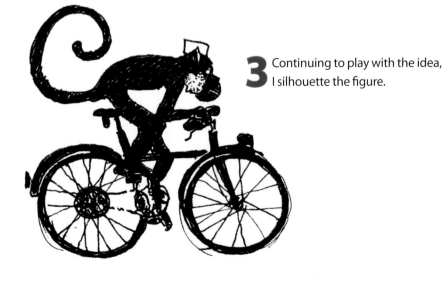

3 Continuing to play with the idea, I silhouette the figure.

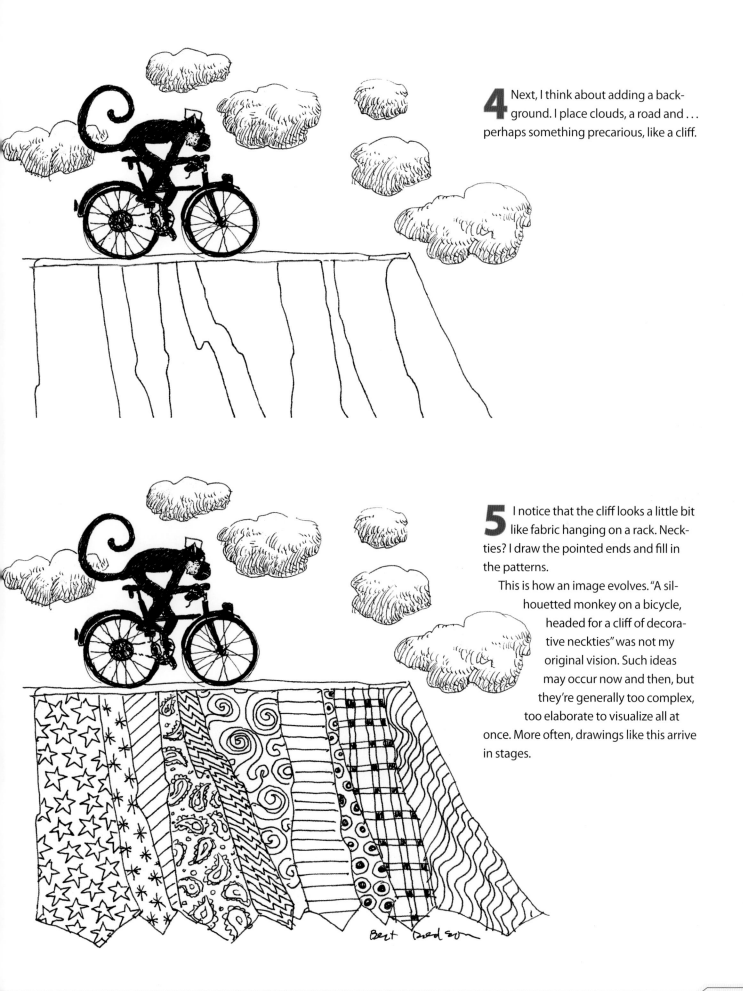

4 Next, I think about adding a background. I place clouds, a road and ... perhaps something precarious, like a cliff.

5 I notice that the cliff looks a little bit like fabric hanging on a rack. Neckties? I draw the pointed ends and fill in the patterns.

This is how an image evolves. "A silhouetted monkey on a bicycle, headed for a cliff of decorative neckties" was not my original vision. Such ideas may occur now and then, but they're generally too complex, too elaborate to visualize all at once. More often, drawings like this arrive in stages.

joining two bags

JOINING TWO BAGS

Here's another way to think about connecting different things and building fresh ideas. Imagine that you have one bag containing *x*, and another containing *y*. Let's assume that these two items don't really go together, at least not in any obvious way. You need to go beyond logic and into the world of strange, creative associations. What if *x* was huge and *y* was tiny? What if *y* was swallowing *x*? What if *xy* were combined into a single shape? What if *x* was background and *y* was foreground? Joining two bags is simply a metaphor for evolving an idea out of two things that seem incompatible using experimentation and creative play.

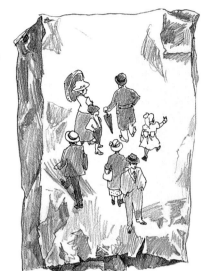

These two different subjects might be labeled "people" and "face," but you could also call them "content" (the subject) and "context" (the framework or environment).

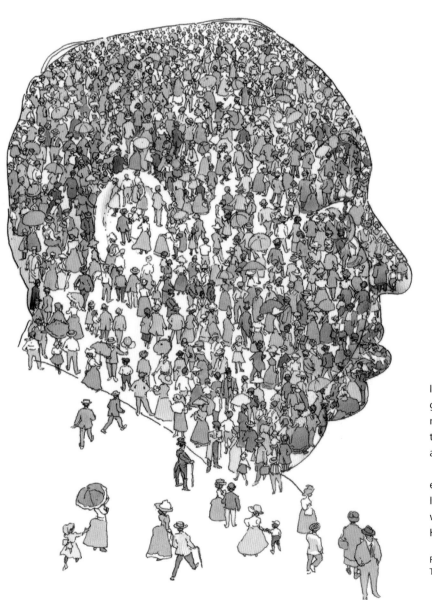

I made this drawing for a book I co-authored with distinguished biologist Mahlon Hoagland. Its purpose was to metaphorically show that complex living creatures are themselves made of smaller living creatures (cells) and that, astonishingly, each individual cell has a life of its own.

In a symbolic drawing such as this, I like to make the elements distinctive. Instead of drawing generic people, I put them in ninteenth-century attire. The face is the well-known profile of the late British film director Alfred Hitchcock.

From *The Way Life Works*,
Times Books/Random House

Making the Familiar New

One of my favorite words is *context*. I like it because I can never quite grasp it. It means something like "how the parts fit together to make a whole." Drawing a strange idea often means presenting familiar content in some new and unexpected context. That is, the drawing has realistic parts, but they're put together in an unconventional way. This fresh look stretches the viewer's imagination.

Unlikely Mixing

Make a list of five objects (including people or animals), such as clock, asparagus, clown, etc. Then make a list of five locations or environments, such as junkyard, ocean, theater, etc. Choose one item from each list and combine them into a single drawing in some unusual way. You may want to make several preparatory sketches to work out your idea. Strive for some believability in your final drawing. Make it look convincing, no matter how absurd the combination of elements.

Optional, for the adventurous: Make a list of qualities—adjectives such as soft, ominous, melted, etc. Choose one from this list and one each from the other two. Combine all three elements in one drawing (i.e., join three bags).

Here's another unlikely pairing of content and context. Two elegant dancers in the woods may not seem all that strange, but something about this drawing seems like pure fantasy. I think it's the spotlight.

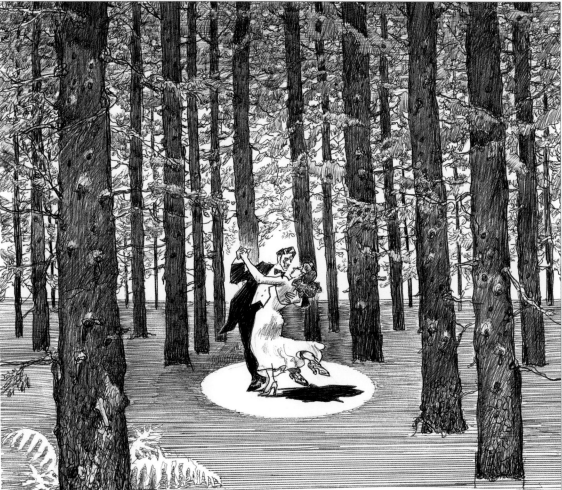

variations on a theme

VARIATIONS ON A THEME

Generating variations may be the essence of creating. Ideas stand on the shoulders of earlier ideas, and a new idea quickly becomes source material for subsequent ideas. This is one of the core principles of creating, driving biological evolution and human invention alike.

Think of a theme as an arena for creative play—an arena that's broad enough to encompass possibilities yet narrow enough to impose constraints. To play in this arena is to make a series of sketches that depict the theme in alternative ways. Typically, you begin by making small and subtle changes from one drawing to the next. Then at some point you jump out of that set and strike out in a bolder direction.

It's generally best to explore a theme over a period of time rather than in one sitting. Many years ago I did the sketch below as an illustration for the popular story (and movie) *The Birds*. But the visual possibilities of this theme stuck with me, and I have returned to it several times in subsequent years.

IDEAS FOR VARIATIONS

While there is no formula for generating variations, here are a few useful strategies:
1. Change the viewpoint.
2. Change size relationships (play with scale).
3. Change the context (time period, surroundings, framing).
4. Intensify (greater contrasts, more drama, exaggerated forms and actions).
5. Do a reversal (switch roles, positions or characters).

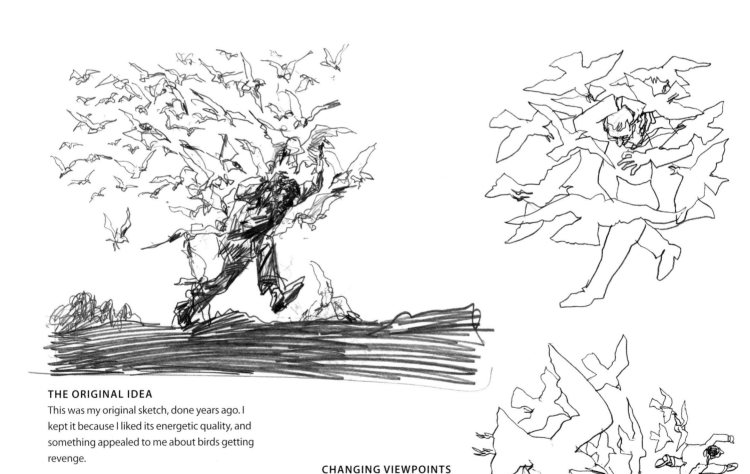

THE ORIGINAL IDEA
This was my original sketch, done years ago. I kept it because I liked its energetic quality, and something appealed to me about birds getting revenge.

CHANGING VIEWPOINTS
A simple way to create a variant is shifting the viewpoint. Picturing how things might look from another viewpoint stretches the imagination.

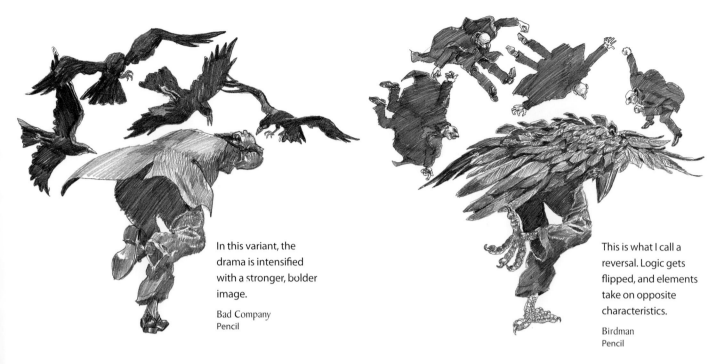

In this variant, the drama is intensified with a stronger, bolder image.

Bad Company
Pencil

This is what I call a reversal. Logic gets flipped, and elements take on opposite characteristics.

Birdman
Pencil

Radical cropping, reflections and an exotic background combine to suggest an interesting story.

Reflections
Pencil on coquille board

Does the man flee something real, or just his own imagination? The birdlike clouds put this story into a new context.

Killer Clouds
Pencil on pebble board

exercise 21

Variations

Do four different variations of a previous doodle or drawing. As you move from one drawing to the next, consider changing one or more of the following: viewpoint, scale, mood or context. See if you can make each drawing progressively more strange.

GIDON STAFF
Variations on the Face

Gidon Staff draws almost exclusively from his imagination. One of his major themes is the human face—a subject with endless possibilities. He has made hundreds if not thousands of drawings like the ones shown here. Where others might see sameness, even repetition, Gidon sees subtle and significant, sometimes even radical differences. True to the spirit of making variations on a theme, he uses each drawing as a springboard to try something new on the next. "I look at one of my face drawings and it gives me ideas, such as a new shading pattern, a stronger expression or even a different kind of hat."

Gidon has a poetic fascination with his theme: "A face has a completeness to it," he says. "It stands by itself, undaunted. When I draw one, I have a feeling of wholeness."

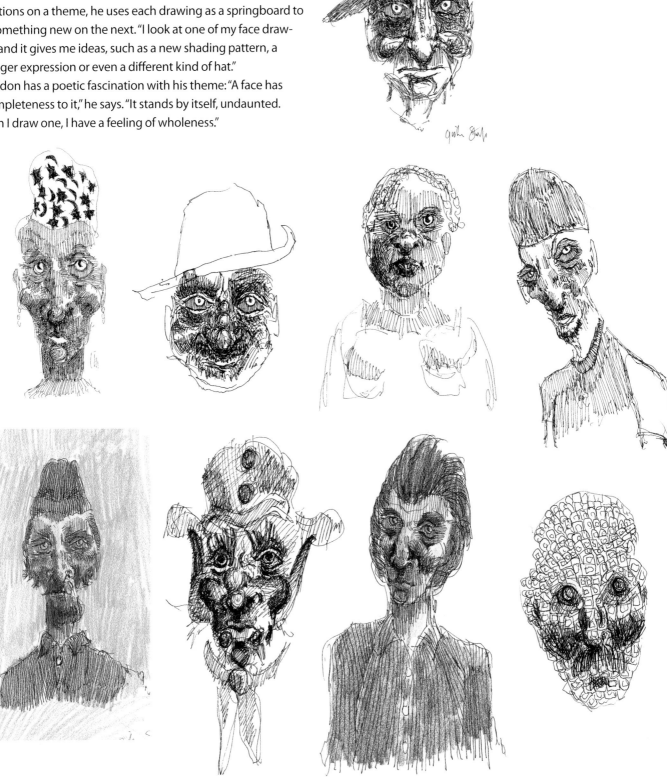

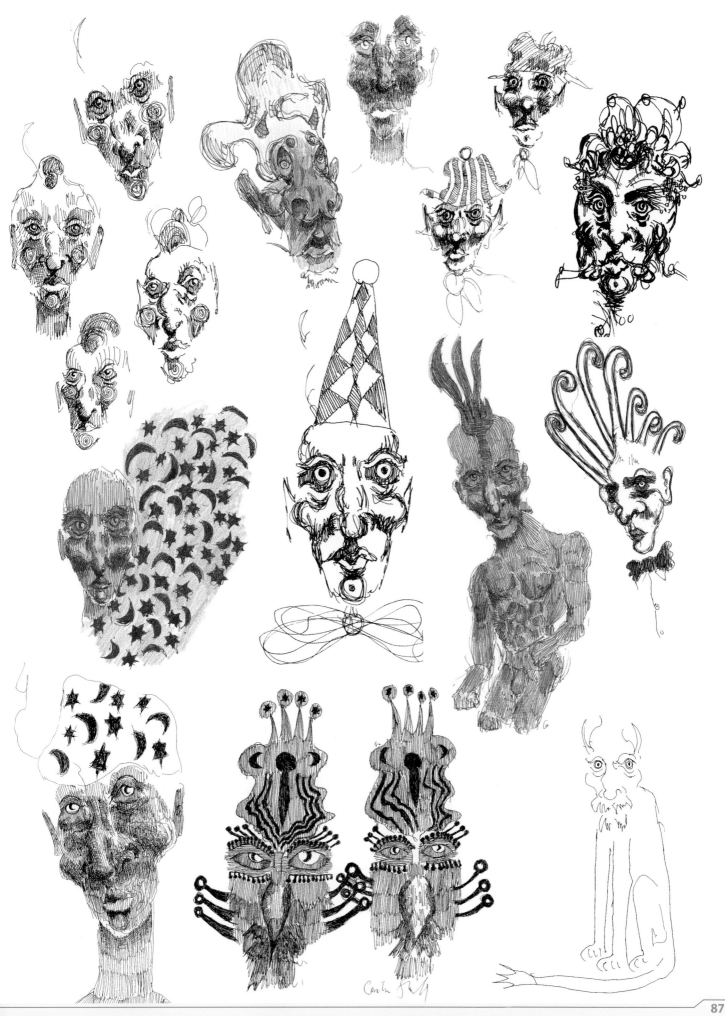

reversing

REVERSING

Flipping an image or idea around and imagining its opposite can almost always generate an interesting variation. But deciding just what and how to flip is not always obvious. We all know that the opposite of night is day. But what about the opposite of hamburger? Is it hot dog? Veggie burger? Or is it regrubmah (hamburger spelled backward)? What is the opposite of a man standing on his feet? Is it a man standing on his head? A man lying down? A woman standing on her feet? Feet standing on a man? The more you think about it, the more intriguing the subject of opposites becomes. The poet John Ciardi once wrote a poem in which he wondered about the opposite of summer. He concluded that, for people living on opposite sides of the equator, the opposite of summer is summer.

SISYPHUS REVERSED

There are lots of ways to reverse an image. Here I've illustrated this using the Greek myth of Sisyphus as my theme. It's a complicated story, but the relevant part is that Sisyphus was doomed to push a giant boulder up a mountain only to have it roll back down as he reached the top. The first drawing (*below, left*) depicts the struggle. All of the others are reversals, opposites of one kind or another.

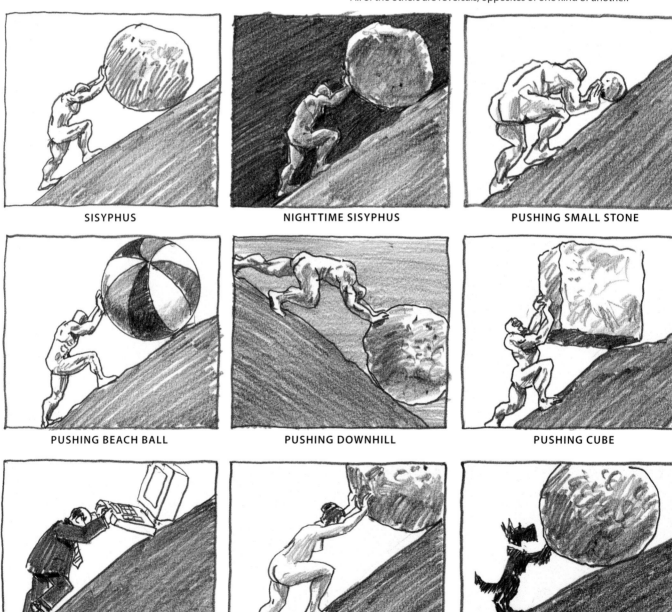

SISYPHUS

NIGHTTIME SISYPHUS

PUSHING SMALL STONE

PUSHING BEACH BALL

PUSHING DOWNHILL

PUSHING CUBE

BUSINESSMAN PUSHING COMPUTER

FEMALE SISYPHUS

DOGGY SISYPHUS

Pushing Variations

The beauty of variations lies in the way one idea triggers another. These drawings are spin-offs of the reversal sketches on the facing page. But I stretched the concepts, pushed them further by subtracting, multiplying and adding elements. The more you draw a theme, the freer you get.

A HEAVY RELATIONSHIP

WHEN PUSH COMES TO SHOVE

PUSHING THE MOON

SISYPUSS

exercise 22

Reversals

Choose a theme that conveys a strong visual image . This can be an existing theme, such as a myth, poem, fairy tale or nursery rhyme, or it could be a theme that you make up yourself. Do three drawings of the theme you've chosen. The first should depict the theme in a direct way. The other two should be reversals—they should flip some aspect of the drawing to its opposite. Choose different aspects to flip in the second and third drawings.

one idea triggers another

ONE IDEA TRIGGERS ANOTHER

Ideas are fuzzy. Their boundaries overlap the boundaries of other ideas, and these shared similarities make it easy to slide from one to another. Have you ever cleaned out a closet or an attic? Each item that you find reminds you of some experience, person or place. A photograph of an old railroad station can evoke a childhood fear of abandonment, a time when you missed a train, or a memory of a movie you saw. Each of these ideas will then spin off into other images, so that soon your thoughts will be miles away from the original photo.

Imagination works in just this way—by association. Every idea has connections to other ideas. Some things have a similar function, some a similar shape, and some are related by your own personal experience. Associations make possible an endless stream of ideas. As you look at these examples, see if you can recognize the transition points where one theme slips into another.

exercise 23

Associating

Make four drawings that are connected by some common association. For example, let's say you start with a dog sleeping. Your second drawing will spin off from the first—possibly a dog that can't sleep, a dog's dream, a person sleeping in a similar position, a sleeping robot, etc. Keep the drawings simple and without backgrounds.

THINGS ON FEET . . .

THINGS ON WHEELS . . .

YIN/YANG . . .

HANDS . . .

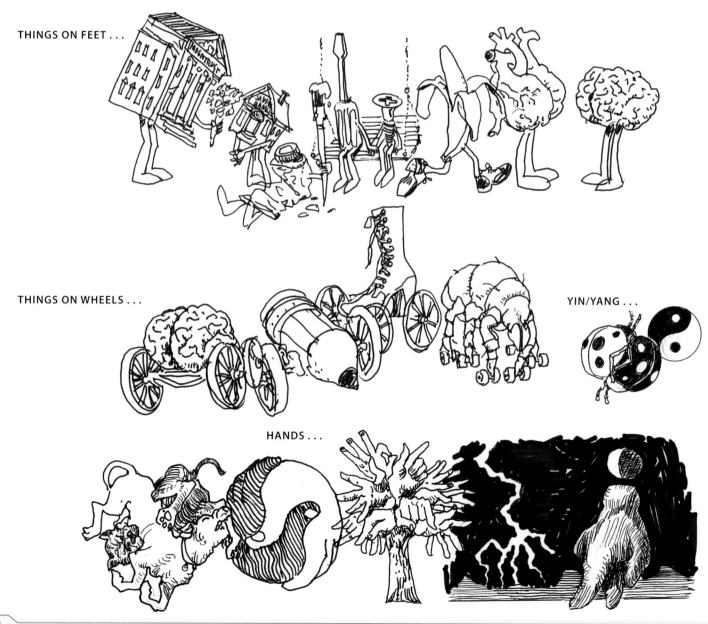

STRANGE LANDSCAPES . . .

THINGS COMING OUT OF THINGS . . . MASKS . . .

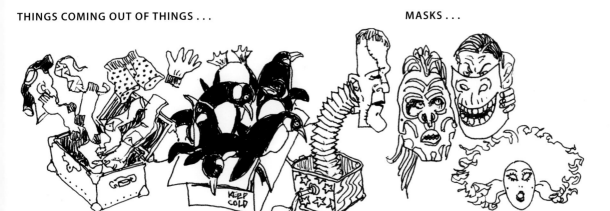

LIMBER DANCERS . . . DISJOINTED . . . GROUP SHAPES . . .

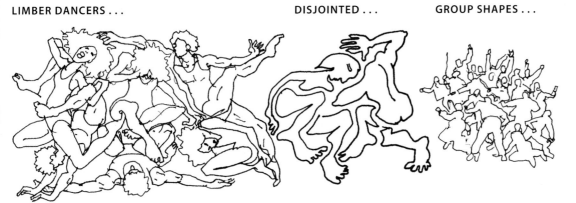

NONCONFORMIST . . . ESCAPE . . . FLIGHT

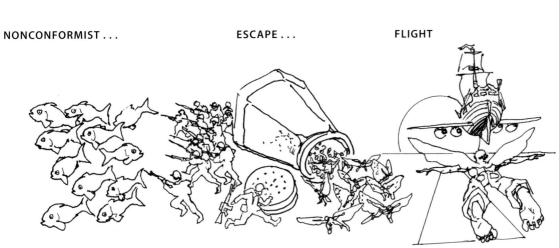

making metaphors

MAKING METAPHORS

A metaphor is a figure of speech in which one kind of object or idea is used in place of another to suggest a similarity between them. In metaphorical drawing, objects are stand-ins for the real subject, showing that something has the qualities of something else. When we think and draw metaphorically, I suspect we do a kind of mental mapping. We overlay two distinct ideas as if they were templates. If we find some commonality, a metaphor is born. Example: A bed has legs. Legs walk. Hence, a drawing of a walking bed.

It's really quite simple, and yet this simple idea lies at the core of art, poetry and even humor. Metaphor is an archaic language. It lives very deep within us. It makes connections beyond logic, connections that logic would find absurd. And that's why we love it.

These examples artfully demonstrate how an object can be itself and something else at the same time. Any subject can be turned into a metaphor, but the subject of metaphor is always relationship.

In a world obsessed with answers, this tragic figure is doomed to struggle with the question. The endlessly inventive Saul Steinberg (1914–1999) created this psychological interpretation of the Sisyphus myth.

Saul Steinberg
Untitled
Ink on paper
Originally published in
The New Yorker, March 19, 1966 © The Saul Steinberg Foundation/Artists Rights Society (ARS), New York

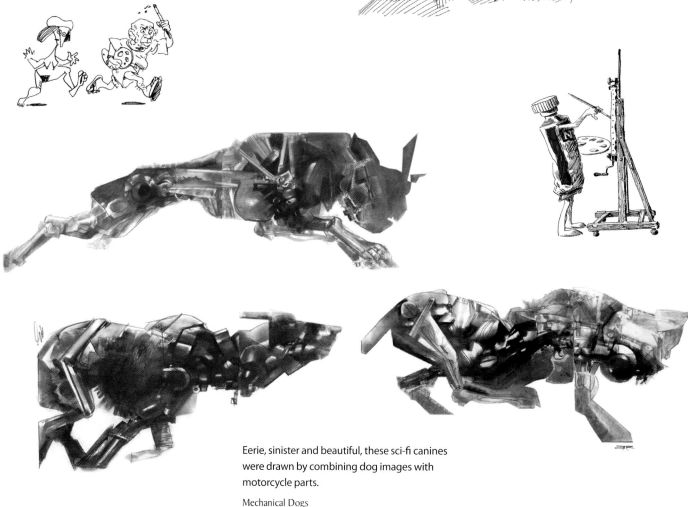

Eerie, sinister and beautiful, these sci-fi canines were drawn by combining dog images with motorcycle parts.

Mechanical Dogs
R.J. Smith

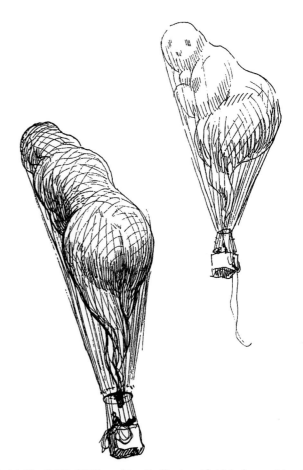

Paradox arises when logic resists what the eye sees. Guy Billout leaves us with a puzzle in this beautifully evocative work. And he adds a sinister touch—a large knife, stuck in the table.

Moonlight
Guy Billout
From *Something's Not Quite Right* by Guy Billout (published by David R. Godine, 2002)

Heinrich Kley (1863–1945) combined brilliant and fluid draftsmanship with a very playful spirit. Here, he offers a metaphorical variation on the novelty of his day, hot air balloons.

A Well-Rounded View
Heinrich Kley
From *The Drawings of Heinrich Kley*, Dover Publications, Inc.

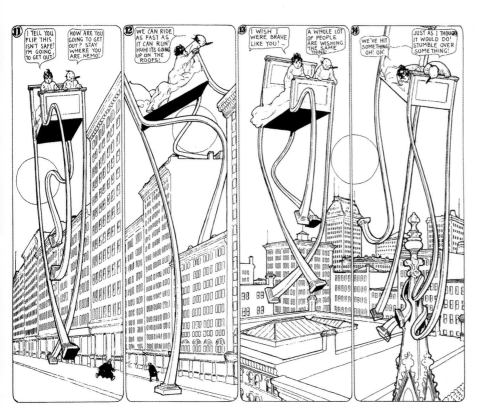

Winsor McCay (1867–1934) depicts not just a walking bed, but a bed that ambles, climbs, floats and clings. It's a bed with a mind of its own. This graceful sequence comes from McCay's weekly comics feature, *Little Nemo in Slumberland*.

Nemo's Walking Bed Episode
Winsor McCay
From *Winsor McCay—His Life and Art* by John Canemaker, Abbeville Press

STEVEN GUARNACCIA
A Fertile Thinker With a Deft Pen

Some thirty years ago a very young man came to my studio with sketchbooks in hand. He was looking for work, possibly as an assistant. After one look at the first sketchbook, I knew that he wasn't going to be anyone's assistant for long. Sure enough, in less than a year he was illustrating for *The New York Times*, *New York Magazine*, *Esquire* and other leading publications.

His witty, economical lines, often combined with his trademark cast shadows, is widely admired and frequently imitated.

Steven is currently the chair of the illustration department at Parsons School of Design in New York.

Rather than spending time thinking out an idea, Steven goes right to work with his pen and lets the idea emerge as he draws. He draws rapidly and fearlessly. If the drawing isn't quite what he wants, he simply starts another, quickly generating a number of variations on the same theme. His object is to capture an idea quickly and move on to the next.

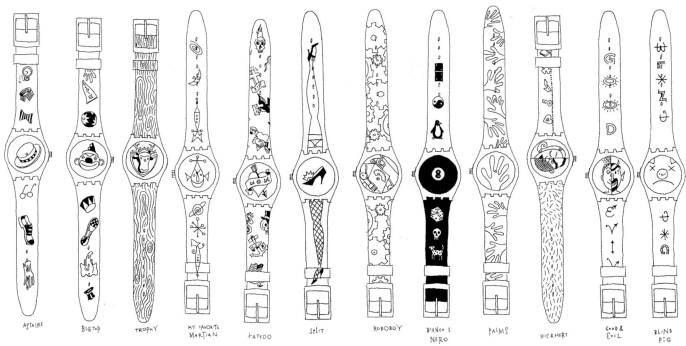

ASTAIRE BIGTOP TROPHY MY FAVORITE MARTIAN TATTOO SPLIT ROBOBOY BIANCO E NERO PALMS HIS & HERS GOOD & EVIL BLIND PIG

WATCH DESIGNS
In addition to graphic arts, Steve sometimes designs clothing and accessories. These are designs for a playful line of watches for Swatch.

"My goal here was to generate as many watch-strap and face ideas as possible. It was a fun challenge, but also I was afraid that none of the ideas would be accepted. It was about idea survival—sort of like animals that have big litters. Some are bound to make it. Though only one idea had been contracted, two of the sketches were eventually made into watches."

REGALI DI NATALE
Abitare Magazine, Milan

END PAPERS (OPPOSITE)
These end papers, drawn for the alternative comics magazine *Drawn & Quarterly*, play on the simple and whimsical idea of showing an assortment of people and things in the front of the book and their skeletons in the back.

"I tend towards the sunny in my work. This is sometimes a liability, as I don't often get asked to illustrate pieces that call for gravity. This image may have been an attempt to redress that—a chance to inject some dark humor into the illustration."

NOAH'S ARK

For familiar stories, especially epic tales told
on a grand scale, the challenge is to give the
eye plenty to look at while keeping the design
simple. In general, with complicated pictures,
the viewer should be able to take in
the whole scene at a glance.

 This began as an add-on
drawing in my sketchbook.
I drew the animals a few at a time over
a long period. It was much like a doodling
exercise. Putting the whales on board doesn't
make sense, but I liked the way it looked.

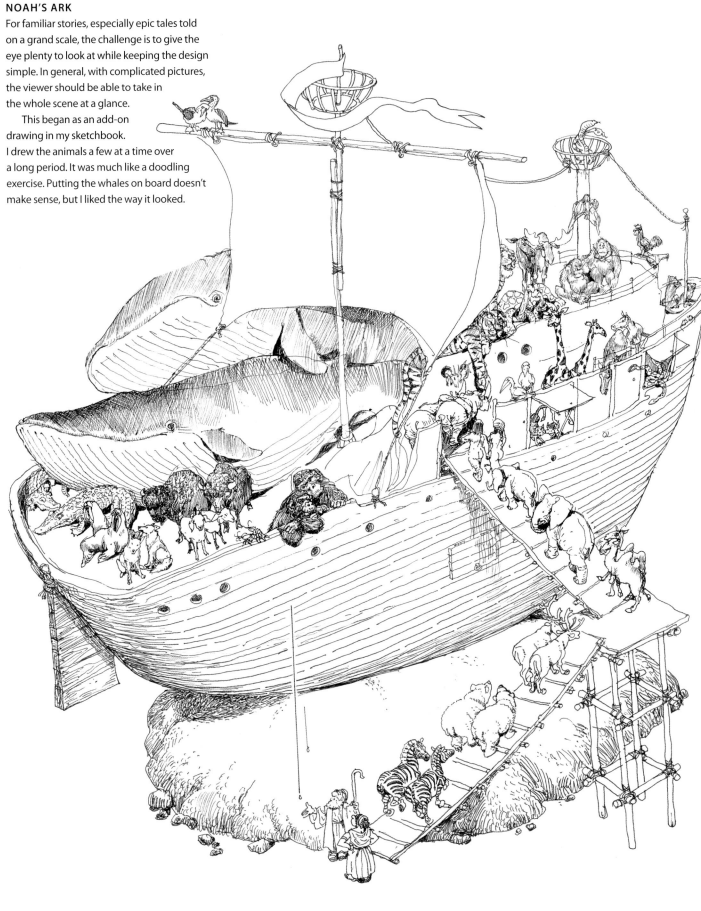

Storytelling

Combining Words and Pictures / Making It Vivid / Intensifying the Action / Inventing Characters /
Recycling Your Doodles / Illustrating Dreams / Working in Sequence

Human beings are natural storytellers. We make stories out of virtually everything, including our own lives. Storytelling is a method we use to make sense of the world, as well as a point of deep access to our imagination. Think about it: As we're rushing to an appointment, we are already arranging a mental narrative about why we're late. We make up stories about why someone failed to speak to us, why the economy is changing, why we like what we like. Even our dreams are stories.

This chapter is an exploration of the close connection between words and images, and of how access to one grants you access to the other. American humorist Mark Twain loved to tell bedtime stories to his grandchildren. Each night he would gather the children together and ask one of them to select a little glass figurine from a shelf of knickknacks. He would then make up a tale using the figurine as the main character. One suspects that even a gifted storyteller like Twain found this little trick a useful creative device. In a sense, the figurine gave him the story.

Picture-Making Tricks

Part of the work of the imagination is to surprise ourselves. We start drawing a character or two, and they begin to tell us a story—we get pulled into a drama of our own making. We look at our picture and wonder what might happen next. So as we create, we are sometimes the storyteller and sometimes the audience. This is a useful strategy, a trick really, for making pictures that tell tales. Here are a few others:

- Stories are told through the orchestration of elements: Establish a hierarchy of importance among the elements in your picture. You make something important in a variety of ways—size, contrast with other elements, degree of sharpness and/or detail, etc.

- A good story leaves some things unexplained. By "unexplained," I mean using such visual devices as obscuring, distorting, juxtaposing in odd ways, or radical cropping. These devices require the viewer to actively fill in the gaps with his or her own imagination.

- Believable fantasy is grounded in authenticity. Some realism in a drawing allows the viewer to more readily accept the fantastic elements.

- The mood of your characters is conveyed as much through body posture as facial expression. Consider the overall silhouette: Is it slumped? Angular and explosive? Stable and proud? The best way to create an attitude with body posture is to feel it in your own body.

- Details enrich a story and make it more real. A select few details are crucial to the story, while enrichment details add believability and interest.

- The anticipation of an event is sometimes more intriguing than the event itself. Consider depicting an event at the moment before the main action actually happens.

words and pictures

WORDS AND PICTURES

I like to stress the strong mental connection between words and images. While not exactly interchangeable, these two modes of thought are deeply intertwined. One triggers the other. Imagine two parallel ladders, one labeled "words" and the other "images." You begin an easy climb on one of them until, at some point, the climbing gets difficult. Now, instead of feeling stuck, you simply cross over to the other ladder. Suddenly the climbing gets easy again.

The creative storyteller learns to move fluidly from words to images and back again. Each of these two modes presents its own inner vocabulary—different, but overlapping and mutually supportive.

These drawings, nearly all taken from my sketchbooks, were drawn with no particular story in mind. Sometime later I added these captions as if they were illustrations of an existing story. Although I haven't yet done so, I feel that I could make up a story out of any one of these pictures. And so could you.

"Ali knew that the old cobra was still dangerous."

"To make matters worse, even the dog was rude to him."

"One of the elves sniffed the air and smelled something cooking. 'Where's Virgil?' he asked."

"It can't be mine," he thought.

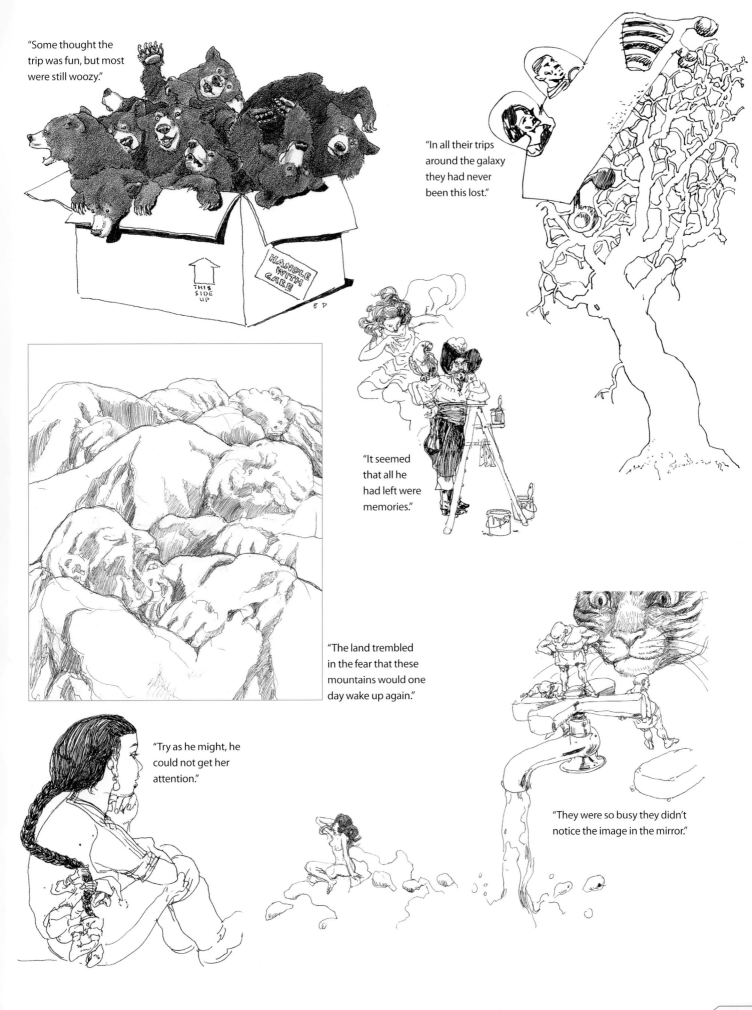

"Some thought the trip was fun, but most were still woozy."

"In all their trips around the galaxy they had never been this lost."

"It seemed that all he had left were memories."

"The land trembled in the fear that these mountains would one day wake up again."

"Try as he might, he could not get her attention."

"They were so busy they didn't notice the image in the mirror."

making it vivid

A picture might tell a story, but rarely can it tell the whole story. In fact, the level of curiosity your drawing raises is one measure of its effectiveness. If your picture provokes the question "What is going on here?", you have actually enlisted your audience in helping tell the story.

To this end, I like to find ways of intensifying the drama. Sometimes I redraw an image just to make it more vivid. This could mean making any number of alterations and transformations, such as strengthening the image, adding an element of mystery, creating an exotic background or getting more movement in the picture.

A BEGGAR'S WARNING
This little sketchbook drawing is the kind of classic encounter you might find in any number of tales of errant knights.

WIND-BLOWN APPARITION
Here the beggar is changed into a specter—perhaps a visage of death. Equally important is the spooky wind blowing his hair and garments. Not good for the knight.

THE GLOWING MESSENGER
A figure lit from within might suggest a spiritual presence, or perhaps someone enchanted. Note how the effect is mainly achieved by the strong lighting around the edges of the knight and horse.

PADDLING ACROSS TIME

Drama can usually be enhanced by strong contrasts. *Below*, I darkened the canoe near the bow and kept it lighter at the stern (emphasized in the diagram *at left*). This allowed me to play dark against light and light against dark.

Authentic details, drawn from observation, help impart a sense of reality to fantasy scenes. This church steeple is the one I see from my studio window.

THE ENCOUNTER

I began this drawing with the camel, not knowing where I was headed, then I added the little centurion (don't ask me where he came from). Finally, I drew the large head, using a mirror for the hand positions. Although this sketch has no intended meaning, it does seem to convey a little drama—perhaps an encounter on a journey.

THE ENTRANCE

I retraced the image and made some modifications. The hands have become trees and the face more of a concave shadow. This picture is ambiguous. Is the face a forest spirit? A bewitched hermit? A door to another world?

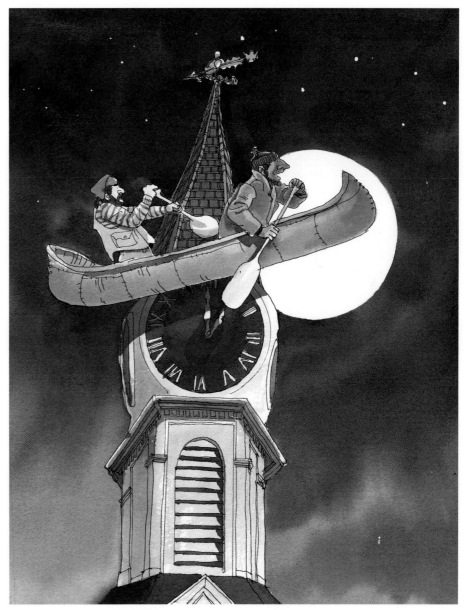

intensifying the action

INTENSIFYING THE ACTION

The way you arrange the shapes in a drawing speaks an abstract language. For example, verticals and horizontals tend to suggest stability, while diagonals generally suggest instability or movement. Likewise, smooth flowing lines suggest tranquility and grace, while sharp angles indicate action and violence.

These interpretations are not simply artistic conventions. They take advantage, at a deep unconscious level, of the way we "read" the world. Clouds, trees and even buildings can be made to look ominous or cheery simply by the way the shapes are handled. This points to the value of first seeing things in terms of their silhouettes, and only later adding the details.

One other technique in visual storytelling involves the use of shapes to direct the viewer's eye. A shape can point like an arrow, leading the eye along a desired path, or surround, like a frame or arbor, giving added importance to some key element. And then there is what we might call the law of contrast—one passive shape in a frenzied sea of activity, or vice versa, calls attention to the lone dissenter.

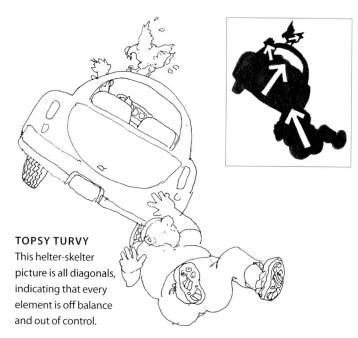

TOPSY TURVY
This helter-skelter picture is all diagonals, indicating that every element is off balance and out of control.

SHIP OF FOOLS
Here, chaos is conveyed by the many conflicting lines of force. The size disparity between the ship and the waves only makes you glad you're not aboard.

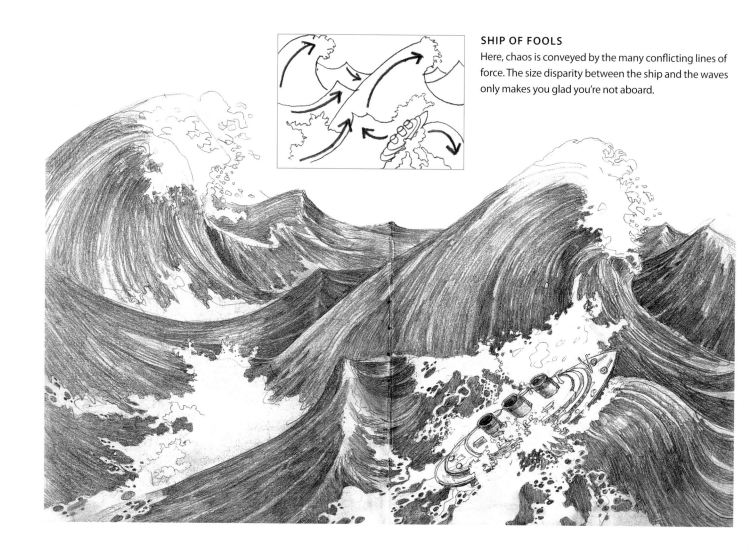

ROYAL TREATMENT
The elements of this writhing mob, reaching, threatening and grabbing, act as arrows that point to the hapless king.

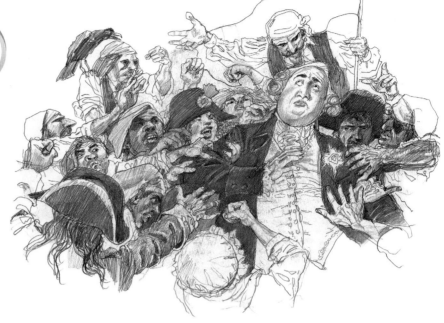

exercise 24

Intensifying

Make a drawing of two silhouetted figures in extreme action (running, fighting, dancing, falling, etc.). Make sure that the silhouette of each figure is active, angular and placed on a diagonal.

MULES ARE STUBBORN
These jagged, angular silhouettes emphasize the violent struggle taking place in this picture. I made this drawing on a plane after watching the movie *Operation Dumbo Drop*.

exercise 25

Framing

Make a drawing of a small, central figure surrounded by large background shapes (clouds, trees or man-made structures). Arrange the background shapes so that they either frame or point to the figure.

inventing characters

INVENTING CHARACTERS

The first requirement of a good story is a strong, memorable character—from shy and lovable to eccentric and outrageous. Make your character a definite individual. For authenticity, there is no substitute for basing your character on a real person and drawing from life. People are generally flattered to be asked. Make studies of their hands. For many people, hands present the biggest drawing challenge. Whenever possible, draw hands from life. Pay attention to clothing, shoes and hairstyle. Such details help define personality.

If you're making a series of illustrations for a story, you'll need to know your character well. It's important to draw them in a number of positions and from a variety of angles. If you want to show extreme action, photographs help, but use them only as a starting point. You can rarely get the action extreme enough in a photograph, so you need to improve on the photos, pushing them into more exaggerated expressions and body positions. And when you draw the person in action, make sure the overall silhouette expresses that action.

Using Authentic Backgrounds

Use details and backgrounds from your own life to make your drawings more authentic. If you're on a plane, draw your character on a plane. In this way, your work will develop narrative muscles. Also, use accessory objects like hats and umbrellas as props to signify various kinds of actions. Choose elements that give your character a unique identity.

An Invented Character

Make a series of drawings of a character out of your imagination. Draw your character in different poses and in different situations. Include some back views and ¾" (2cm) back views. Your character needn't look realistic; instead, strive for an exaggerated and expressive feeling in the poses and actions and literal realism in the props and backgrounds behind them. Save these drawings for future work.

modeling characters in clay

MODELING CHARACTERS IN CLAY

Modeling a head out of clay gives you a tactile as well as a visual sense of a character. Feeling the hollows of the eye sockets and the ridges of the cheekbones deepens your understanding of the face and head.

Once you have created a model like this, you can then alter it in subtle and even major ways. Note how, with a few changes, the character on the top row of photos becomes the wilder, fiercer visage on the bottom row. Draw your character from different angles and under different lighting effects to make the most out of the model.

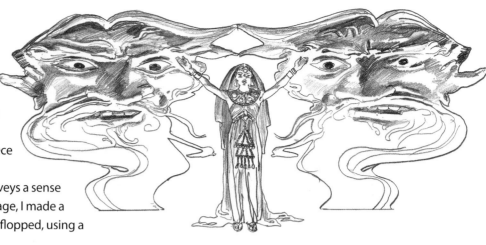

Lighting Effects

Clay modeling helps you appreciate the powerful effects of lighting on the mood of a picture. The photographs *below* of the head show how different lighting can change a piece from comforting to frightening.

The strongly underlit drawing *at right* conveys a sense of sorcery and magic. To create the mirror image, I made a tracing of the man's head and then redrew it, flopped, using a light table.

THE CHALICE

Here, I drew from the underlit profile of the clay woman and then drew two versions of the clay man, using different angles and light effects. Attention to detail imbues a sense of believability to a scene like this.

TRINA SCHART HYMAN
Imagination Grounded in Reality

Trina Schart Hyman was a gifted and acclaimed children's book illustrator. Her characters are always very real and expressive, no matter how fanciful the tale. One of her gnomes may have outlandishly oversized feet, but the knuckles and bunions are convincingly drawn. A big toenail may be split, or the buckle on one of the sandals may be broken. These touches imbue a believability to the story by grounding readers in their own experience: We've all had a broken buckle.

Trina had a way of feeling her subjects: she tried to literally experience her character's physical sensations. She once illustrated a dragon picking up a horse in its mouth. This entailed an unusual view of the horse's underside with awkwardly flailing legs. She simply felt what it might be like for a horse to be lifted in such an ungainly and terrifying way, and then drew the image from her own body sensations and her general knowledge of horse anatomy. This is a *double description*—two separate streams of information about the same subject. Double descriptions greatly enrich an artist's mental pictures.

Unlike most illustrators, Trina did very few preparatory sketches other than a few simplified compositional thumbnails. She preferred to pencil right on the final illustration. This, she felt, kept an immediacy and aliveness in her scenes and characters. But every once in a while, Trina did resort to sketching. Here are some monster sketches Trina made for the book *Hershel and the Hanukkah Goblins*, written by Eric Kimmel (Holiday House, New York). She added her own irrepressible commentary.

Illustrations copyright 1989 by Trina Schart Hyman. Reprinted from HERSHEL AND THE HANUKKAH GOBLINS by permission of Holiday House, Inc.

"Why is it that we think of arms and wings as having a connection?"

"His tail could also scratch his back."

"This one looks too much like everybody's grandfather or banker. Three eyes??? Always hard to pull off, because then what do you do with the eyebrows? I like the teeny, scary, weird arms, but then how would he play the dreidel? With his tail, maybe? . . . "

Cultivating a Visual Memory

Trina had a phenomenal visual memory. Without looking, she could draw any room of her house—which included a myriad of art objects, knickknacks and pictures. She could even draw vivid details of the house she grew up in.

How does one account for such an ability? Trina taught herself to be a keen observer. She took time to notice the graceful slouch of a young girl in a chair, the thick fingers of someone who works with with his hands or the way a strong light falls on velvet. By paying attention to these details, she remembered them.

Trina fueled her memory by spending a lot of time painting and drawing from life. I know because I painted with her every Monday for over ten years. We'd invite friends to pose for us, and with two other colleagues, we'd paint, have lunch, then paint some more. A weekly ritual of drawing or painting from obser-vation does wonders for an artist's visual memory.

THE FINISHED ILLUSTRATION

"This is the dreidel-play-ing goblin: Money-loving, greedy and a gambler, he's described in the text as having a "fiery red face and two enormous horns." He's also a dim bulb. This first concept is okay, but too human (he looks too much like my ex-hus-band!). Also, the Bambi antlers are too endearing, somehow. What can I do to make this guy less human and more of a Goblin?"

"The Tail—i.e., the wife? Or the conscience?? What torture!"

"The idea of many noses (sixteen!) was handed to me by a neighbor who'd gone with her two sons to the South of France. The kids claimed to have seen a guy there who had sixteen noses!! I kept questioning and found out that he had one big (original) nose, with other noses growing out of it??? Good goblin material!"

recycling your doodles

RECYCLING YOUR DOODLES

If you spend enough time doodling, you'll never run out of story ideas. Because we generate doodles with nothing particular in mind, they often offer the most freedom as story subjects. I go through my doodles periodically and pick out the ones that already look like story ideas. They make no real sense on their own but have some spark of strangeness or daring that appeals to me. Sometimes I make photocopy blowups and work directly on those. I may also use the doodle as a jumping-off point, perhaps redrawing the characters in a totally different context, and sometimes I'll begin a doodling fragment on a larger sheet of paper and add to it a little at a time so that it eventually builds into some sort of story.

FINDING THE STORY
Save doodles that seem to tell a story and redraw them with a more complete idea in mind.

THE GENIE'S MASK
After making the building block doodle *at left*, I got the idea of putting someone behind it who looked like the mask. I was thinking of a character somewhat like the genie from an old movie, *The Thief of Baghdad*. I made a photocopy of the doodle and then did the rest of the drawing directly on the copy.

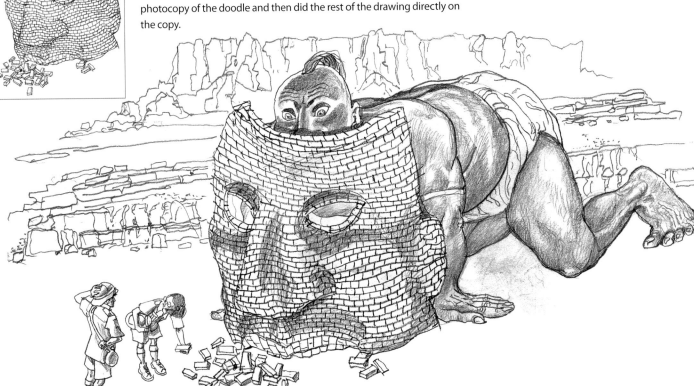

MY OCTOPUS

I did this doodle of man hanging by one arm, intending to have something hanging off him. When I added the octopus, I drew them hand in hand as if it was a rescue. It looked so friendly, I began to think of the octopus as a pet and started to imagine a tale of their affectionate adventures together.

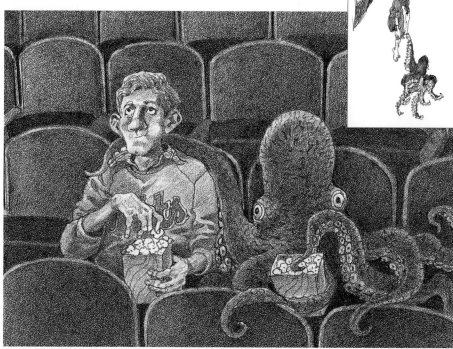

exercise 28

Making a Story From One of Your Doodles

Go through your doodles and select one—one that seems to tell a story—to serve as a key element in a new picture. The doodle can be used either as the background or a featured object. If you need a central subject, use one of your character drawings.

GULLIVER'S MOUSE

When I sketched the four figures at left, I had no idea what they were reacting to. I imagined it was something that provoked curiosity and amazement more than fear. I decided on a giant mouse. Then I began adding crowd members, a few at a time. On a whim, I decided to make each person an individual from different places and different eras.

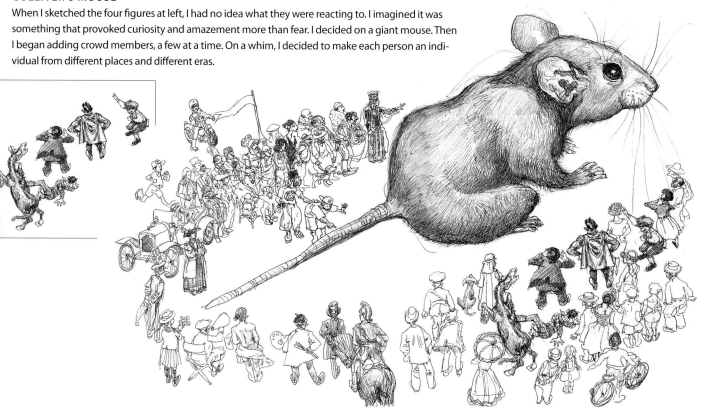

illustrating dreams

ILLUSTRATING DREAMS

From a creative standpoint, the nice thing about dreams is that they don't bother to explain themselves—they simply present us with a rich stream of images. Psychologically, it may be useful to understand the meaning of these images, but creatively, it's liberating to draw from that stream without any need to understand. For most of us, our waking life is spent sorting things into logical catergories. But when we sleep, unlikely, unexpected and uncensored images and combinations of images flow in abundance. We can tap this resource.

So much of dreaming is about mood and feeling. These are elusive qualities, conveyed mostly by suggestion rather than by direct representation. Manipulating contrasts, exaggerating body postures and emphasizing symbolic elements are a few ways of communicating mood in pictorial language.

You may have your own reasons for illustrating your dreams, but for me, dreams are simply source material for imaginative pictures. And because dreams often come to us as fragments, we need to assemble them into a unified whole. This means creating a perspective, moving and removing elements, and adding enriching details. You also might need to find reference pictures. In the *Catching a Train* studies on the facing page, I used some old locomotive photos to get a more authentic feel.

For the *Lonely in Paris* drawing, *far right*, the cats in the window were taken from a sketch I did of my own cats. I always admired and envied their utter bliss when they curled up together in this way, and in a dream I watched them through a window while indifferent, elegantly dressed people passed by.

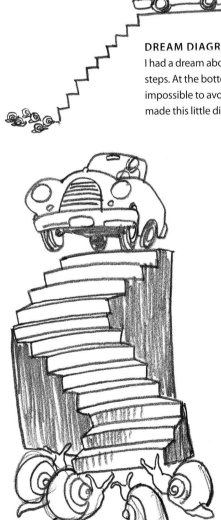

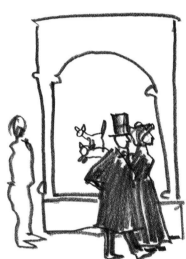

DREAM DIAGRAMS
I had a dream about driving a sports car down some steep steps. At the bottom were a bunch of snails that would be impossible to avoid running over. To remember this dream I made this little diagram in a notepad that I keep by my bed.

IN PARIS, WISHING I WAS A CAT

CATCHING A TRAIN

BUMP, BUMP, BUMP, SQUISH
Later I began to play with the composition. This sketch suggests some movement, as well as a more dramatic perspective. The bigger snails are now more like characters in the drama.

CARRIED AWAY WITH REGRET

Illustrating a Dream

Keep a notepad by your bedside so that you can write down your dreams (or make dream diagrams) the moment you wake up. After you have recorded six to ten of these, choose one to illustrate. Spend some time working out the composition. You might need to make several compositional sketches before settling on the final one.

Make your illustration vivid; capture the surreal qualities of the dream. Draw from photographs or actual objects when necessary for realism, but strive for an overall dreamlike mood.

sequences

A sequence is a series of drawings linked by time or logic. Each drawing flows from the preceding one and sets the stage for the next. The transition from one drawing to the next can be extremely simple and obvious or subtle and complex.

Sequence drawing is much like storyboarding a movie scene. Break the action down into discrete steps, often employing "movie thinking": zooms, close-ups, pans and the like.

Drawing sequences shift the question of "What shall I draw?" to "What happens next?" In the sequence *on the facing page* which I call *Cat and a Ball*, I had no idea where I was going when I did the first drawing. Once I started making the ball bigger, the story began to evolve. I relied on a limited repertoire of film devices and noodling tricks (which are labeled) to move the story along.

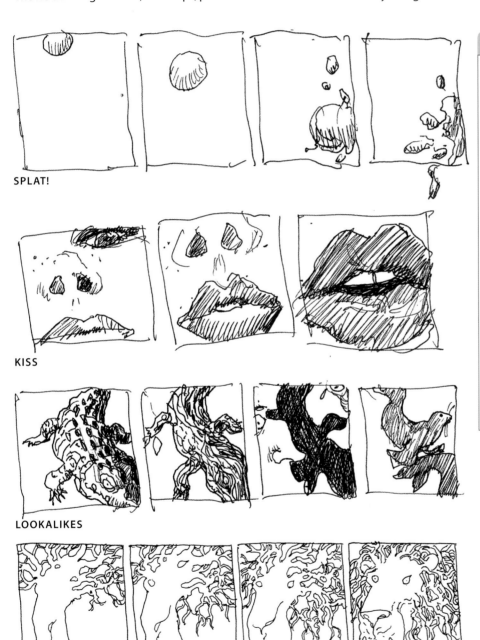

SPLAT!

KISS

LOOKALIKES

TRANSFORMATION

exercise 30

Drawing in Sequence

1. Make a row of four panels about 3 inches (8cm) square. Draw an object or person in the first box. In the next three panels, show some progressive change—make something happen. Here are just a few possibilities: collision, deterioration, melt-down, transformation, growth. Strive to make the changes evenly spaced from panel to panel.

2. Divide a large sheet of paper into twelve equally-sized panels. Leave a little space between each panel and a margin all around. This is your storyboard; use it to tell a tale in a sequence of drawings. Think of your story as if it were a movie, with the action advancing from frame to frame. Consider using film-making techniques as well as the doodling techniques described in chapter one.

BALL STARTS GETTING BIGGER (PROGRESSIVE CHANGE)

CAT BECOMES TIGER (TRANSFORMATION) **BALL FLOATS UPWARD; TIGER HANGS ON (INTENSIFIED ACTION)**

BALL BECOMES MOON
(PULL BACK, TRANSFORMATION) **TIGER FALLS . . .** **. . . AND LANDS IN WATER**
(INTENSIFIED ACTION)

 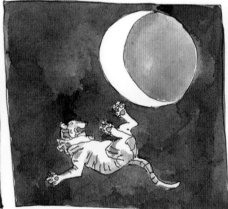

LICKS WOUNDS . . . **SILHOUETTE, MIRROR IMAGE** **ZOOM IN TO CLOSE-UP**

VICTOR MOSCOSO
Surrealist Sequences

Victor Moscoso is a well-known graphic artist who rose to prominence in the 1960s with his San Francisco rock poster designs and his work in the underground comics. Moscoso created these ingenious sequences for Zap Comix. Originally he drew the panels on separate 5" × 8" (13cm × 20cm) index cards as variations on a theme, then arranged them into sequences.

Remarkably, Moscoso worked directly in ink with a Rapidograph pen. He did no conscious planning or preliminary pencil sketches. He just invented as he went along, using elements from the cartoon world: lightbulbs, word balloons and vaguely familiar characters. The result is kind of meta-cartoon, a cartoon about cartoons. Moscoso's free-associative method is very much in the spirit of the surrealist artists of the last century.

So what is the story in these images? "The story is that there is no story," says Victor. "Like life, it has a beginning and an end, but most of the stuff in between is random."

To put it another way, the story is whatever you make of it. And the interesting thing is that you can make a story out of it, or at least fragments of a story. It's almost inevitable. If you put some characters and elements together in an interesting setting, and show some continuity from picture to picture, your viewers will see a story of some sort even if it's one they make up themselves.

CHOOSE YOUR OWN ADVENTURE

This Moscoso sequence seems very dreamlike to me—a kind of reality without logic. Three-dimensional mixes with two-dimensional. Soft, stipple shading makes the forms appear rounded. Parallel lines, getting closer together, give an illusion of depth. And then, here and there, the elements look cut out and flat.

I love to think that there's a story present here. Something about a duck without a vision and a companion (therapist?) who opens his eyes to a new way of seeing. Some precarious moments ensue, but it all seems to end well. That's one idea, anyway.

MICHAEL MITCHELL
Visualizing a Story

Storyboards for movies are made for the purpose of plotting the action and diagramming the shots. In Michael Mitchell's hands they become a miniature art form, as the little compositions at right attest. Mitchell's subtle tonality and his sure, fluid line always reveal the process. He reminds us, even as he involves us in a story, that these are simply marks on paper. These, and his larger concept pieces, become a celebration of drawing itself.

The drawings on these pages were made for a film project under development—a runaway King Arthur satire. Sir Gleam is a rogue knight on a rampant quest to lighten up the Dark Ages. He dons a missile helmet, saddles up an old Harley and takes off on a series of well-intentioned misadventures. His odyssey takes him through a series of narrow escapes, from underwater sea monsters to "mountain gorillas." Along the way he wreaks unintentional havoc in high places.

At this stage of development, rather than following a tight script, Mitchell is producing idea pieces—images that will stimulate the imaginations of the writers and producers. As it happened the film wasn't made, but the drawings and storyboards stand on their own as marvelous works of fantasy art.

Take 2—"Sir G" Hitting on "Lady of Lake" Quest (underwater fade-out)
HB and 3B pencil

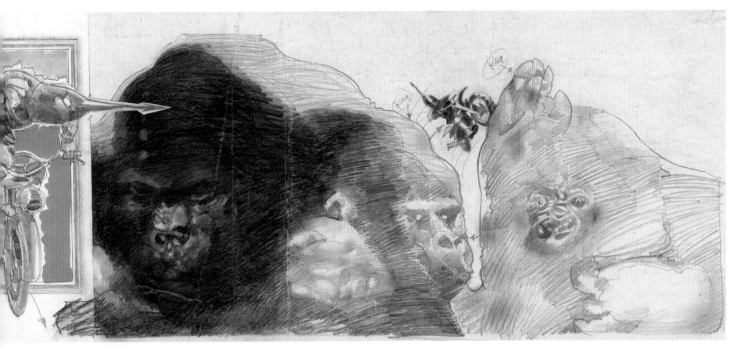

A Ride Over Mountain Gorillas
4B pencil and colored markers

VALLEY

The drawing *at left* was done from a photograph. I just wanted to capture the character of the shapes in black and white. I used a stipple for the intermediate tones.

SHAPE STUDY

Here are some of the shapes used in *Valley*, drawn close up with a 3B pencil. Note how some edges are sharp and others soft. Isolated in this way, they look almost like birds in flight.

MOUNTAINS

Here I have turned *Valley* upside down and added a lot of enrichment shapes (I'm a great believer in the upside-down method for pattern drawing). As I drew, I was thinking much more about shape than I was about landscape. A surprising feature of this drawing is that, in this inverted state, the valleys become mountains and vice versa.

Exploring Pattern

Repeating With Variation / Interpreting Nature / Describing Form With Rhythmic Lines / Merging Shapes / Revealing Shape Characteristics / Mapping and Coloring / Escher Tiling

When you look at the landscape from a great height, you see that everything is in a pattern. Fields, forests and lakes appear as a set of interlocking shapes like little puzzle pieces. Some of the boundaries are sharp and defined, others soft and indefinite. And even though we know we're looking at the real world, everything seems flattened out and vaguely abstract.

What is pattern? I used to think of it as something that occurs exclusively in the world at large, certain observable regularities in the environment that just happen to show up for us. But I've come to realize that pattern also occurs as a higher-level product of our mind. When we grasp pattern, we do something akin to grasping the part and the whole at the same time. Some sense of connectedness lights up in the visual centers of our brain, a flash of wholeness and unity. The experience is usually aesthetic and pleasurable—like an "Aha!"

Seeing patterns involves seeing your subjects as shapes and not objects. Pattern is a phenomenon with few rules and endless variations, but these things hold true:

- Shapes are flat.
- The spaces between objects are also shapes.
- Everything locks together.
- There is a general sense of repetition, but not exact repetition.

Once, in an airport, I noticed a man with a shiny silk suit. Whenever he moved, even slightly, the light and dark shapes of his suit shifted and changed. I could see this like a map of changing territories, or a landscape in motion as viewed from a plane. It can be very helpful to create a map like this, some basic outline of the important shapes to guide you where you're going. When you draw with this perspective, you exercise a new kind of creative control. Distorting shapes is easier than distorting things—you have fewer preconceptions about how shapes are supposed to look. You can bend and stretch them at will.

SILK SUIT

SILK SUIT MAP

repetition with variation

REPETITION WITH VARIATION

A certain regularity, similarity or uniformity among parts is at the core of pattern sensing and creation. But absolute uniformity quickly bores us. We need the parts to be recognizably related but not exactly the same.

One way to capture this quality in a drawing is simply to observe it. Objects in nature, like the bean roots on this page, often exhibit similar, but not exact, shape regularities. Or you could draw a single object, like a toy truck or a pushpin, over and over from different angles. Also try drawing many different objects with uniform spacing between them. Here, it's the spacing that provides the regularity and sense of pattern.

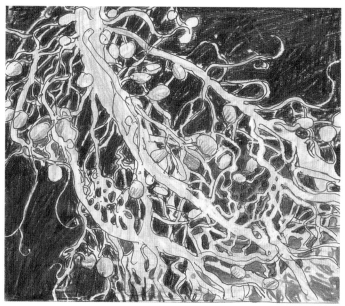

ROOTS
I made this drawing of bean roots from a biology textbook. The pattern is enriched by a contrast of two kinds of forms: the curving tendrils and the bean-shaped nodules.

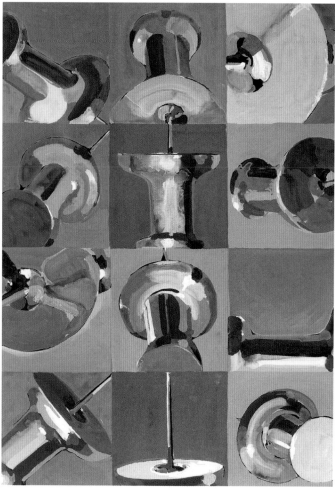

PUSH PINS
This large piece (18" × 24" [46cm × 61cm]) was done in black, white and gray poster paint. I liked the variety of reflected shapes, especially the bright whites.

ALL TOGETHER NOW
For this kind of drawing, start with a single shape (I think I started with the archer), then fit new shapes around it, keeping the spaces between as uniform as possible.

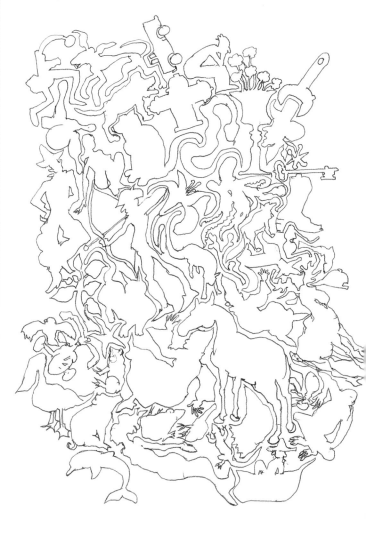

BATTLE CHARGE

I started this drawing by copying the knight from a movie still. Once you get a template like this, the other drawings are just variations involving little alterations of angle, body posture and flowing cape.

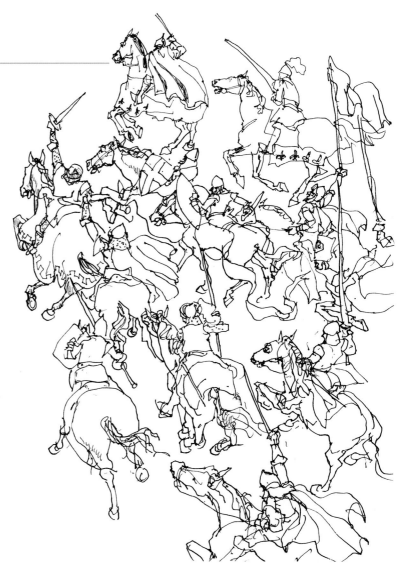

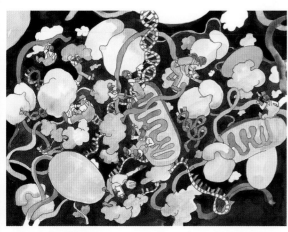

CELL MACHINERY

This is a fantasy drawing of the inner workings of a cell. There are about seven different kinds of shapes, repeated in different positions.

MASS STRUGGLE

I like to draw seething, turbulent crowd scenes, mostly because of the interesting and varied patterns they make. In this one, the shapes are all merged together into a single, writhing mass.

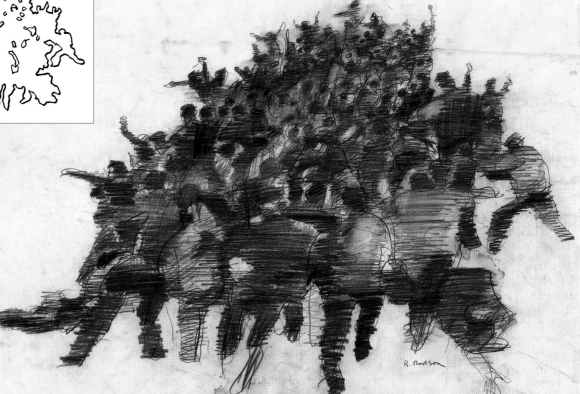

interpreting nature

When you want to draw a patterned landscape, it's useful to ask yourself questions about the translation from eye to hand. Are the patterns linear or in aggregates? Are they rhythmic or chaotic? What stroke or strokes that will capture the feeling efficiently?

These questions are often answered by trial and error. As you begin to make marks, your hand generally takes over. Your stroke is a little algorithm, repeated many times with different variations.

Pattern is a bridge for transforming an observational drawing into something different and unexpected. Once you have found a way to express the character of your subject, ask yourself what you can do with it or what next creative step you might take. For such a transformation, you might do well to look, not at your subject, but at your drawing—you're more apt to see new possibilities. Perhaps you can do a spin-off piece where you intensify the stroke, use more pressure or employ a bolder tool. You might turn the work upside down and rework the scene into an abstract. You may see metaphorical possibilities: rocks that look like creatures or clouds, or the branched structure of a river that resembles the veins of a leaf or the back of a hand.

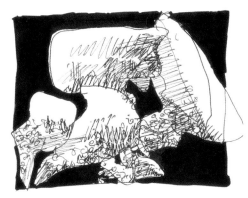

VOLCANIC ROCKS
I liked the texture of these rocks I saw on a beach.

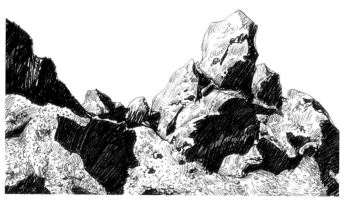

CRAGGY
I drew these rocks with a fine textural stroke and black shadows. Then I turned the drawing and retraced it as two matching halves, *below, left*.

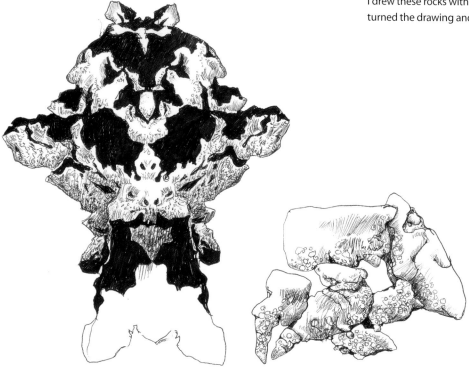

PUZZLED
Bilateral symmetry usually suggests some kind of creature, but you never know just what you'll get with these mirror-image drawings. This one seems to have multiple faces, stacked vertically.

CRITTERS
I re-drew "Volcanic Rocks" (*top of page*) with slight modifications. To me, they look like fantasy animals with almost cartoonish features.

exercise 31

A Patterned Landscape

Observe a rocky subject and make several sketches. Pay particular attention to the type of stroke you use to capture the character of the rocks. Now, spin off: Choose one of your sketches and trace or redraw it to achieve a more dramatic result. Try one or more of the following:

- Turn the drawing upside down or sideways.
- Make a mirror-image drawing.
- Choose a bolder drawing tool.
- Emphasize the metaphorical qualities. If your rock sketch resembles something else even a little, bring these qualities out in a new drawing.

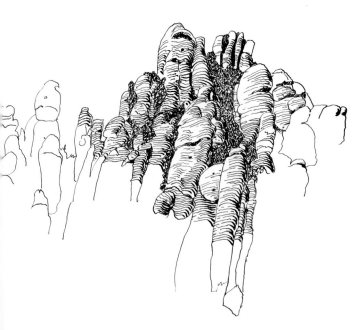

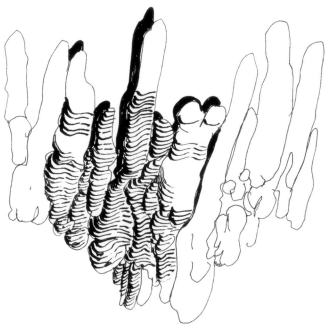

SERRATED MOUNTAIN

This drawing of the mountains of Montserrat was done with a crow quill pen and ink. The serrations were made by putting increased pressure on each stroke of the pen as it moved from left to right.

SURREAL FORMS

This drawing was made the same way, but with a chisel-point calligraphy pen. I turned the drawing upside down to add the black shadows.

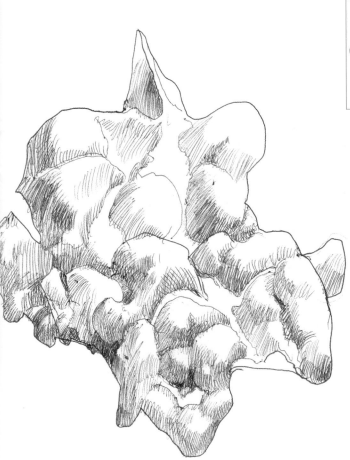

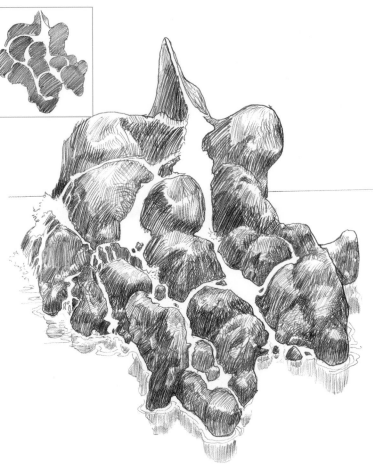

WALNUT

I like drawing walnuts because they look so much like other things—brains, ruins, landscapes. After I drew this one, I noticed that the white recesses looked like water. I decided to retrace the drawing, darkening all but the water areas.

ISLAND IN THE STREAM

Here, the walnut is transformed into a strange landscape. As this drawing developed, I began adding little touches like foamy splashes, reflections and a horizon.

interpreting nature

INTERPRETING NATURE

Drawing nature requires a kind of shorthand; we need to find ways of working that summarize, and actually stand in for, the overwhelming layers of detail arrayed in front of us. Our strokes need to represent what we see, but in the most economical way.

We do this, as I have suggested, by shifting from drawing things to drawing patterns. Instead of asking "What kind of bark is that?", ask "What are the rhythms here? How do the lines and shapes move, twist and flow?" Answer these sorts of questions not with your head, but with your hand and your kinesthetic sense. Your drawing is apt to become freer and more expressive. And when you choose to spin off or intensify, the fluidity of your strokes can often suggest the new direction.

Trees are a bounty to artists: They offer an endless feast of shape and pattern and can express youth, age, serenity, tenacity, majesty and just about anything else. Anytime you can't think of something to draw, there's always a tree.

These trees, from my sketchbooks, were all made with a conscious shift to drawing shape and pattern.

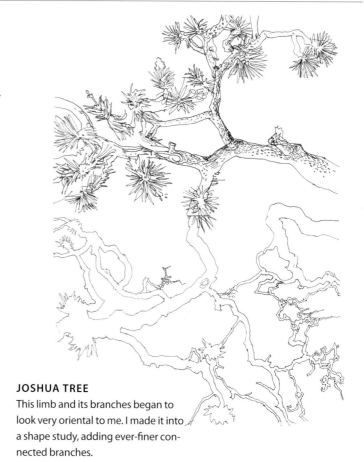

MIXED MEDIA
Most of the drawing below was done with a heavy black marker. But for the oak bark, I added some little ballpoint strokes.

JOSHUA TREE
This limb and its branches began to look very oriental to me. I made it into a shape study, adding ever-finer connected branches.

BIRCH AND OAK
When I observe a contrast, I tend to push it further in my drawing. Here, I liked the difference between the smooth birch and gnarled oak.

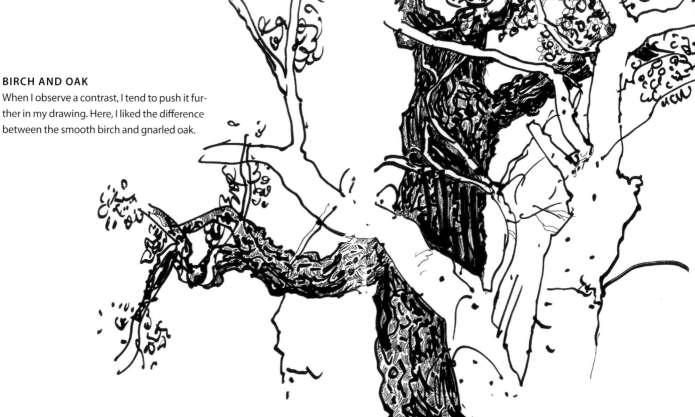

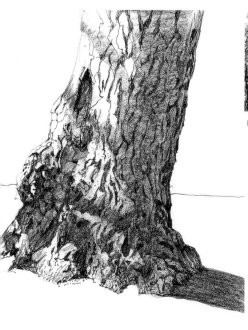

Detail

TRUNK

I liked the combination of rugged and softness in this subject. I used a fine tip marker for the bark shapes and black Conté crayon for the shadows. Before I added the shadows, I made little indentation lines in the paper with the end of a straightened paper clip. The Conté skipped over the indents, leaving white edges on some of the bark pieces.

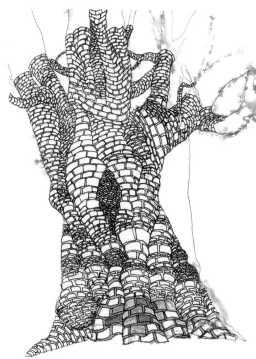

MANMADE

The above drawing evolved from an accident. It rained while I was drawing, and some of the lines from the drawing at left bled onto the next page of my sketchbook. I had already drawn some bricks on the page, so I just continued the pattern over the entire tree.

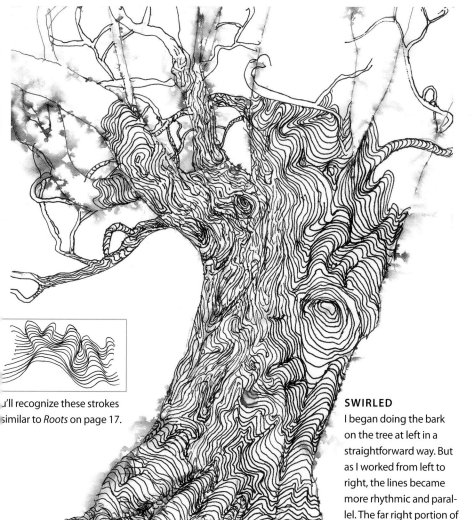

...'ll recognize these strokes
...similar to *Roots* on page 17.

SWIRLED

I began doing the bark on the tree at left in a straightforward way. But as I worked from left to right, the lines became more rhythmic and parallel. The far right portion of the trunk is pure decorative fantasy.

exercise 32

Textural Patterns

Repeat Exercise 31 using a tree trunk or branches as your subject. Make several sketches, emphasizing the character of the stroke. Then make a spin-off drawing that further emphasizes and strengthens the pattern. The spin-off need not look like a tree. Rather, it should embody more abstract qualities like boldness, vigor, rhythm and movement. Strive for a strong difference between the original sketch and the second drawing.

describing form with line

DESCRIBING FORM WITH LINE

With practice, you can make linear drawings that fool the eye into believing that the image is three-dimensional. Besides being aesthetically interesting, this method of drawing will teach you a lot about form. In directing your line around contours and up and over bumps, you understand form at the neuromuscular level. This technique employs a couple of visual tricks:

1. Draw the lines so that they appear to curve around the object.
2. Make the lines wider apart in some areas and closer together in others.

closer

wider

VARY THE SPACING AND FOLLOW THE FORM
Watch the spacing variations—lines grow closer together as they travel over a bump or around a form. Also, draw lines so they appear to curve around the contours of an object.

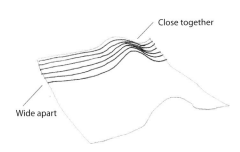

Close together

Wide apart

CREATE THREE DIMENSIONS
The illusion of three-dimensional forms can be produced by undulating parallels which are sometimes apart, other times close together.

WORK IN PATCHES
Change the direction of your strokes for each separate patch.

AVOID USING OUTLINES
Although it may not look it, these intertwined forms were done entirely without outlines. The illusion is produced by the way the lines change direction or gather together at the edges.

PATTERNED GRASSHOPPER
I slipped the macro drawing from page 46 under a fresh sheet of paper and put them on a light table to make this piece. The diagram of the eye area shows how I changed the direction of the strokes for each little patch.

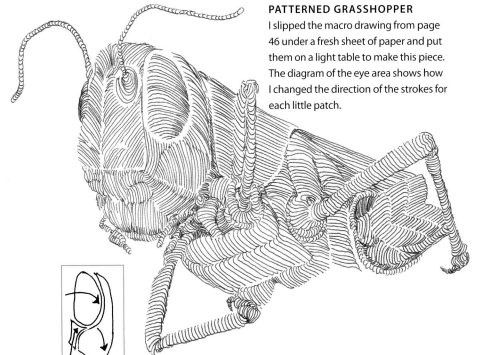

CRACKED NUT
Here's another example of working in patches, but in contrast to the relatively straight lines of the grasshopper, these lines are more undulating and rhythmic.

Finding the Unique in Conformity

There's a tendency to think of drawings like these—or any work employing a controlled technique—as rigidly mechanical, leaving little room for individual creativity. But you cannot help being yourself even when executing a rote algorithm, as evidenced by the drawings below.

Rhythmic Lines

1. Take one of your previous drawings and redraw it in rhythmic lines. Do not use outlines. Let your curving parallels describe the forms by bending around them. Your lines should converge near the edges and widen apart in the central regions.
2. Do a second rhythmic line drawing of an object, but do this one from direct obsevation.

Mixed Artichoke
Reinhart Sonnenburg

Closed Artichoke
Paul Rump

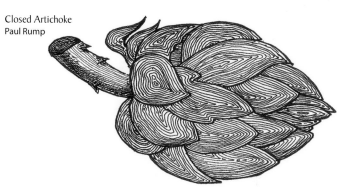

Ruffled Artichoke
Aya Itagaki

Double Artichoke
Joan Waltermire

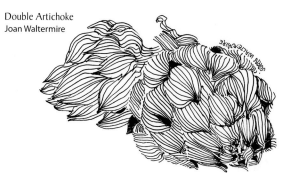

Wilted Artichoke
Stephen Plume

Open Artichoke
Donald Helms

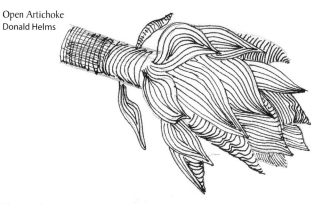

Bud of Artichoke
Joey Tate

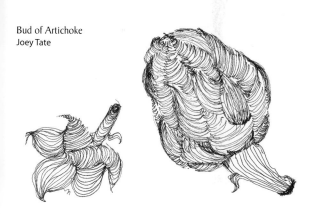

Thin Artichoke
John G. Crane

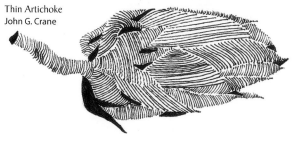

RICKER WINSOR

A Strong Attack

Ricker Winsor took up drawing and painting at age thirty and never looked back. A dedicated naturalist and former photographer, Ricker had already trained himself to be a keen observer. But his approach to drawing is based not on realism, but rather on a bold expressionism with an emphasis on pattern. He has developed what he calls "a strong attack," vigorously applying ink washes with large brushes and pens that he makes himself. He works large (generally 18" × 24" [46cm × 61cm] and larger)

so that he can draw with his arm and shoulder rather than just the fingers and wrist.

Always seeking to capture the essence of things, Ricker works with laser-like intensity. Where others strive for fine detail and subtle shading, he looks for large masses and renders them with energetic strokes. The repeat-stroke brushwork in some of his work, especially his landscapes, looks like impressionist painting in black and white.

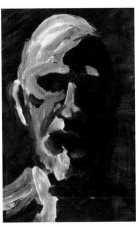

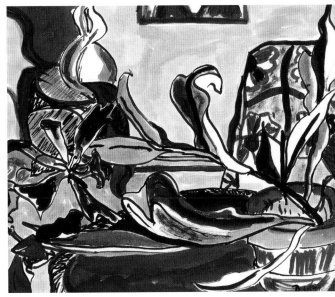

RICKER'S TOOLS
A brush, a palette of ink washes and a few pens, made from a reed called "phragmite."

SELF-PORTRAIT
This drawing was done with ink and white poster paint. As well as a likeness, it's a study of light and dark. The shadow side of the face all but disappears into the background.

STILL LIFE WITH HOUSEPLANT

TURBULENT PATH

ARTICHOKES, RADISHES AND SQUASH

THE WOODS NEAR BRADFORD
Ricker uses a variety of bold strokes to convey trees, ground, mountains, etc.

VIEW FROM THE VERANDA, BIMINI, THE BAHAMAS
This interesting composition includes a "drawing of the drawing" in the lower left of the picture. The artist's palette is at lower right.

shape character

To acquire a sense of how shapes soften, curve, bend and taper, we observe with real care, taking our time. While our initial attempts at translation may be slow and painstaking, we are building a foundation. In time we "get" the character of the things we draw—not so much as a concept, but as a feeling. That's when things start to flow smoothly.

Motorcycles, with their tubular chrome and sweeping lines, seem to be made for shape studies. But it's the wealth of abstract, reflective detail that most attracts me.

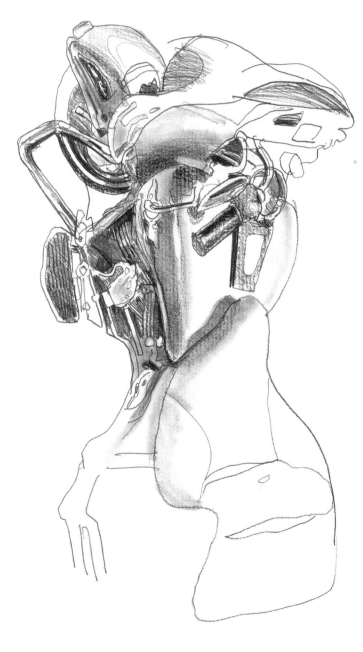

Shape Play

In each of these drawings I took a small idea, like shiny surfaces or wobbly shapes, then pushed it to the extreme. This sometimes involved retracing, literally tearing and cutting apart the drawing, redrawing the shapes as geometric patterns or radically cropping to bring out the abstract qualities of the subject.

BYZANTINE

ULTRA SHINY

WATERY

SHATTERED

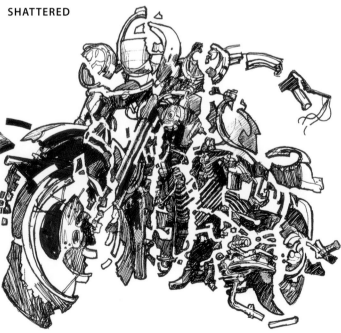

WOBBLY

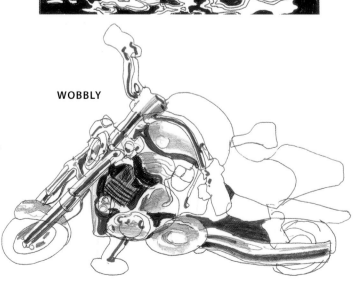

merging shapes

MERGING SHAPES

Shapes describe things, but sometimes indirectly. Often an image that seems immediately recognizable is actually made up of surprisingly abstract shapes. Observed up close, the pieces are little shards and blobs, while at a distance they suddenly fuse into a distinguishable picture.

Shape mergers occur when two or more shapes of the same value blend together as a single image. The dancer's black leotard and the black doorway (*right*) have no separating boundary. In our mind's eye we have little trouble seeing them as distinct, but this visual ambiguity tends to flatten and unify the image. It activates our sense of design.

Consciously creating shape mergers helps you transition from drawing things to drawing shapes. And it helps you make pictures in which the parts all lock together into an integrated whole. This is a pretty good definition of design.

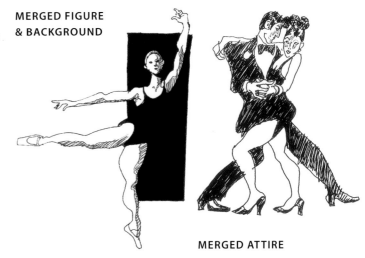

MERGED FIGURE & BACKGROUND

MERGED ATTIRE

MERGED SHADOWS

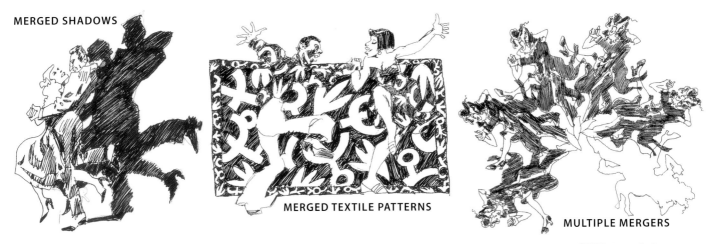

MERGED TEXTILE PATTERNS

MULTIPLE MERGERS

Here's a fine example of the beauty of merging complex shapes. In Robert Baxter's pencil landscape (*above, left*), he makes only the subtlest of distinctions among the tangled elements. In the wash drawing (*above, right*), he merges and simplifies even more, creating an almost abstract design.

THE MIND "FILLS IN" WHAT ISN'T THERE
At left is a detail from a drawing of an old movie still, showing how little information is needed to make a picture understood by the viewer. The full drawing is shown *below*.

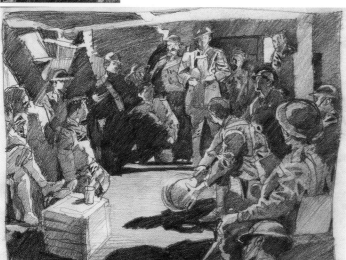

Shape Mergers

1. Do a shape breakdown of a news photo using only black, white and two shades of gray. Merge shapes of the same or similar shade.
2. Set up a still life with a strong, single light source in an otherwise dark room. Make a drawing which emphasizes the pattern. Merge shapes of the same or similar shade (value). Make at least one of these mergers between an object and the background.

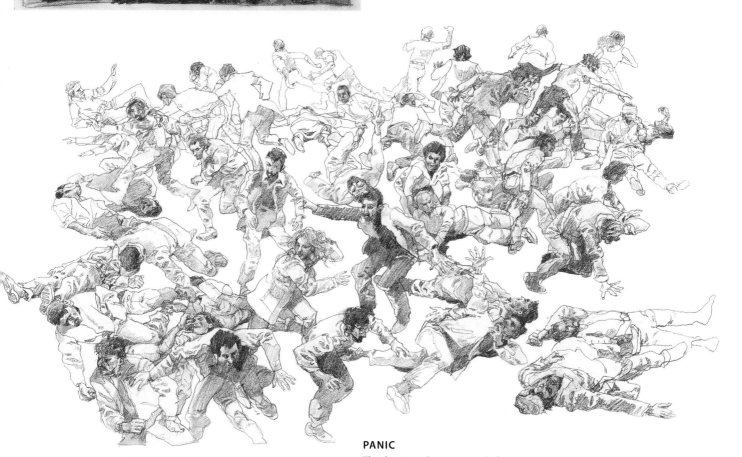

PANIC
The drawing *above* was made from a number of different news photos. I knitted the figures together by repeating a little algorithm that resembled folds of clothing. As you can see from the two details, the patterns are very abstract.

mapping and coloring

MAPPING AND COLORING

I am a strong believer in mapping—making a basic outline of important shapes to guide your drawing. I see it as an effective strategy for analyzing and clarifying what you observe. In fact, it is the best way I know to organize the design of your picture. Maps have unequivocal shapes; the boundaries are clear and distinct.

The reality we observe is not always so clear. Shadows, movement, dim light and other factors tend to fuzz and blur things. It takes imagination to override the ambiguities and map everything in your picture as a defined shape and then—as a further imaginative step—to assign a flat, bright color to each shape and fill it.

There are lots of ways of mapping and coloring. I generally like to keep the colors bright and flat with very little shading. Markers provide the brightest colors, but they sometimes seem a bit too acrid or concentrated, so I tone them down by adding colored pencil on top.

You can think of this work as akin to stained glass—work in which your lines are like the leaded mullions. They may or may not correspond to the outlines of the forms, as some of these examples demonstrate.

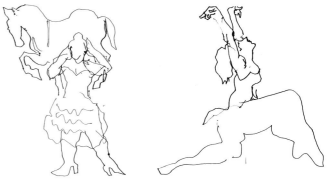

CIRCUS

I took my sketchbook to the circus, but due to the dim lighting and constant motion of the performers, it was impossible to draw with accuracy. But it didn't matter. I later traced the the crude images I made, *above*, combined them with some background shapes and colored them in, *below*, with bright watercolor, markers and colored pencils.

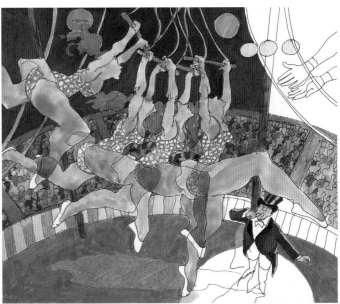

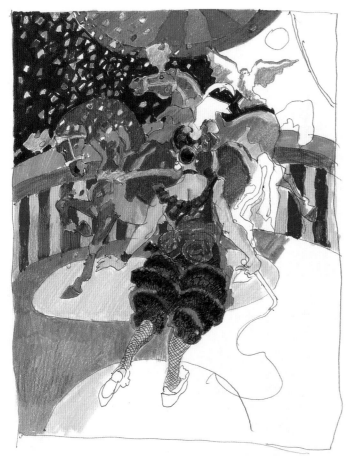

PURPLE SHADE

In spite of this title, I was seeing almost no color as I looked at my soft reflection in the screen of my darkened TV. I just drew the shapes and then added these bright colors arbitrarily.

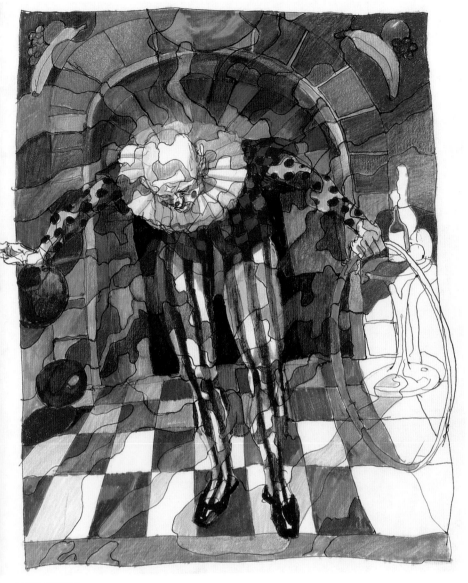

HARLEQUIN

I drew this figure with no particular thought in mind. Sometime later—when I had partially colored it in—the idea of a jigsaw puzzle came to me. The color sometimes conforms to the shapes of the image and sometimes to the shapes of the jigsaw pieces.

Map and Color

1. Choose one of your previous drawings or doodles and retrace it as if it were a map. Enclose every shape and color them with bright and occasionally arbitrary colors.
2. Create a new and more complex map. This can be from a previous drawing. Add numerous enrichment shapes (i.e., smaller, interwoven shapes like jigsaw puzzle pieces or sections of a stained glass window). Color in the shapes with bright and occasionally arbitrary color.

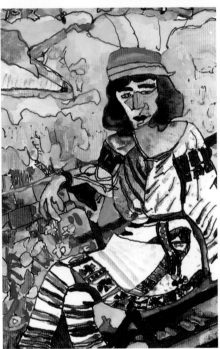

PHOTOS TO FANTASY

These are two colored drawings by Ted Chaffee. Ted likes to work from photographs, but in the process of mapping and coloring, he transforms them to the point where they bear little resemblance to the original. Some become quite abstract. The little landscape *above* can be turned on either side and it still looks right side up.

escher tiling

ESCHER TILING

The object of this technique is to make a drawing that has no background spaces; every shape is an object that fits into every other shape. I call this Escher tiling, after the Dutch artist M.C. Escher who created complex and beautiful variations on this theme.

My version is less profound than his was. I simply draw an object, usually from imagination, and then see what other object, person or animal might fit snugly against it. In this way, I build my drawing one shape at a time.

Fishes and Scales
M.C. Escher
© The M.C. Escher Co., Holland

1 Draw an object, then study the negative shapes around it. Look for a fit with another object.

DUCK AND PIG

COFFEE AND CAR

2 Draw a second object (the man's head) so that it exactly fits the adjacent space. Continue with a third object.

3 Keep doing this for as long as you have the energy or room on your paper.

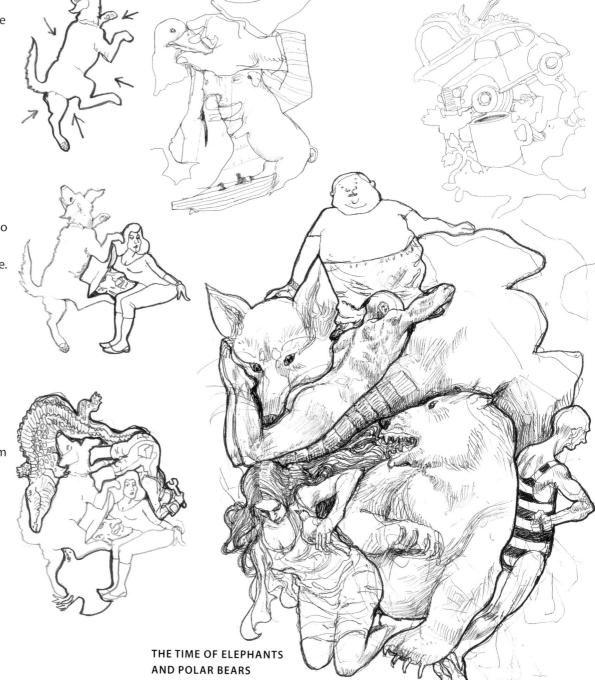

**THE TIME OF ELEPHANTS
AND POLAR BEARS**

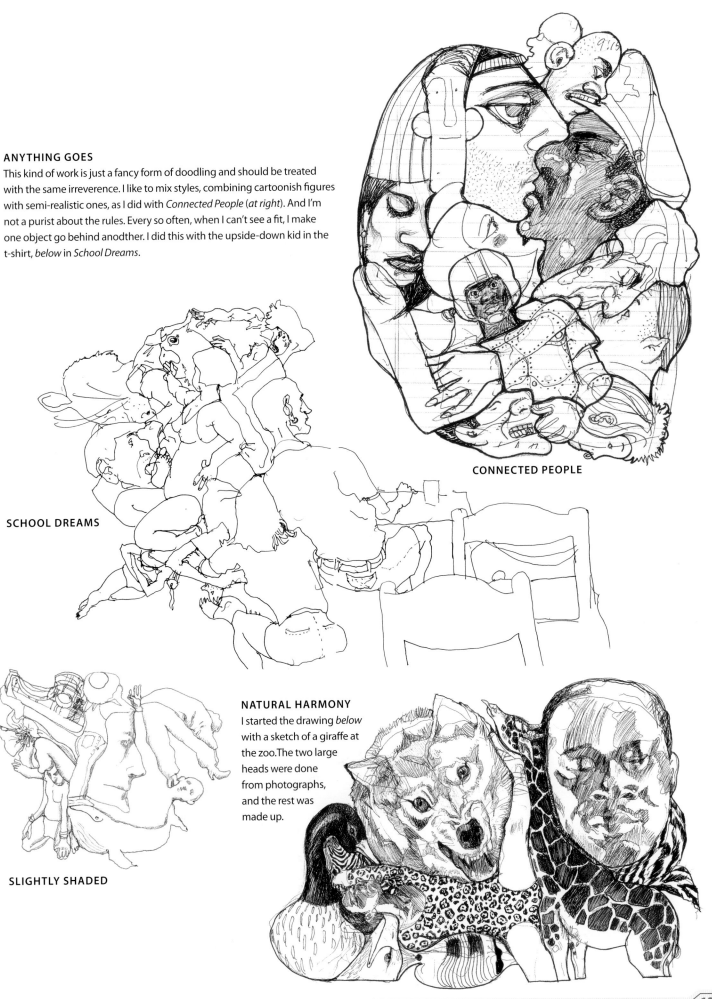

ANYTHING GOES

This kind of work is just a fancy form of doodling and should be treated with the same irreverence. I like to mix styles, combining cartoonish figures with semi-realistic ones, as I did with *Connected People* (*at right*). And I'm not a purist about the rules. Every so often, when I can't see a fit, I make one object go behind anodther. I did this with the upside-down kid in the t-shirt, *below* in *School Dreams*.

CONNECTED PEOPLE

SCHOOL DREAMS

SLIGHTLY SHADED

NATURAL HARMONY

I started the drawing *below* with a sketch of a giraffe at the zoo. The two large heads were done from photographs, and the rest was made up.

ZELMA LOSEKE
Weaving a Drawing

Some of the most original work comes from self-taught artists. Zelma Loseke wove her first basket when she was making a doll's cradle for her young daughter. This moment inspired her to try larger sculptural pieces in willow using a technique that she developed herself. Today she is a well-established basket maker.

When she turned to drawing, Zelma brought a weaver's sensibility along with her. Using ballpoint pen lines instead of willow branches, she patiently builds up images with a regular repeated stroke. Just as with her baskets, she begins with no preconceived idea of how the piece will turn out—she simply draws lines until certain shapes begin to emerge. When this happens, she reinforces the shapes and builds variations of them.

Zelma begins a drawing with this simple stroke . . .

. . . which she repeats at different sizes.

At some point she begins to bend the peak in some new direction . . .

. . . and then repeats the process all over again.

ONE OF ZELMA'S WILLOW-WOVEN BASKETS

NATURE FORM #35

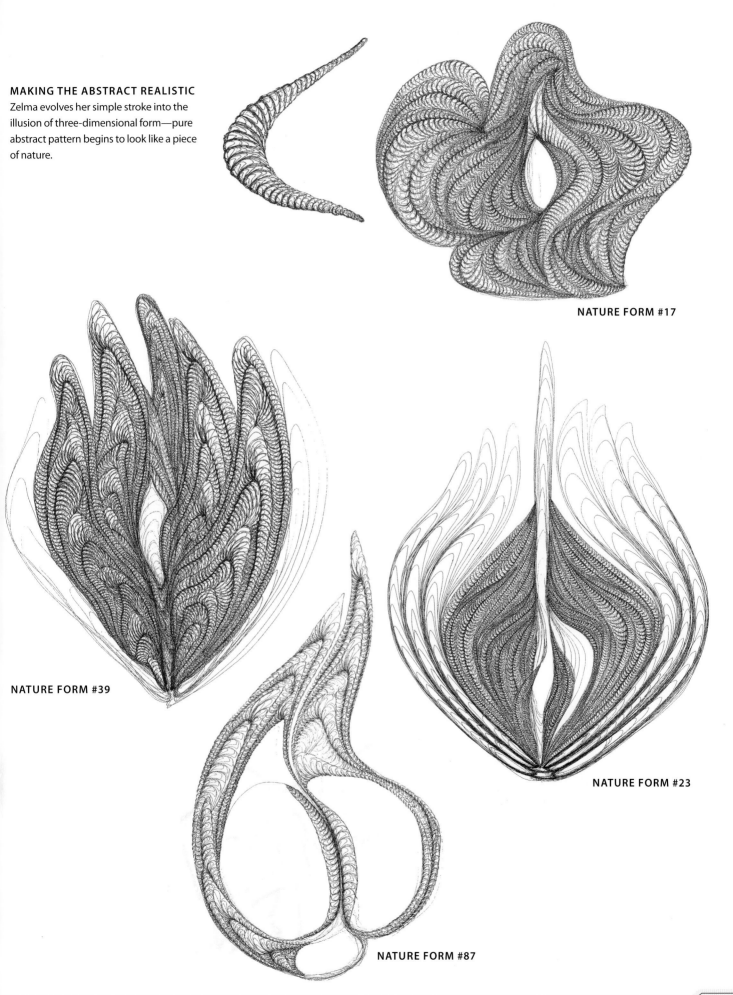

MAKING THE ABSTRACT REALISTIC
Zelma evolves her simple stroke into the illusion of three-dimensional form—pure abstract pattern begins to look like a piece of nature.

NATURE FORM #17

NATURE FORM #39

NATURE FORM #23

NATURE FORM #87

Mining
7 Culture

Perhaps our greatest challenge as creative people is getting outside our own box. As long as we stick to the world as we know it, we will produce work that is safe, comfortable and familiar. What lies beyond this world is pretty much invisible to us, but it also happens to be where the creative juice flows. It seems that we are at our most creative when we are in a state of *not knowing*.

The most committed artists understand this. They leap in with no certainty about the outcome. They improvise. They try things that they aren't already good at. They look closely at and experiment with strange and unfamiliar sources.

The Italian and the Egyptian

It is impossible to see the world through someone else's eyes. But when you look at the work of other cultures, you can get a sense not only of *what* they saw, but also *how* they saw. In his classic book, *Art and Visual Perception*, Rudolph Arnheim offered a useful thought experiment on how differently people from separate cultures might visualize the same things. I will paraphrase his idea here. Let's imagine that somehow we could bring together two artists, the first an Italian from the sixteenth century, and the second an Egyptian from several thousand years ago. Now suppose that we gave each this assignment: "Draw a rectangular pool. It should have equal-sized and equally spaced palm trees growing all around it."

We can presume that the Italian would draw something like this:

The Egyptian would look at the Italian's drawing with a skeptical eye. "The instructions were to make a rectangular pool," he would protest. "But this is a trapezoid. And weren't the trees supposed to grow around the pool? Some of these are inside the pool. The trees were also supposed to be the same size, but some are big while others are small. And they aren't equally spaced."

The Egyptian's version would look something like this:

These examples represent two very different ways of seeing. The difference is all about perspective—one image has depth, while the other is flat. Either version offers rich possibilities for the creative artist. This holds true for many other stylistic opposites: realistic vs. symbolic, elaborate vs. minimalist, linear vs. tonal, romantic vs. classical.

For most of art history, these conventions remained sealed off from each other. The work of another culture may have been an amusing curiosity, but it had little to do with one's own understanding. Sometime in the late 19th century this attitude shifted. Work formerly regarded in Europe as primitive and strange began to be appreciated for its own intrinsic qualities. Paul Gauguin, for instance, went to Tahiti to get a fresh view of the world. His art thereafter was deepened by these influences. Around the same time, Japanese postcards became the rage among the impressionists and the post-impressionists of Europe. The linear style and radical cropping of great artists like Katsushika Hokusai jolted the Europeans into a radically new way of seeing. And in 1905 Pablo Picasso—deeply impressed by the expressive power of African art—put African masks on the faces of some female nudes in his cubist masterpiece *Les Demoiselles d' Avignon*.

This chapter is about *seeing other ways of seeing* and acknowledging the value this can have for your own work. When something catches you about the artwork of another culture, it may be strange, but it is also familiar. It reminds you of things in your own experience—but with a new twist. Perhaps it exhibits a verve and daring that inspires you to break out of your own timidity. Perhaps it treats a semi-taboo subject, like death, in a fresh and amusing way, one that gives you new permission to depict a subject in a fresh fashion. Maybe you will discover a celebration of the sacredness of the small and insignificant, as in representations of beetles, wasps or caterpillars.

The practice of stepping outside the world you know can be creatively transforming. It calls forth images you had never imagined. It brings up questions you never thought to ask. It takes you outside your box, offering new ways of seeing and interpreting the world.

To illustrate some ways of mining culture, I have chosen three distinct styles of art. They are the art of ancient America (or pre-Columbian art), Art Noveau, and oriental carpets. In each of these traditions, the things that inspire me, and the resulting spin-off drawings I make, are personal and idiosyncratic. They are offered here as examples of how one might abduct from historic art styles. Your own choices, inspirations and abductions will certainly be different from mine.

abductions and spin-offs

ABDUCTIONS AND SPIN-OFFS

The term *abduction* has been used to describe the lifting of certain features from one context and then superimposing them on another. I call the resultant new drawing a spin-off. Spin-offs are not copies. They are drawings inspired by or suggested by an original source.

Here is how I go about this process. I go to a museum with my sketchbook in hand and look for work that interests me. Sometimes it's major work, like the Michelangelo sculptures on this page. More often it is obscure works I have never seen before. When I find something I like, I make a drawing or two of it, trying to imagine the experience of the artist. What was he or she thinking? What makes this work unique? What do I like about it?

Later, sometimes months later, I flip through my sketchbook with a playful eye. When I see the *Captive* drawings, *below*, they trigger a number of ideas and associations. For example, I wonder about the difference between finished and unfinished work, about what makes us feel trapped or imprisoned, about ways of depicting human struggle. I make my own spin-off drawings, some of which are shown at *right*, on these themes—sometimes incorporating my earlier figure drawings, sometimes working from photographs or memory. I usually start with simple, literal abductions and then begin stretching them, always seeking to draw a more radical version.

There are lots of things that one can borrow from any work of art, but to simplify, I focus on three categories:

1. Style: How is the work executed?
2. Content: What is the work about?
3. Spirit: What unique qualities reveal the imagination of the artist?

Playing with associations, imagining the artist's intentions, and pushing the boundaries of what you already know comprise the essence of mining culture.

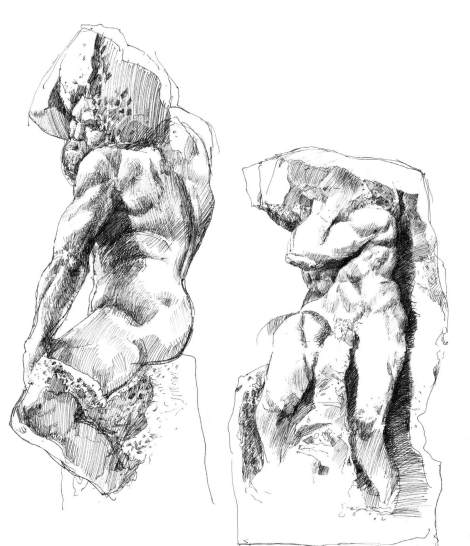

I drew these *Captives* by Michelangelo at the Florence Academy. There has been some speculation about why he never finished them. I suspect that, in part, he liked the way they looked, partially emerging from the marble. The semismooth quality of the torsos contrasts expressively with the roughly gouged stone.

Whatever Michelangelo was thinking, he left us with something to stimulate our own thinking. The act of drawing these pieces was a form of immersion (see page 146) for me. I began to wonder how carefully he planned. For example, in the right-hand figure, he seemed to leave insufficient marble for the neck and head, unless he intended to tilt or twist it. Did he plan this all along? Or did he like to create tricky situations that he knew he would have to work around?

The sketches on the facing page show how spin-offs work. Start with some key feature of a work and then "push" that feature to a more extreme limit.

Spin-Offs

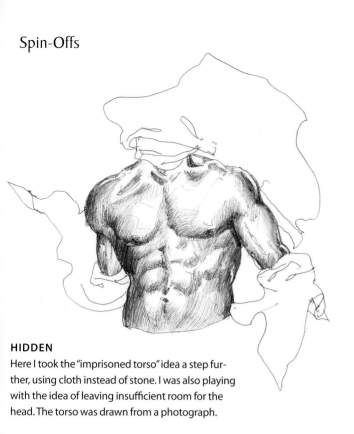

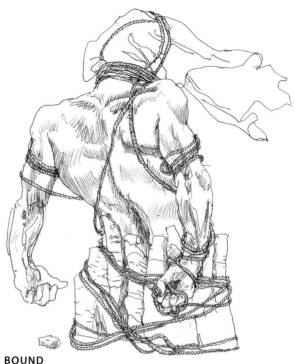

HIDDEN

Here I took the "imprisoned torso" idea a step fur-
ther, using cloth instead of stone. I was also playing
with the idea of leaving insufficient room for the
head. The torso was drawn from a photograph.

BOUND

In Italy I once saw some marble sculptures being prepared for moving. They
were partially covered with ropes, cloth and soft foam. They reminded me
of the *Captives*. This figure grew out of that memory.

FALLING

The idea of a figure that turns into cloth
grew out of my previous drawing, *Hidden*,
so this is a spin-off of a spin-off. You can see
how quickly spin-offs take you away from
the source, and into some unpredictable
direction.

 I'm still intrigued with the ambiguity of
whether or not there is room for a head.

TRAPPED

Here's a straightforward spin-off, again pushing the "figures imprisoned
in stone" idea, to "figures partly stone." To get a craggy coral-like texture, I
copied the rock pattern from page 124.

IMAGINARY FOSSILS

The *Captives* remind me of the way
some fossils look trapped and strug-
gling. *Dying,* at *near right,* pushes and
exaggerates that idea.

 Archaeopteryx Bound, at *far right*, is
drawn from one of the famous fossils
found in the quarries of Bavaria, Ger-
many. I drew it with added ropes just
to see how it would look.

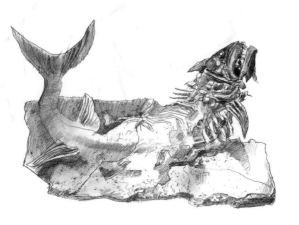

immersion

IMMERSION

When I look for inspiration in the work of another culture, I first go through an "immersion" process. I study the work by reading or (when I can) by going to museums and drawing. You learn a lot from sketching: how other artists handled shape and form, how they simplified and stylized, and what subjects interested them.

I prefer to draw from sculpture and pottery rather than from other drawings because there is some translation involved in converting three dimensions into two. But anything that grabs your attention is worthy of a quick sketch. The sketches on these pages are based on original Mayan and other Meso-American art, drawn mostly in the National Museum of Anthropology, Mexico City. A few are from photographs.

A BOLD IMAGINATION
The Mayans and their antecedents were creatively fearless in combining elements. Here is a warrior god coming out of a serpent's mouth.

HIDDEN IMAGES
Little human forms clamber and peek around a two-headed serpent, all standing on a Death's head.

This was a very artistic form of hieroglyphic writing.

"SHAPE-CONSCIOUS" ART
Large major shapes get filled in with tightly fitting smaller shapes.

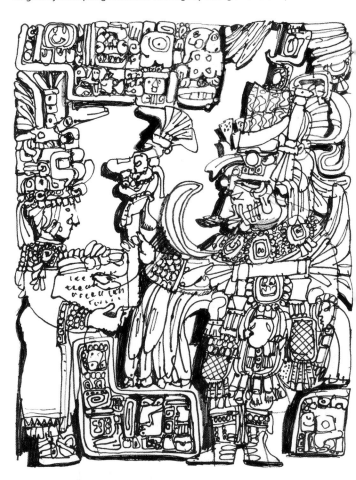

Immersion Sketches

These sketches were made in various museums. I chose artifacts that struck me as displaying the originality of the maker. As I drew, I imagined the artist working inside a tradition but also breaking free with small bursts of creativity. Sketches like these become source material for spin-off drawings.

This bowl is wildly and beautifully decorated. That's an alligator on top.

A jug holding a bowl.

Both his tongue and his bare feet stick out.

Round pot with man—or vice versa.

I like the clay sculpture that mixes three-dimensional with flat. The dimensional parts look so striking in the intense Mexican sun.

I like the symmetry of this foot, with toes all the same length.

A two-bowl chihuahua.

Heads are the centers of flowers

This three-headed ring may have been uncomfortable, but it sure is inventive.

Rounded head

Flat body

Head inside a curled leaf.

Even though I no longer remember what this is, it still has spin-off possibilities.

Quetzalcoatl, god of the air and benefactor of humans, depicted as a coiled, feathered serpent.

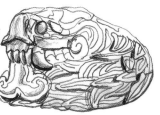

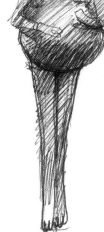

A rattle—dry seeds inside the belly.

inventing

INVENTING

If I were to use one word to describe pre-Columbian art it would have to be *inventive*. Two-headed snakes, pots that look like people, headdresses that are actually heads, grinning skeletons, sneering weasels, and men being devoured by jaguars—these were all grist for the artists of ancient Mexico. We don't need to know the symbolic meaning of these works to appreciate the pure creative impulse at play and to incorporate that spirit into our own drawings.

Skeletons, Masks and Headdresses

These artists were comfortable with the macabre and the strange. Ugliness was not a quality they avoided. Rather, they invented freely with it. The same with Death. We find frequent and imaginative appearences by skeletons. Some seem terrifying, others almost comic. One of my favorites is the one *at right*, who looks like he's on a cell phone.

The drawings on this page are immersion drawings. Those on the facing page are spin-off drawings. Notice that the spin-offs often veer wildly from the source. Spin-offs should be like that— free associations, rather than imitative versions of the original.

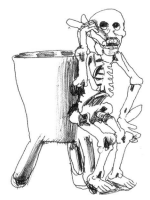

SKELETONS

In ancient America, death could come suddenly. And judging by their art, the people seemed to accept that.

I've seen several of these half-alive/half dead pieces. Reminders of mortality? Man's divided nature? Peeling back layers?

OVERSIZE HEADDRESS

This fierce vampire bat goddess wears a headdress that is also a menacing face.

SPINAL POT

Here's a fascinating idea for a container. Looks like you could play a tune on it.

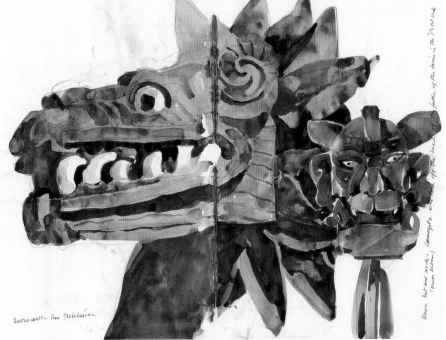

FIERCE AND SINISTER FACES

This is a combination sketch of a Mayan jade bat god and an Aztec plumed serpent. The bat god looks like he is thinking. The serpent looks aroused and hungry .

Spin-Offs

Sometimes you need only the smallest fragment of an idea to give you a fresh idea. Some of these sketches are far removed from the source—but the original pointed the way.

BACKWARD
Spin-off drawings don't need to make sense. Some merely play with ideas.

SWITCHED
This reversal plays with the notion that masks give identity.

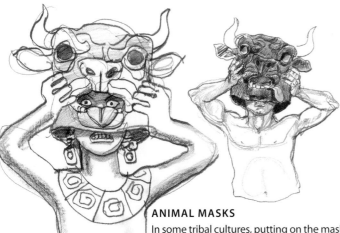

ANIMAL MASKS
In some tribal cultures, putting on the mask of an animal imbues the wearer with that animal's power. In these two sketches, I was thinking of that moment of transformation.

HEADS UPON HEADS
The Meso-Americans were fond of multi-tiered headdresses.

LONE STRANGER
Dancing skeletons were a common theme in the movies and cartoons of the 1930s. This one is doing the Texas Two-Step.

TOP DRAWER
This shows how one idea leads to another.

THE KISS
I like drawings that incorporate some kind of blend between realism and symbolism. This idea is partly based on a still from the film *Viva Mexico*.

FACE-OFF
The face behind the mask can be just as scary.

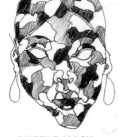

PUZZLE MASK
Here I was thinking of a mask with some missing pieces here and there.

PELVIC MASK
Bone shapes have an abstract quality —with just a hint of the macabre.

stylizing and symbolizing

STYLIZING AND SYMBOLIZING

Symbolizing seems to involve several types of skills—careful observation, understanding the constraints of the materials, and a sense of the essence, to name a few. The ancient Mexicans had a genius for this, especially in their depictions of animals. The lowly creatures of the rainforests and deserts—toads, lizards, tarantulas and, especially, snakes—are all elevated to respected status in this art. The remarkable rattlesnake column, *below, right*, from Chichén Itzá in Mexico, is an inspiring case in point. One normally thinks of snakes as *curving* forms: undulating, rounded and/or coiled. How can these qualities be conveyed in a stack of rectangular blocks? The Mayans solved this by placing the head on the ground and stacking the blocks directly behind it. Then they balanced an overhanging lintel (the rattle) on top. My sketch, from a photograph, inspired the fanciful spin-off drawings on the facing page.

Constraints

This work reminds us of the important role that constraints play on creativity. Constraints often dictate structure. They set boundaries for creative play. The Mayans had to work within the size and shapes of the stones they used. In your case, it might be the drawing tool, the time available, or certain choices you make regarding what your drawing is about. For example, as I made the spin-off drawings on the facing page, I tried to imagine everything as made of carved stone.

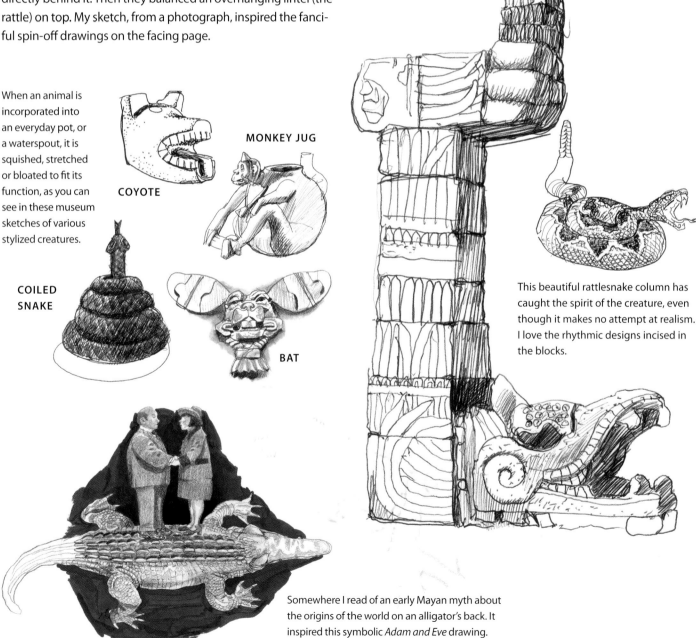

When an animal is incorporated into an everyday pot, or a waterspout, it is squished, stretched or bloated to fit its function, as you can see in these museum sketches of various stylized creatures.

COYOTE

MONKEY JUG

COILED SNAKE

BAT

This beautiful rattlesnake column has caught the spirit of the creature, even though it makes no attempt at realism. I love the rhythmic designs incised in the blocks.

Somewhere I read of an early Mayan myth about the origins of the world on an alligator's back. It inspired this symbolic *Adam and Eve* drawing.

Spin-Offs

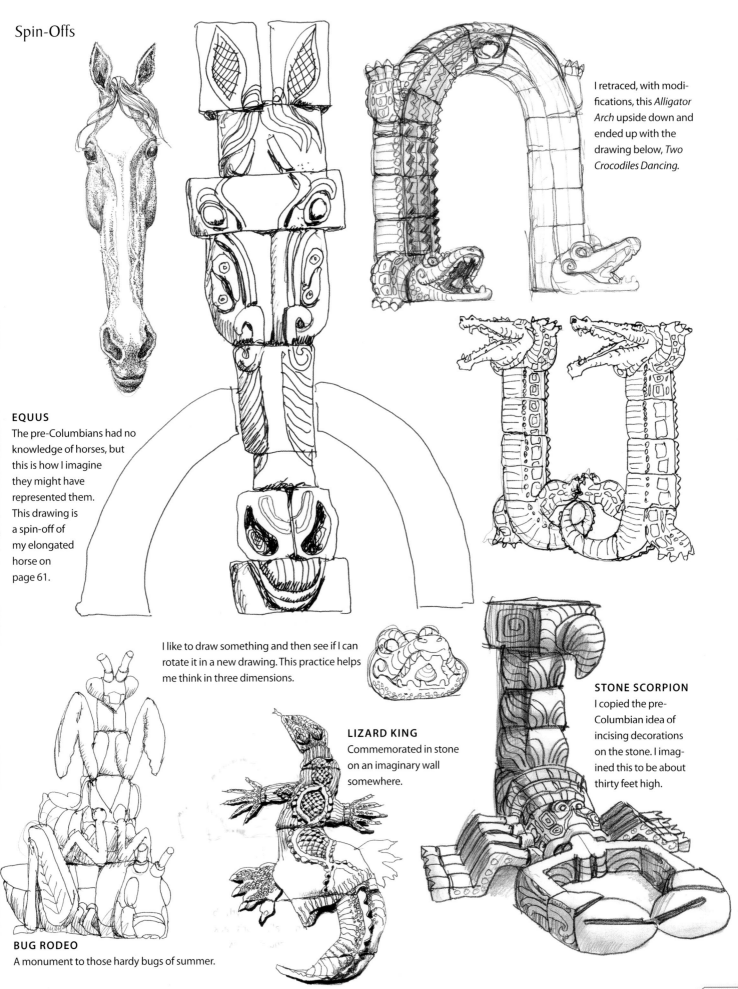

I retraced, with modifications, this *Alligator Arch* upside down and ended up with the drawing below, *Two Crocodiles Dancing.*

EQUUS
The pre-Columbians had no knowledge of horses, but this is how I imagine they might have represented them. This drawing is a spin-off of my elongated horse on page 61.

I like to draw something and then see if I can rotate it in a new drawing. This practice helps me think in three dimensions.

LIZARD KING
Commemorated in stone on an imaginary wall somewhere.

STONE SCORPION
I copied the pre-Columbian idea of incising decorations on the stone. I imagined this to be about thirty feet high.

BUG RODEO
A monument to those hardy bugs of summer.

graceful linearity

GRACEFUL LINEARITY

Artists have always been interested in the graceful curving forms of nature. The artists of the Art Nouveau style in the late 19th century took this interest to new heights. Influenced by Japanese wood block prints, they translated the world around them into flat patterns with fluid, undulating lines and radical cropping. Art Nouveau was a short-lived but richly creative movement that influenced painting, posters, jewelry design, architecture, furniture and typography.

Here I have focused mainly on the linear qualities of the style. When you draw objects in pure line—especially objects that have soft, blurry edges, like clouds, mist, water or fabric—they are transformed into almost abstract designs. This opens up new opportunities for playful invention.

As before, I start with simple immersion sketches, shown *below*. As I begin to get a feeling for the style, ideas emerge.

"POSTERIZING"
The Nouveau artists found that poster art was a perfect medium for expressing their interest in flat design, arresting composition and experimental typography.

from a poster by Toulouse-Lautrec

ROMANTIC IMAGES
Art Nouveau focused on the female. Its themes were romantic, and its compositions were sensuous and graceful.

from a poster by Louis Rhead

STYLIZED LINE
Almost every element is drawn in a controlled, graceful line. Here we see decorative possibilities even in steam.

from an advertisement for coffee by Alphonse Mucha

FROZEN ACTION
The careful, linear qualities of this style tend to make the subjects appear "frozen" in mid-action.

from a drawing for a cigar box by Carl Otto Czeschka

NOT-QUITE-SYMMETRY
The Nouveau artists liked to play with symmetry, often approaching and then veering away from it.

from a dressing table by Antonio Gaudi

TANGLES AND OUTLINES
One linear trick employed in this style is drawing the outer lines while eliminating the overlapping lines. This emphasizes the design qualities.

from a calendar illustration by Alphonse Mucha

Spin-Offs

LINEAR MOVEMENT
These fabric sketches began to look like human figures, and I began to play with that, ending up with the Louis XIV character *at right*.

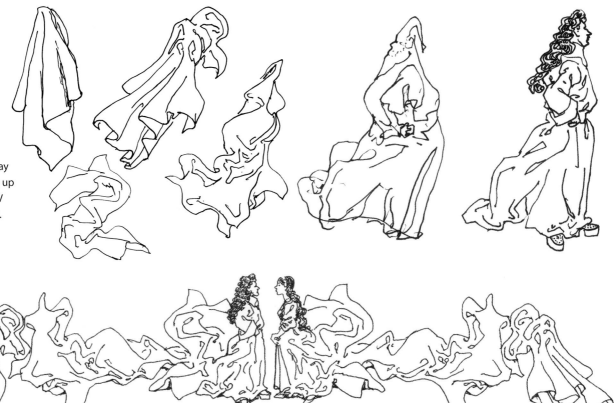

NOT-QUITE-SYMMETRY
The previous sequence led me to the idea of making a decorative border. I simply re-drew the shapes, connecting them all as if they were a single piece of cloth. Symmetry has a way of making otherwise chaotic elements look orderly. I used the light table method on pages 8–9 to duplicate the halves, but as you can see, I made the second half slightly different.

EXTREME NOUVEAU
I drew this Art Nouveau doorway, *at left*, from a photograph. (Once again, I drew only half of it and then flopped the drawing for the other half.)

Then I decided to make a not quite symmetrical version, *at right*. Here I introduced differences between the two sides, exaggerating and distorting as I drew. For me, this version captures the runaway extremism sometimes found in the Nouveau style.

flattening and posterizing

FLATTENING AND POSTERIZING

Many of the Nouveau artists liked to adapt their decorative style to drawing flowers and insects. Even though they executed these subjects in sinuous lines and flat patterns, they prided themselves on careful and accurate observation. This is fertile ground for abduction: Draw things in the natural world accurately, but at the same time, emphasize the abstract design. Draw your flowers and insects as if they were posters. Eliminate or subdue the modeling and shading, keeping your forms within well-defined outlines, then try cropping radically—that is, zoom in close, boldly clipping off important objects in your picture.

When you adopt certain features of a style, you can stretch these features over different kinds of subject matter. Try drawing people and animals with these constraints in mind. Then make spin-offs of these drawings. Your results may look nothing like Art Nouveau—which is just as it should be. The style is just a starting point. Creativity then feeds on itself. Ideas generate ideas.

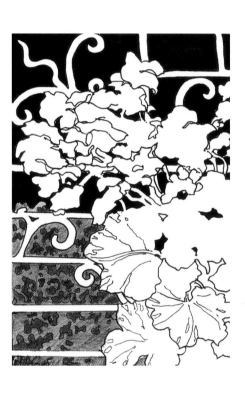

In the photograph, the background grate is nearly invisible. In the drawing it almost becomes part of the flowers. This has a flattening effect set against the simple black background.

Here's an example of radical cropping. We see only the center of the flower. And the butterfly is partially out of the picture. Everything looks suspended in time and space.

Strong black outlines create a "cut-out" effect, as if the flowers were two-dimensional. This makes us as aware of the background (the "in-between" shapes) as well as the flower shapes.

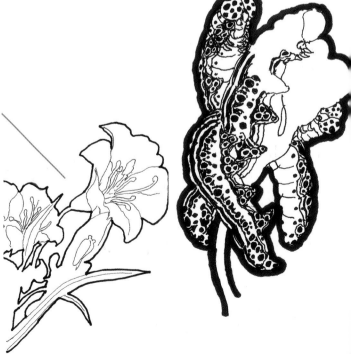

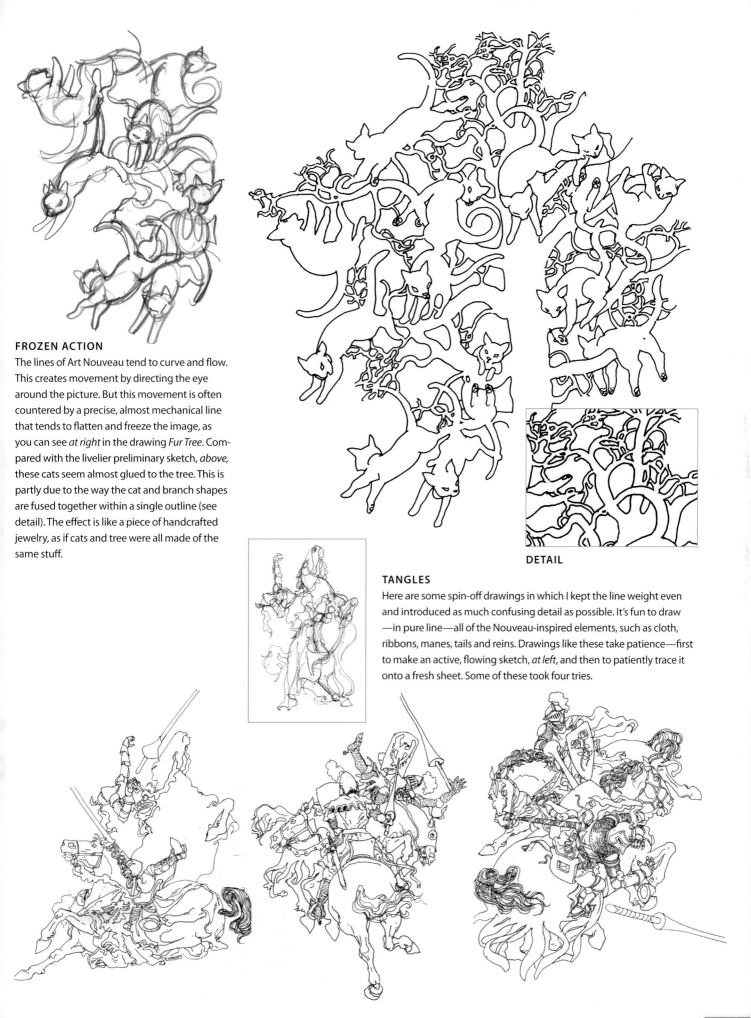

FROZEN ACTION

The lines of Art Nouveau tend to curve and flow. This creates movement by directing the eye around the picture. But this movement is often countered by a precise, almost mechanical line that tends to flatten and freeze the image, as you can see *at right* in the drawing *Fur Tree*. Compared with the livelier preliminary sketch, *above*, these cats seem almost glued to the tree. This is partly due to the way the cat and branch shapes are fused together within a single outline (see detail). The effect is like a piece of handcrafted jewelry, as if cats and tree were all made of the same stuff.

DETAIL

TANGLES

Here are some spin-off drawings in which I kept the line weight even and introduced as much confusing detail as possible. It's fun to draw —in pure line—all of the Nouveau-inspired elements, such as cloth, ribbons, manes, tails and reins. Drawings like these take patience—first to make an active, flowing sketch, *at left*, and then to patiently trace it onto a fresh sheet. Some of these took four tries.

pattern, movement, detail

PATTERN, MOVEMENT, DETAIL

Much of the Nouveau style is about keeping the eye busy. These artists gravitated to subjects that offered graceful, flowing lines and intricate, ornate shapes.

It's fascinating how a change in what you draw automatically shifts what you notice in the world. When I began thinking about Art Nouveau, I began noticing decorative railings and ornate architectural details. I paid attention to hair patterns and growing vines. I stopped to pick up dead insects. I've had a studio in an old school building for twenty-five years, and—for the first time—I really looked at the floor grate just inside the entrance, *shown at right*. I even photographed and then traced it in the small drawing *at right, below*.

FLOOR GRATE

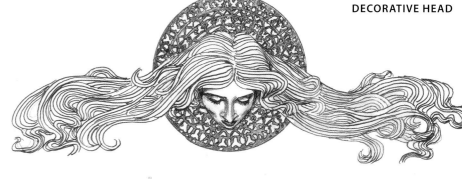

DECORATIVE HEAD

CLEOPATRA

A critic once described Art Nouveau as "spaghetti hair." I like to do this kind of intricate patterning. Another Nouveau feature is making a distinct contrast between the soft tonality of the face and the linearity of the hair and ornaments. (This face was drawn from the clay model on page 107.)

SWIRLING

This is a phone doodle. I was thinking of shapes like water reflections, or possibly flames. It just happened to turn into a face.

DRAGONFLY WING

FADING

This tattered dragonfly wing that I found seemed to fit well with a life drawing I had done years ago. This is another example of not-quite-symmetry.

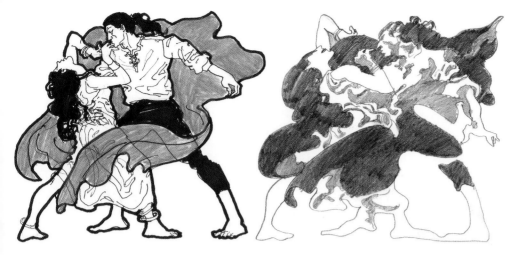

SWIRLING SHAPES

A popular Nouveau device is to envelop figures with a cape or fabric to enhance the feeling of movement. I did this first drawing to evoke a feeling of intensity and passion. In the second spin-off drawing, I emphasized the abstract flowing quality of the shapes.

WAXEN FIGURES

I drew this melted candle, *below*, because I liked the strange blobby shapes and strong shadows. Only later did I notice the resemblance to human figures, and I made the metaphoric drawing on the right.

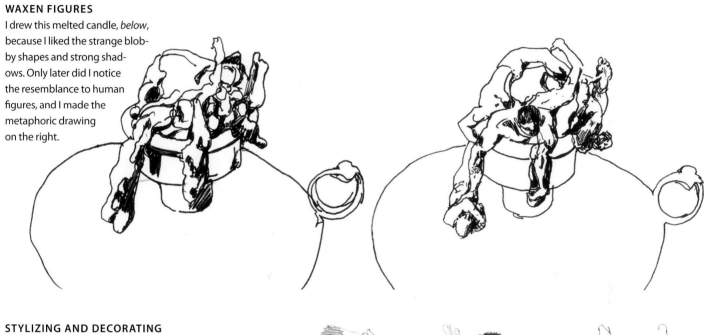

STYLIZING AND DECORATING

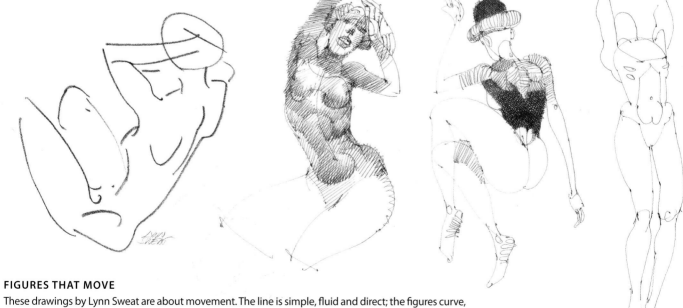

FIGURES THAT MOVE

These drawings by Lynn Sweat are about movement. The line is simple, fluid and direct; the figures curve, bend and stretch. While these were not consciously done in the Nouveau style, they embody its spirit.

simplifying and abstracting

SIMPLIFYING AND ABSTRACTING

It is not always clear what inspires us. Sometimes it's something entirely new. Sometimes it's seeing something that has been in the background for many years suddenly come forward, as if you are seeing it for the first time. This happened for me on a trip to Morocco when I happened to visit an oriental rug maker. Here are a few of the ideas I got from that visit:

1. Symmetry can be beautiful.
2. What appears to be purely decorative can also be spiritual.
3. Within a somewhat rigid format, a tremendous range of creative solutions can emerge.
4. Symbolic meaning can be hidden inside an abstract design.
5. Over time, designs tend to cross-pollinate. Indigenous motifs migrate from one region to another, like a story passed from one teller to another.
6. By simplifying and making objects geometric, the artist can make them disappear into a larger pattern.

On these pages I illustrate how naturalistic objects can evolve into pure decorative designs.

PERSIAN RUG, LATE 19TH CENTURY
Courtesy Peter Pap Oriental Rugs (Dublin, New Hampshire, and San Francisco, California)

REPEATING

MAKING GEOMETRIC

STACKING

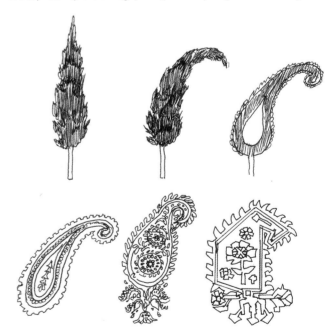

PROGRESSIVE STYLIZATION
It's uncertain where this design—called a boteh—originated. Some claim it came from Kashmir, inspired by the windblown cypress tree. Today it's found in an endless variety of decorative interpretations, and in widely dispersed geographical regions.

REVERSING AND MIRROR-IMAGING

FRAGMENTING
Detaching elements and spreading them apart tends to flatten the design.

Here I've combined the various "pieces" shown on these pages into a single, integrated design. I recommend this sort of playing with pattern. And I especially recommend it for those who prefer working realistically. It's a good way to appreciate the role that shape plays in picture organization.

The design was first drawn with a fine-point marker and then filled in with colored pencils.

Rug designers typically introduce some kind of symmetry. Symmetry reinforces the abstract qualities of a design. Here we have symmetry in four directions. Notice how the man on horseback is nearly "lost" in this design.

Much of this kind of work can be done with a computer, but doing it by hand (with the aid of a light table) is more in the spirit of the carpet weavers. And it's always good to develop those fine motor skills in your drawing hand.

making the familiar strange

MAKING THE FAMILIAR STRANGE

Shortly after the Soviet invasion of Afghanistan, the tribal weavers of the region began turning out carpets with a new kind of imagery. In the place of floral patterns and abstract designs, they wove armored personnel carriers, tanks and helicopters. The first time I saw one of these, I was amazed. A timeless art form was suddenly converted into a current-events medium. Leaving aside the tragedy of this particular war, and of wars in general, the idea that a traditional form might be so freely separated from its roots took me completely out of my box.

The notion that content (the *subject* of a work of art) and context (in this case, the *medium and method* of execution) can be detached and remixed in unexpected combinations might challenge our sense of appropriateness. The artist wants to be respectful of venerable traditions. And we also want to create. The Afghan war rugs offer a kind of permission to use the carpet format in experimental ways.

I began making "carpet" drawings, abducted from some of my previous work. I redrew the subjects , but this time using an Oriental rug template. This usually meant creating a center element, called a *medallion,* adding corner elements, called *spandrels,* and finishing with a decorative border.

AFGHAN WAR RUG
Courtesy Oriental Rug
Review, www.rugreview.com

CUTTING A RUG
A tribute to the music and dance of the 1930s. That's Fred Astaire and Ginger Rogers in the medallion.

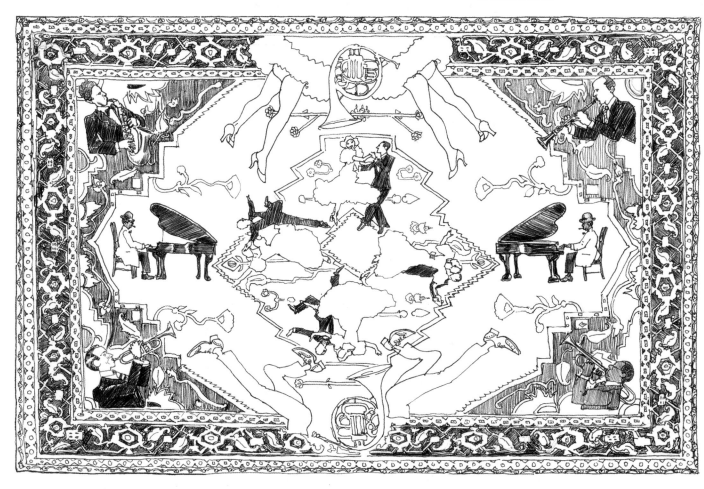

PANIC IN THE ABSTRACT

I made this design from my drawing *Panic* on page 135 . I simply made the shapes geometric and filled them in with flat colors. Adding color is always interesting because you never know just how it will turn out.

These little secondary shapes are drawn geometrically.

This halo outline anchors to the border in several places.

These abstract border shapes are actually stylized figures.

The source of the design below, *Candy Mountain*, is a drawing in Chapter 6, *Serrated Mountain* (inset and page 125). Here is another example of symmetry in four directions.

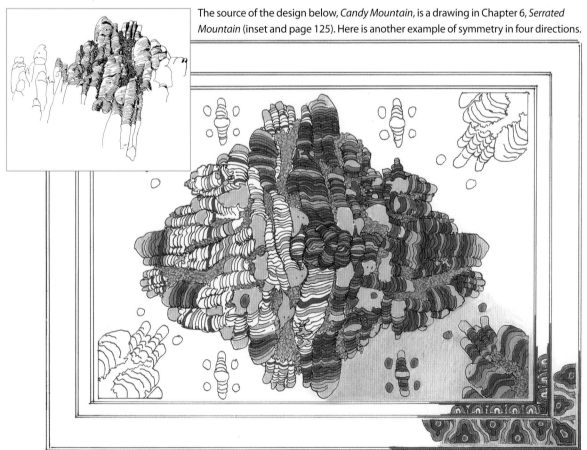

decorating

DECORATING

Years ago I made a series of drawings illustrating the verses of *The Rubáiyát* by Omar Khayyám, translated by Edward Fitzgerald. While they do not directly use the carpet format, they are clearly inspired by oriental rugs and other Middle Eastern decorative elements, such as tiles, railings and fabrics. I wanted to retain the patient, ornate quality of carpets or tapestry but with a freer, more spontaneous line. To get the right quality, I found some turkey feathers which I turned into drawing quills. The ink line seems to almost draw itself. In a little more than a week, I made several dozen of these drawings. I still like to draw this way occasionally—first creating big, loose shapes, then patiently filling them with decoration.

I can't say that I fully understand *The Rubáiyát*, but I have always been attracted to its positive affirmation of life and its stoic acceptance of death. It seems a paradox that as we embrace either of these, the other becomes more available to us.

Ah, make the most of what we yet may spend.
Before we too unto the Dust descend:
Dust into Dust, and under Dust, to lie,
Sans Wine, sans Song, sans Singer,
and—sans End!

Come, fill the Cup, and in the Fire of Spring
The Winter Garment of Repentance fling:
The Bird of Time has but a little way
To fly—and Lo! the Bird is on the Wing.

For in and out, above, about, below,
'tis nothing but a Magic Shadow-show,
Play'd in a Box whose Candle is the Sun,
Round which we Phantom Figures come and go.

'Tis all a Chequer-board of Nights and Days
Where Destiny with Men for Pieces plays:
* Hither and thither moves, and mates,*
* and slays.*
And one by one back in the Closet lays.

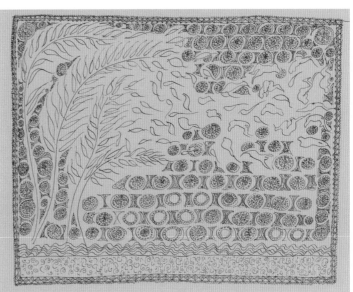

With them the Seed of Wisdom did I sow,
And with my own hand labour'd it to grow:
* And this was all the Harvest that I reap'd—*
I came like Water, and like Wind I go.

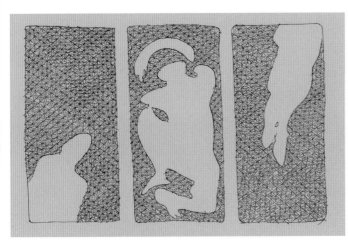

Think, in this batter'd Caravanserai
Whose Doorways are alternate Night and Day,
* How Sultan after Sultan with his Pomp*
Abode his Hour or two, and went his way.

exercise (36)

Mining Culture

This project has three stages.

1. Immersion: Choose a distinct art style or an art movement that interests you. Visit, if possible, a museum that has a collection of works in that style. Make a series of sketches of, and notes about certain pieces you like.

2. Spin-Off Sketches: Make a series of free-association sketches from your museum drawings. These should add something new and different, abducting parts and putting them in other contexts. Make them personal and playful—and increasingly radical.

3. Final Drawings: Take three or four of your spin-off sketches and transform them in a way that gives them a "family resemblance," i.e., they should be visually related to each other in subject and style.

Allow yourself weeks or even months to complete this project. Put it aside from time to time and just think about it. Your final drawings need look nothing like the work that originally inspired them. In fact, the degree of difference is actually a good measure of the project's success.

SIMPLE THEMES ARE OFTEN THE BEST

Frank Bettendorf enjoys sketching everyday objects and architectural subjects. He organizes his efforts by inventing themes for himself. Each day for a month, for example, he drew a simple tool or utensil from his garage or kitchen. He made the drawings on index cards and mailed them as daily postcards to a friend. Each one has a title, such as "The Real Jaws" (pliers) or "Wash Day" (watercolor tubes), along with a note about the drawing medium used and sometimes a literary quotation.

DRAW WHAT INTERESTS YOU

John Joline indulges two of his central passions, drawing and rock climbing, in his fantasy landscapes. Meticulous and patient, these drawings are rooted in real places, but something about them seems otherworldly. The stones seem cut a little too square, the overhangs are a little too extreme, and the angles are too regular. For most of us rocks are rocks, but Joline is aware of the subtle differences between granite, schist, gneiss and quartzite conglomerate rock. And he is interested in details.

"I have long been intrigued by the fact that when we look out at a scene—if we use our eyes well—we see not [just] a set of broad, generalized shapes but rather the particulars of a scene with astonishing clarity and in all their overwhelming multiplicity. When we look out from a cliff-face at the forest below, we see thousands and thousands of *individual* trees—not just a few paint-like swatches of color. So in these cliff-fantasy drawings, that aspect of vision is also something I am trying to capture—in a sense going back to an earlier, more Renaissance-like awareness and pictorial approach."

Exploring Themes

Sooner or later—if you haven't already done so—you will discover the great value of doing a series of drawings on a single theme. This is the best way I know to deepen your artistic vision. It will get you beyond self-conscious concerns about drawing skills and techniques. Think of it as moving beyond drawing things and on to drawing ideas. This is where art lives.

With a single drawing you hardly seem to get warmed up, but in a series you can really explore an idea. Each drawing provides clues for the next. The result is that the theme inspires a direction for the artist rather than the other way around. It is one more way that your imagination can drive your drawing.

A workable theme has two qualities. First, it must be fertile. This means that it arouses your interest enough to carry you through a series of drawings. And second, it should have defined boundaries. When you know the rules, it's a lot easier to play the game.

A theme is the thread that holds disparate parts together—an overarching idea that spreads out over a body of work. While the field of play does need to be defined, the number of ways of exploring it varies considerably. You might express that idea in a limited series, perhaps a dozen or so drawings in quick succession. Or a theme might inspire a thousand drawings and take years—even as long as a lifetime. In either case, a theme gives you sustained focus.

Once you have chosen a theme, give it a title. Be specific. Let's say you like to draw your cat. By titling a series something like *Ashley in Sunlight* or *The Many Poses of a Sleeping Cat*, you have given your project a particular shape.

A theme evolves as you work on it, so give it the time it needs. Let's say you do a series of several drawings in one sitting and set them aside. If you return several weeks later, you will bring something new to it. You are, in a very subtle way, not the same person you were when you started. Your drawings will reflect your new thoughts and experiences.

This chapter features a gallery of artists and themes they have chosen. I selected a diverse group that includes professional artists, amateurs and students. These distinctions are unimportant. What matters is each artist's passionate commitment to their theme—it has discovered them, and they have embraced it.

choosing a theme

CHOOSING A THEME

The best themes are the ones that choose you: you simply draw the things that interest you. This is what the writer Joanna Field refers to as "drawing what the eye likes." There will be some subjects—no matter how strange or eccentric they may appear to others—that just light you up.

The cartoonist Basil Wolverton (1909–1978) was fascinated by the theme of ugliness. His goofy, macabre drawings of distorted faces are so grotesque they're almost beautiful. Henry Darger (1892–1973) was a self-taught artist and a recluse. As a result of a painful, institutionalized childhood, Darger devoted most of his life to writing and illustrating a fantasy novel about a war between a group of children and adults. Alone in his room, he wrote over 20,000 pages and made hundreds of intricate drawings and murals.

Sometimes the subject itself is less important than the manner in which it is handled. Think of the drawings of Georges Pierre Seurat, in which the edges are all soft and grainy, or the blown-up faces of Chuck Close, in which the grid he uses becomes a tool for abstract exploration.

Some years ago I did an odd, idiosyncratic comic strip featuring a brain on two legs. I was interested in capturing the way various parts of our brain are in dialogue and sometimes in conflict. It was a strange idea, and the results often made little sense, even to me. But I enjoyed it—and I learned something about myself in the process.

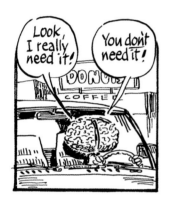
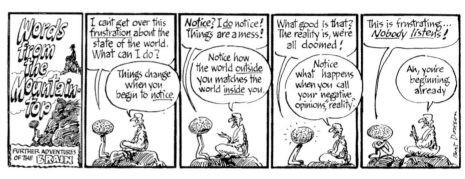

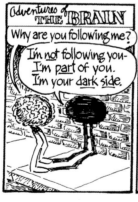
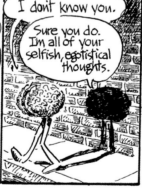

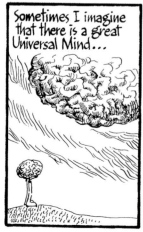
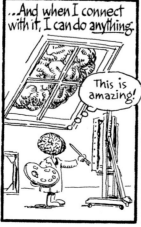

image-rich themes

IMAGE-RICH THEMES

I like themes that offer lots of possibilities for imagery. For many years I have made drawings of technology and its effects. I draw images of laboratories, space, war and medical technology, sometimes combined with mythology. I make lots of drawings of people and machines juxtaposed in tension. Because technology impacts almost every aspect of our lives, I am depicting a struggle that is not entirely conscious. Nor is it easy to summarize.

I even did some of these in terra cotta (*bottom, left*). I don't always know what the drawings are about. But the series—the theme—has a certain coherence. When I look at them as a group, they seem to convey a unified idea.

 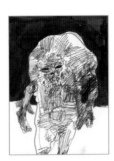

 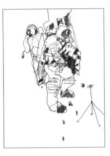 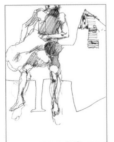

self-portraits

SELF-PORTRAITS

If you think you have no compelling idea to explore, you can never go wrong with self-portraits. There are many reasons why self-portraits make a great theme, not the least of which is that the model is always available. Some of the greatest painters turned to self-portraits when they couldn't afford models. Rembrandt painted himself over fifty times during his career. Van Gogh painted himself bandaged shortly after he mutilated his ear. Velázquez, Rubens, El Greco, Goya and others gave themselves cameo roles in large multi-figure works.

Drawing yourself sometimes brings up awkward feelings. Initally you may feel self-conscious and a little intimidated, but once you set up a mirror and start drawing you'll be amazed at how quickly that self-consciousness disappears. And after you have drawn yourself over and over—in different ways, in different poses, with different expressions—your face begins to seem less like you. It becomes more like a map upon which you can create, which marks the point when you can get imaginative. How can you stretch and bend this image? Are there costumes, hats or even masks you can wear? What about fantasy backgrounds and exotic settings? How about introducing stark and unusual lighting? What kind of story can you tell about yourself?

And self-portraits can be about more than just your own image. Think of the things that reflect you, like an old car that you have kept for years, your cluttered desk or some objects you have collected.

MAKE UNIQUE BACKGROUNDS
These self-portraits by Alex Pinkerson were made to look like tapestries or Persian Miniatures. The exquisite backgrounds are hand-drawn.

ROMANTICIZE
When George Dugan did these self-portraits, he strongly identified with the hero of Kurt Vonnegut's novel *Slaughterhouse Five*. He depicted himself as Billy Pilgrim, an innocent in a dangerous world.

Self-Portrait as Billy Pilgrim I
1979

Self-Portrait as Billy Pilgrim II
1979

Self-Portrait as Billy Pilgrim III
1979

EXAGGERATE AND DISTORT

Most of us have strong fears about looking ugly or ridiculous. It's time to challenge those fears by deliberately drawing yourself in ways you fear. This helps you get some separation between yourself and your work. It will free you up and allow you to take risks. Robert Fritz, who has written extensively on creating, makes the strong point that "You are not you work. If you think that you are your work, you can't have a relationship with it. It takes two to have a relationship."

Here I've drawn myself in an exaggeratedly pensive mood, being attacked by rubber-stamped ants, and in a meditative moment.

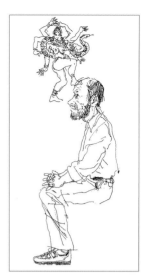

USE IMAGES FROM YOUR CHILDHOOD

Old photographs of yourself—particularly those taken of you as a child—offer rich possibilities for drawing. The snapshots from my own childhood are often grainy and out of focus. I like to capture this quality in my drawings. I also like to drama-tize these photos by turning them into movie posters. I give them titles, using the type faces from the posters of the 1930s and 1940s. In some way this captures the larger-than-life fantasy world that I lived in for much of my childhood. That's me as the Indian.

R. CRUMB
Drawing on the Personal

One measure of an artist's daring is overriding the desire to look good in order to express something personal and vivid. Few artists of any genre are as unflinching about doing this as Robert Crumb, the underground comics icon. Crumb has found a special way—a kind of fantasy autobiography—to creatively express ideas about the absurdity of life.

Most of us think that our lives are too humdrum to use as material for art, but Crumb demonstrates the world of creative possibilities which opens up when such inhibitions are ignored. His work is interesting because it depicts a self-doubting person living the mundane life. This could be any of us. It also reflects the secret need for the spotlight that exists in all of us—even though we really don't think we deserve it.

Crumb makes no attempt to make himself appear attractive or noble. He often draws his image as a homely caricature, with obsessive thought balloons or neurotic musings. He's quite willing to depict himself in this way to make a point. And it's not always clear that he knows what that point is.

"I don't work in terms of conscious messages," Crumb has said. "It has to be something that I reveal to myself while I'm doing it. Which means that *while* I'm doing it I don't know exactly how it's going to come out. I just have to have the courage to take that chance just to see what's going to come out."

HUP #3: Last Gasp Eco-Funnies

ELIZABETH LAYTON
Drawing the Self and Describing the World

It would be difficult to find a more inspiring story than Elizabeth Layton's. Having endured a thirty-five year struggle with depression, she took a drawing class at age sixty-eight and learned the technique of blind drawing—drawing without looking at the paper. She credited this process with curing her depression and saving her life. She made over 1,000 self-portraits before she died in the spring of 1993—but they are not ordinary self-portraits. These are statements about life, death, love, fear, hunger, race, war and the numerous other issues that mattered to her.

Increasingly, she used her image as a vehicle for expressing these larger themes. As she put it, "The personal is the universal; the universal is the personal. It goes both ways."

In her short fourteen-year career one can trace the complete evolution of the creative artist: discovering a passion, gaining mastery through practice, and then using both mastery and passion to express an ever-expanding vision. Elizabeth Layton's work is in over 200 galleries and museums. Her own words accompany these examples.

"Her strength is in her principles."

Buttons
November 22, 1982

"People see you on the street and they're used to you being thin, and one woman came up behind me and said "You're too fat!" and I came home weeping. It really gets to you . . . but this drawing is just watering the flowers . . . I missed the flowers."

Every Which Way
September 14, 1977

"It is told that an old Indian, as his time to die drew near, went out, or was put out, from the teepees to the mercy of the elements. Society tends to overlook the productivity that can continue until a person's death. At the same time, it is the responsibility of the old people to be as productive as they can in whatever ways, for as long as they can. Even a smile in thanks. The rainbowed colors, to me, mean hope. Hope and wisdom go hand-in-hand. Death zeroes in on the old people. Not something black and ugly but a silvery crystal softness. The title, *Indian Pipes*, comes from that clutter of herbs, center foreground, which feed on dead or decaying matter. Each pipe is a ghostlike, waxy-white, leafless plant. Each stem bears one bellshaped flower. The plant looks like the stem and bowl of a clay pipe. They are helpful in that they are nature's way of cleaning up dead or decaying organic matter."

Indian Pipes
April 16, 1984

"Last year, after my sister had a massive stroke, the caretakers at the hospital cut her crowning glory, her long hair she'd always been so proud of. Later she realized what had happened, ran her fingers through the short locks, and shook the bedrails in her anger. 2,000 miles away I worried. What can I do to help her accept this? I'll cut my long hair and send her the word her little sister wants to look like her. I don't know that it helped her any, but I felt better for having done something. After I drew this picture I saw what I was doing—simplifying my life."

Cutting Hair
July 28, 1987

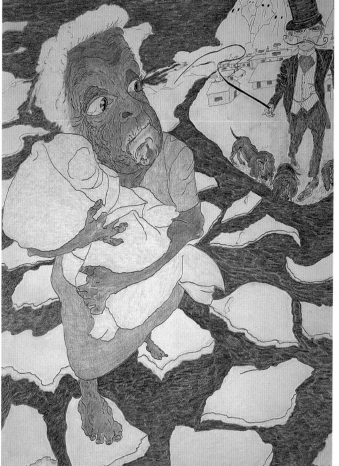

Liza on the Ice

Stroke
August 28, 1978

All drawings on pages 172–173 courtesy of The Lawrence Center

173

DAVE CREEK
Drawing Wonderland

Lewis Carroll's *Alice in Wonderland* has inspired a host of visual interpretations. Dave Creek drew these unorthodox versions during an intensive one-month period, as a student at Cal Arts. Working primarily from models, Dave made over 200 drawings of the *Alice* characters and settings. He wanted to convey the strangeness of the original story, which was darker and spookier than the Disney version he grew up with. These drawings mirror the bizarre dream world that Alice tumbles into.

"My drawing is very spontaneous and improvisational. Although I pay close attention to the model, my work often leans toward the abstract. I incorporate shapes and elements that enrich and extend what I'm observing."

FANTASTIC CHAPEAUS
Only a truly Mad Hatter would design hats like those at left. Creek uses the exaggeratedly tall hat as an apparatus for outlandish and abstract invention.

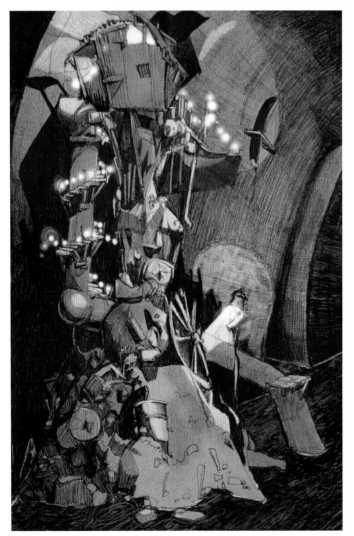

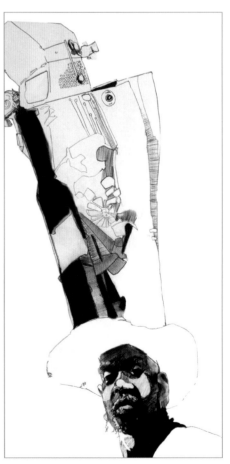

DOWN A STRANGE RABBIT HOLE
This very untypical underground tunnel, complete with stairs and lighting, shows how far the imagination can take an unsuspecting Alice.

ALICE
In a pensive mood.

**THE NOT-SO-
WHITE RABBIT**
Like most of us,
obsessing about
the time.

THE ROYAL CHAIR
A throne with barely a
leg to stand on.

THE *QUEEN OF HEARTS*
Not the loud, screeching type of the John Tenniel
and Disney versions, but a more cunning and
sinister type.

OMAR RUIZ
Creatures From Mars

Omar Ruiz sees drawing as an extension of thinking—perhaps even a form of thinking. So when he chose to visualize the creatures for Ray Bradbury's sci-fi collection of stories *The Martian Chronicles,* his first challenge was to eliminate all of his preconceptions about warty, tentacled, bug-eyed Martians and think up something totally new. Fortunately, Bradbury's descriptions are spare and mostly implied, so Ruiz felt free to create his own versions.

After collecting a good number of animal photos, he started with feathers and feather patterns. From there the creatures just seemed to grow and evolve. He turned the paper frequently, with the result that new fauna appear when many of the drawings are viewed upside down. In the end he made over 300 drawings. They were exhibited at a major Ray Bradbury retrospective in 2005.

AVE

CUERPO

MURCIE

MANTIS

In the book, Bradbury mentions that the Martians used the praying mantis as a form of transportation. He describes these creatures as having crystal-like body plates, which Ruiz captures beautifully with his subtle use of colored chalk.

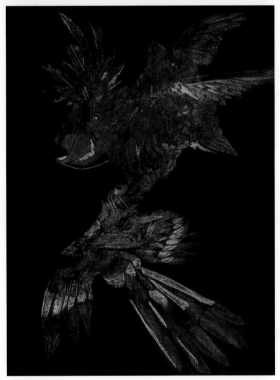

AZUL

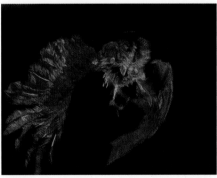

BUHO

ALAN E. COBER

A Compassionate Witness

Alan E. Cober (1935–1998) was an extraordinary draftsman who won hundreds of awards in both illustration and the fine arts. His distinctive pen-and-ink style was firmly grounded in observation. The drawings on these pages were part of a series he did on old age homes and in the Willowbrook State School for the mentally retarded in New York state. He did them in the 1970s, when people were commonly warehoused in underfunded and sometimes shockingly unsanitary state facilities.

Imagine the level of commitment necessary to take on a project like this—getting permission, establishing trust and rapport with the staff and the residents, overcoming squeamishness about the sights and smells, and, most importantly, sustaining the requisite compassion that allows for truthful work. In portraying his subjects with such unflinching honesty, Cober honored and dignified them. He celebrated them as individuals.

In his drawings of the elderly, Cober often added handwritten commentary or snippets of their dialogue. Some of these are poignant, some amusing. The subject *at bottom left* says, "...I traveled to many places but when my wife caught me I was trapped. I never traveled again...."

On the drawing *below*, Cober wrote, "This is one of the drawings that comes to life. I love it as I love the old man in it...."

Cober went to Willowbrook on assignment from *The New York Times*. They needed two drawings; he did fifty. These drawings were published in a collection titled *The Forgotten Society*, Dover Publications, Inc., New York, 1975.

STEVE COSENTINO
Making a Big Statement

When New York artist Steve Cosentino was offered studio space in the rooftop apartment of a homeless shelter in exchange for painting some murals in the building, he jumped at the opportunity. He spent several years decorating the building with city street scenes and large portraits of the residents—a total of fifteen murals in all. Cosentino got to know many of the residents personally, teaching some of them to draw and employing others as assistants on his projects. When Cosentino learned that the building was being torn down and the homeless were being evicted, he decided to make a statement.

Cosentino used the grid system to transfer and expand a small portrait image onto the 65' × 35' (20cm × 11m) rooftop. He created a grid of five-foot squares to scale up his original photograph. For his color palette Cosentino collected and sorted hundreds of pieces of discarded clothing from the shelter's clothing room. Then he nailed them in place with roofing nails. What emerged—visible from the taller surrounding buildings in midtown Manhattan—was a massive portrait of a homeless man. He titled it, in large letters, *Human Being*.

USING THE GRID
Steve gridded off the roof into five-foot squares with chalk; this matched a grid of one-inch (2cm) squares that he placed over his drawing.

ADDING THE COLOR
Finally he began putting the clothes in place, tacking them down with roofing nails. This was a largely intuitive process, as he had no way of stepping back and looking at his work. Notice how the air conditioners, which look so prominent in this view, all but disappear when viewed from above.

TRANSFERRING THE DRAWING
Next he transferred the drawing of the face, square for square, using whitewash to fill in the main shapes.

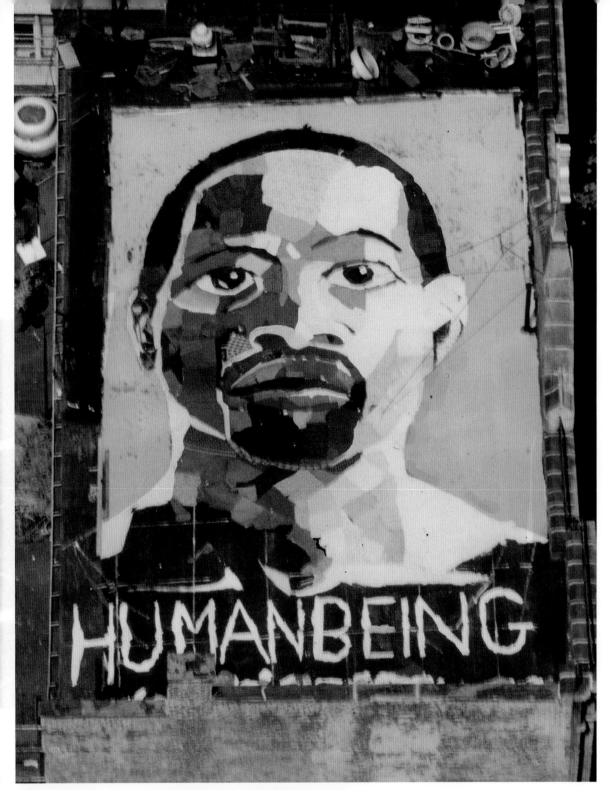

THE FINAL PRODUCT

The final piece took about one week to complete. By that time his project had attracted quite a bit of attention from the people in the taller buildings nearby. Someone contacted *The New York Times*, which did a feature story.

In the end, the homeless were evicted and the building was torn down. But Cosentino's piece brought considerable attention to the problem of homelessness—and to the power of creativity.

STEPHEN HUNECK

A Passion for Dogs

"Dogs teach you what's important," says Steven Huneck. "And there are only a few things that really are."

A fine wood-carver, Huneck has created a world devoted to dogs—both in his art and his surroundings. Whimsical dog furniture, dog rugs, dog sculptures and dozens of woodcut prints and crayon drawings of dogs fill his home. He has named his Vermont hilltop gallery Dog Mountain, and he built an adjacent chapel devoted to dogs. The carved sign out front says, "WELCOME—ALL CREEDS—ALL BREEDS—NO DOGMAS ALLOWED." Needless to say, pet visitors are encouraged at both of Huneck's galleries.

Huneck has found a theme that perfectly fits his wry and witty style. He works in clear shapes and clean colors. Huneck gets the shapes just the way he wants them by first drawing them, then cutting them out with scissors. This allows him to study and adjust them. "The scissors are as important to me as the pencil."

Huneck's deceptively simple ideas reveal not only the canine point of view, but also something fundamental about humans as well.

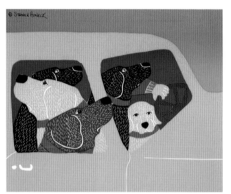

THE PACK INSTINCT

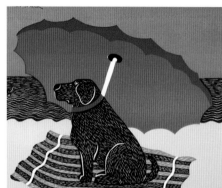

THE LIFEGUARD

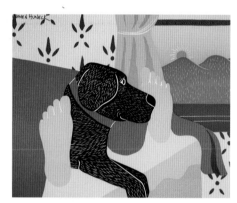

SUNNY DAY

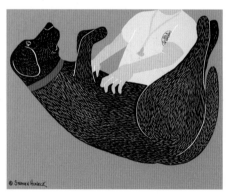

THE VET EXAM

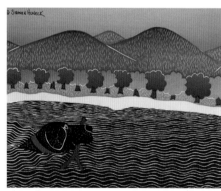

I LIKE STICKS

DOGS LIKE JOBS

GREETINGS

FRIENDSHIP

BECAUSE THEY CAN

MY DOG'S BRAIN

Huneck's drawing shows why dogs don't need therapists—they confine their thinking to the essentials, such as Food, Getting Petted, Treat, and Riding in Car.

BAD DOG

UNITED WE STAND

Even though this has Huneck's characteristic whimsical touch, it was done specifically to raise money for the dogs that assisted in rescue work at the New York World Trade Center after the terrorist attacks on 9/11/2001.

Texture—shown here in fur and water—is very important for Huneck. It gives a drawing energy and flow.

MAYA LIN
Envisioning a Memorial

Maya Lin was a twenty-year-old Yale architecture student when she learned of a competition to design a Vietnam War Memorial to be located in Washington, D.C. She and a small group of graduate students had been studying funereal architecture—monuments erected to honor the dead. So when the competition was announced, she was immersed in the history of the subject. She understood at a deep level the purpose and power of such memorials. Here she describes the moment her conception occurred to her.

"It was while I was at the site that I designed it. I just sort of visualized it. It just popped into my head. Some people were playing Frisbee. It was a beautiful park. I didn't want to destroy a living park. You use the landscape. You don't fight with it. You absorb the landscape. . . . When I looked at the site I just knew I wanted something horizontal that took you in, that made you feel safe within the park, yet at the same time reminding you of the dead. . . . I thought about what death is, what a loss is. A sharp pain that lessens with time, but can never quite heal over. A scar. The idea occurred to me there on the site. Take a knife and cut open the earth, and with time the grass would heal it. As if you cut open the rock and polished it."

Lin's drawings for the project are as remarkable in their simplicity as the design itself. The shape, widest at the center and tapered at either end, acts as a visual record of the war. Her idea was to display the names of the dead in chronological order, but in her sketches, she makes no attempt to show the inscriptions or any of the trees, people and background elements commonly included in architectural renderings. Just the black shape of the memorial wall, surrounded by the muted color of the pastels—striking, daring and simple.

Photo: The National Park Services

Vietnam Veterans' Memorial School Presentation
Pastel on paper, 23¾" × 17¾" (60cm × 44cm)
Located at the Yale University Art Gallery; Courtesy Maya Lin Studios

Pastel on paper, 22½" × 19" (57cm × 48cm)
Courtesy Maya Lin Studios

Pastel on paper, 25" × 19" (64cm × 48cm)
Courtesy Maya Lin Studios

Courtesy Maya Lin Studios

A LITERAL AND METAPHORICAL TRIBUTE

Sky and clouds are reflected in the black marble, showing some of the 58,000 inscribed names of the American men and women who died or remain missing. The names are arranged chronologically starting with 1959—the year of the first death. The final name appears at the bottom of the wall next to the date 1975.

Courtesy Maya Lin Studios

the power of themes

THE POWER OF THEMES

The examples in this chapter should make clear to you the beautiful, kinetic and reciprocal relationship between the artist and the theme. The artist chooses and executes the theme. The theme inspires and energizes the artist.

A good theme is heuristic—one drawing gives you ideas that lead to another. When you work in a series, the perennial question "What shall I do next?" has a ready answer: a variation on the last drawing. Make it alike, but different.

As we have seen from the examples in this chapter, everyone has a unique combination of interests—a unique point of view. (You might say that's what we are: a unique point of view.) We bring this point of view to life in the themes we choose and the way we execute them.

exercise 37

Exploring a Theme

Do a dozen drawings on a single theme; make them relate visually as well as conceptually. In other words, create a unified look to this work, so that if you displayed the pictures, they would appear to belong together. Choose a theme that you can generate some passion about—something that will hold your interest over time. If, after some thought, a theme doesn't occur to you, use the list below to prime the pump. You can take a theme directly from the list, or you can spin off from it. You'll notice that the list contains not only different kinds of subjects (masks, circus, etc.), but also different kinds of approaches and methods (reversals, shape mergers, etc.). These latter are "meta-categories." They could apply just as easily to any subject. Things can get interesting when you combine categories—for example, a subject (musicians) and an approach (puzzle pieces). So as you scan this list, look for possible combinations. As you work, display the drawings, and leave them up a while. You can learn a lot by by studying your work over time.

MATCH BOOKS BACKS OF HEADS ROBOTS GNARLED HANDS FOOD PEOPLE SLEEPING HIDDEN IMAGES SHADOWS MYTHOLOGY AGED PEOPLE FAMILY PORTRAITS EXAGGERATED EXPRESSIONS ROCK PATTERNS DREAMS YIN/YANG WEATHERED BARNS FABRIC & FOLDS JUNKYARD OBJECTS MUSICIANS FROZEN ACTION ANT'S EYE VIEW CLOUDS INSPIRED BY MUSIC QUILTED IMAGES HYBRIDS & CHIMERAS MAPS EXPLOSIONS MACRO DRAWINGS INCONGRUOUS TRAINS MUSCLES PEOPLE ON THE BEACH FRIENDSHIP STUCK TOGETHER LIQUEFIED INFINITE REGRESS HATS ON CHAIRS GRIDS SQUASHED & CRUMPLED MIRROR IMAGE RUINS REVERSALS REPETITION WITH VARIATION SKULLS & SKELETONS HEAVY OUTLINES TRANSFORMATIONS SHOES CHILDLIKE DRAWINGS FOG AND SOFTNESS SYMBOLIC FARM IMPLEMENTS FLOATING THINGS EXTREME PERSPECTIVE ROYALTY & POMP WILDLIFE FANTASY CITIES CARPET PATTERNS HERDS & FLOCKS PLUMBING FLYING THINGS GEOMETRIC ANIMALS INSPIRED BY LOVE REPURPOSING YOUR OLD DRAWINGS URBAN BLIGHT ANIMATED TOYS EXTREME ELONGATION MASKS TECHNO TRASH MOBS & CROWDS COSTUMES SEQUENCES LOOKALIKES CARICATURES SYMMETRY METICULOUS DETAIL REVISED NEWS PHOTOS MELTED MINIATURES DEATH & DYING GLOVES DECORATED SHAPES PRIMITIVE PROGRESSIVELY ABSTRACT TANGLES HISTORICAL MOMENTS CELEBRATION SILHOUETTES KALEIDOSCOPE STRANGE REFLECTIONS REVISED MOVIE SCENES ROOTS RHYTHMIC LINES SHIFTED CONTEXT PROMETHEAN FOLKLORE GIANT BIRDS NIGHTMARES ILLUSTRATED STORY METAPHORIC DRAWINGS RAVAGES OF WAR MONKEYS IN SUITS EVENTS FROM CHILDHOOD ESCHER TILING AERIAL VIEW LONELY & LOST UNUSUAL GEOMETRY PARADOX TREES LIKE PEOPLE ORDINARY BEAUTY LARGE THINGS MADE OF SMALL THINGS COMBINING OPPOSITES BATTLE SCENES MOTHER & CHILD ADD-ON PRECARIOUS CIRCUS OPTICAL ILLUSIONS SACRED FIRE & ICE PUZZLE PIECES FOOD EXOTIC LANDSCAPES SELF PORTRAITS EXAGGERATED DANCERS TOP VIEWS CITY SCENES ANACHRONISMS SHAPE MERGERS OBSCURED LITERALIZED EXPRESSIONS BARBER SHOP HIGH TECH ELEGANCE BIBLE SCENES INTENSIFIED BRIC-A-BRAC BARE FEET EXTREME FORESHORTENING CLUSTERS MULTIPLES CASTLES TRIBAL STARK CONTRASTS DELUSIONS WORD ASSOCIATIONS COFFEE SHOP GRAFFITI DOORWAYS & WINDOWS CONSTRUCTION MACHINERY ROPE PATTERNS ANTIQUE CARS BULLS & BEARS EVOLUTION ROBOTS SYMBIOSIS NEGATIVE SHAPES UNDERNEATH EARLY AIRPLANES ORDER & DISORDER ENTWINED MEMORABILIA REVEALED SEA SHELLS SANCTUARY RODEO MELTING CONNECTIONS OBJECTS ON LEGS FAMILIAR BUT STRANGE SCALE PLAY MAPS ILLUSTRATED POETRY EATING IMPROBABLE TEXTURES BARE FEET FLORAL DESIGNS MICROWORLD INSIDE THE HUMAN BODY MOTORCYCLES ILLUMINATED MANUSCRIPT CURVATURE MAZE VIOLENT WEATHER BALLOON PEOPLE COLLAGE COMPETITION METAMORPHOSIS ABANDONED HAIR PATTERNS ROCK & ROLL POSTERS ORIGINS INNER LIFE EXPRESSIONIST SURREAL UNUSUAL COMPARISONS SOMETHING'S MISSING LABYRINTHS RADICALLY CROPPED SEEMINGLY UNRELATED UNLIKELY PETS

drawing conclusions

DRAWING CONCLUSIONS

According to the poet David Whyte, "At the end of your life, the only thing your soul wants to know is not whether you were good, or successful, but whether the life you led was *your* life. Were the choices you made *your* choices . . . were they *your* failures." And, we could add, "Were they your drawings?"

Who are you? Why are you here? What really matters? If there are answers to such questions, I doubt they are found in language. More likely, the answers will reveal themselves in the experience of being fully engaged. This is when "*you*" (that is, all of your ideas about who you are) disappear. This is when you are most yourself, most alive.

This is why you and I love to draw. We discover ourselves this way—by doing things we didn't know we could do, expressing that which we don't fully understand. Begin without knowing the ending. Fail—and exploit the failure. These are the keys to drawing with imagination. And, one suspects, they are also keys to the experience of aliveness.

glossary

GLOSSARY

Algorithm: A simple procedure governed by precise instructions whose execution requires no special insight, cleverness or dexterity, but the result of which can be complex and elegant.

Abduction: Lifting certain characteristics from one thing and superimposing them on another. Abduction is the basis of metaphors.

Add-On Drawings: Building a drawing over time, adding new and sometimes diverse parts as you go.

Breakthrough: A moment of new realization, when what seemed difficult, even impossible, suddenly becomes easy.

Creative Advancement: A strategy (articulated by Robert Fritz) for creative progress. Just before you achieve comfort and mastery at one level, you move on to a more challenging level.

Constraints: The working parameters that define a creative project.

Distortion: Stretching and bending the parts while preserving the pattern of the whole.

Double-Description: Describing something through more than one channel (using words and pictures, binocular vision, seeing and feeling, etc.); a redundancy that gives depth.

Escher Tiling: A drawing with no background. Every shape is an object, abutting its neighbor.

Feeling Out: Using light strokes of your pencil to help you visualize an image.

Generating and Transforming: A two-stage creative process. The object of the first stage, generating, is to get something down on paper. The second stage, transforming, introduces changes, sometimes major, to the original.

Ground State: A calm, meditative state of mind conducive to creative work.

Heuristic Drawing: A method of drawing in sequence in which discoveries in one drawing suggest the approach for the next.

Hyper-Literal Seeing: A way of looking at things, particularly their shape, in which you take nothing for granted. Especially useful in drawing accurately. Related to Inquisitive Seeing.

Iconic Figures: Invented characters that are easy to draw and have multiple applications; often used in telling stories.

Immersion: Thoroughly absorbing a subject or style of art in preparation for doing a body of work.

Infinite Regression: An image that contains a smaller version of itself; within that small version is a yet smaller version, and so on.

Intensifying: Exaggerating and emphasizing for emotional effect.

Inquisitive Seeing: Looking at something as if you have never seen it before.

Joining Two Bags: A novel combination of incongruous elements.

Literalizing: Illustrating verbal expressions ("he hit the ceiling"; "raining cats and dogs") as if they were real.

Making the Familiar Strange: Transforming everyday scenes and objects into something vivid, compelling and even unrecognizable.

Metaphoric Seeing: Looking at something as if it were something else (i.e., a cloud as if it were a lion). Also: establishing a visual similarity between two things normally considered unrelated.

Metaphoric Drawing: Drawing an image that has the shared characteristics of two disparate things (e.g., a landscape and a carpet).

Mirror Imaging: Redrawing or tracing a previous sketch so that it appears to have a reflection; creating symmetry by redrawing and flopping an image.

Noodling: Embellishing or fussing over a drawing or doodle, sometimes applying various algorithms.

Obscuring: Making a drawing in which the subject is not fully revealed. This allows for viewer participation, as they can use their imagination to fill in the hidden spots .

Pattern Seeing: Looking at your subject as a set of interlocking shapes. .

Progressive Drawing: Drawing the same subject in a series in which increasingly radical modifications are made at each stage.

Random Capture: Jotting down in words or pictures the odd bits and pieces that show up in your life or in your dreams. This becomes source material for later development.

Repetition with Variation: Multiple, inexact copies of an image or motif within a single drawing. This is the essence of aesthetic pattern.

Reversing: Creating the opposite of what is expected; turning logic upside down (i.e., man bites dog).

Shape Cluster: A group of tightly packed shapes, drawn so that the spaces between them are more or less uniform. This is a less rigorous version of Escher Tiling.

Shifting Context: Putting ordinary people or objects in improbable settings. This is related to Joining Two Bags.

Spin-Off: A variation of a previous drawing, often bolder and more imaginative.

Synthesizing: Combining, in a new drawing, certain features of two or more of your previous drawings.

Utilitarian Seeing: The everyday, practical way we look at things. Essential in daily life, but a hindrance to good drawing.

Variations on a Theme: A series of drawings on the same subject. One of the keys to creative discovery.

Wobble: The less-than-perfect quality of anything done by hand; imperfections that express the personality of the artist.

Medieval Fair

Index

Figure and Ground
Colored Pencil

Expand Your Skills With These Other Fine
North Light Books

In his best-selling book Keys to Drawing, Bert Dodson shares his complete drawing system—55 "keys" and dozens of exercises that will teach you to draw any subject with confidence, even if you are a beginner.

ISBN-13: 978-0-89134-337-0
ISBN-10: 0-89134-337-7
Paperback, 224 pages, #30220

Drawing People provides a complete course on drawing the clothed figure from an award-winning illustrator and drawing instructor. In addition to basic drawing topics such as proportion, perspective and value, Barbara Bradley explains how clothing folds and drapes on figures both at rest and in motion and gives special tips for drawing heads, hands and children.

ISBN 13: 978-1-58180-359-4
ISBN 10: 1-58180-359-1
Hardcover, 176 pages, #32327

Ever wanted to try pen and ink with watercolor, but found other instructional methods intimidating? George Olson's friendly guide makes this classic art form accessible and achievable even for beginners. The 15 exercises and 12-step-by-step demonstrations covering flowers, people, animals and landscapes will give you everything you need to create beautiful pen-and-ink drawings with the sparkle of watercolor.

ISBN 13: 978-1-58180-754-7
ISBN 10: 1-58180-754-6
Paperback, 112 pages, #33421

These books and other fine North Light titles are available at your local fine art retailer or bookstore or from online suppliers.